DIGITAL PHOTO
DOCTOR

DIGITAL PHOTO
DOCTOR

Simple steps to diagnose, rescue,
and enhance your images

Tim Daly

David Asch

Reader's Digest

The Reader's Digest Association, Inc.
Pleasantville, New York/Montreal/Singapore

A READER'S DIGEST BOOK

This edition published by The Reader's Digest Association, Inc.
by arrangement with
THE ILEX PRESS LIMITED
The Old Candlemakers
West Street, Lewes
East Sussex, BN7 2NZ, U.K.

For Ilex Press
Publisher Alastair Campbell
Creative Director Peter Bridgewater
Editorial Director Tom Mugridge
Editor Ben Renow-Clarke
Art Director Julie Weir
Designer Ginny Zeal
Design Assistant Kate Haynes

For Reader's Digest
U.S. Project Editor Kimberly Casey
Canadian Project Editor Pamela Johnson
Associate Art Director George McKeon
Executive Editor, Trade Publishing Dolores York
President & Publisher, Trade Publishing Harold Clarke

Library of Congress Cataloging-in-Publication Data

Asch, David.
 Digital photo doctor: simple steps to diagnose, rescue,
 and enhance your images / [David Asch, Tim Daly].
 p. cm.
 Includes index.
 ISBN 0-7621-0686-7
 1. Adobe Photoshop elements. 2. Photography—Digital
 techniques. I. Daly, Tim, 1964- II. Title.

TR267.5.A33A83 2006
775—dc22

 2006040931

Address any comments about *Digital Photo Doctor* to:
The Reader's Digest Association, Inc.
Adult Trade Publishing
Reader's Digest Road
Pleasantville, NY 10570-7000

For more Reader's Digest products and information,
visit our website:
 www.rd.com (in the United States)
 www.readersdigest.ca (in Canada)
 www.rdasia.com (in Asia)

Printed by Hong Kong Graphics and Printing Ltd., China

1 3 5 7 9 10 8 6 4 2

contents

Introduction

There's never been a better time to try your hand at digital photography than right now. Camera and lens quality is increasing with each new range of devices, and the prices are falling rapidly. This is happening alongside advances in printer technology that allow you to make top-quality digital prints in your own home. *Digital Photo Doctor* is a straight-talking manual that helps you diagnose and repair faults in your digital pictures, and improve your shooting techniques.

Many potentially great photographs are spoiled by a single, easily made error. This book will show you how to solve shooting and exposure errors on your desktop computer using the now almost universally adopted Adobe Photoshop Elements application. However, the same techniques are transferable across a range of applications. By following this guide's simple, step-by-step examples, you'll quickly learn how to draw out the very best from your digital photographs.

How to use this book

There are two main types of pages in this book: "Symptom/Treatment" pages detail a common photographic problem and give a step-by-step walk-through for treating any of your images that share similar symptoms. "Good health help" pages provide you with helpful information for avoiding problems when you're out taking photographs with your digital camera. As you go through the book, you'll also find "Healthcheck" boxes. These contain important tips that relate to the subject covered on that page.

What you'll learn

In Chapter 1, the Hardware Healthcheck, you'll learn all about cameras, printers, and computer workstations, and how to set them up properly. With practical advice on how to prioritize a limited budget, you'll see what's worth investing in and what's not. Along with advice on software and useful Internet services, the first section establishes a foundation for all your future projects.

Chapter 2 covers all you need to know about making correct exposures while shooting photos; a skill that can prevent unnecessary image editing later on. You'll learn which exposure methods to use at which time—with a range of subjects under a range of lighting conditions. You'll also discover how to correct the exposure in Photoshop Elements for any images that didn't work the first time. Once your exposure technique is right, you'll be well on the way to making eye-catching prints.

Chapter 3 looks at another key photographic skill: composition. Like most creative techniques, composition can seem like a process only mastered over time, but there are plenty of tips that can help beginners start off on the right foot. You'll also discover ways to improve poor composition in Elements.

Chapter 4 sheds light on the complex topic of flash photography. Explaining the fundamental principles of artificial lighting and how to fix awkward mistakes, this section will help improve the pictures you take, and give you a better understanding of the limitations of your equipment and how these obstacles can be overcome.

Chapter 5 offers expert advice on how to use shutter speeds and software to experiment with the impression of movement in your pictures. Not all subjects look their best when captured frozen in time, so this section helps you to see the potential of movement, and teaches you some clever software tricks, too.

Chapter 6 deals with a subject at the heart of digital photography: color, and how to make the most of it. Learning how to correct, enhance, and manipulate color is a core skill for any digital photographer, and you'll learn the best software fixes for the color problems that can occur in your images.

Chapter 7 covers the fundamental retouching skills that you'll need to fix, improve, and design better photographs after the exposure has been made. Whether it's improving poor complexions or opening the eyes of that relative who blinks in every picture, you'll learn it here.

Chapter 8 examines ways to solve common errors that occur when parts of your image are distorted because of the limitations of your camera equipment or your original viewpoint. With a selection of software moves, you'll soon be able to correct converging verticals and unwanted reflections.

Chapter 9, the final section of the book, provides you with a useful glossary, a run-through of the extra features that can be found within Photoshop Elements, and a useful guide to troubleshooting common printing problems.

Digital photography is something to be enjoyed, and the less time you spend worrying about making mistakes, the more chance you'll have of making great images. *Digital Photo Doctor* will help you over those "how to" hurdles, so you can get on with the fun.

Hardware healthcheck

Before you delve into the world of digital photo retouching, check that your computer system and camera are set up correctly. If you want to make hard copies of your images, it's a good idea to calibrate your printer first.

Using your digital camera

Digital cameras operate very much like film cameras—point the camera at your subject, focus the picture, and press the shutter button. The main difference is how the image is captured and stored. With this in mind, you only need to know the basic equivalents between digital and film cameras to be able to get started quickly. Refer to your camera's manual if it differs from the model shown below.

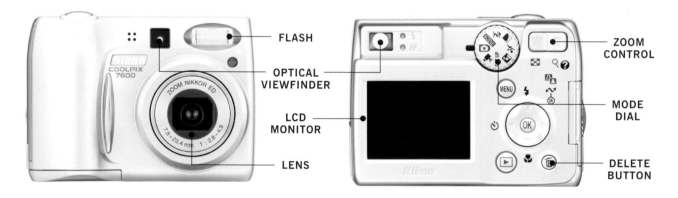

FLASH

OPTICAL VIEWFINDER

LCD MONITOR

LENS

ZOOM CONTROL

MODE DIAL

DELETE BUTTON

Computer connector port
Essential for getting images out of your camera, the computer connector port is usually a mini Universal Serial Bus (USB) or FireWire socket. You can transfer your images without removing the memory card by using the camera-to-computer cable that came with your camera.

Delete button
This button enables you to delete poor shots and free up space for better ones on your memory card. The delete function is usually a two-step process, so that it can never be used accidentally.

Flash
Although they are usually only powerful enough to light subjects less than 15 feet (5 m) away from your shooting point, built-in flash units give you the convenience to illuminate most low-light situations.

Image sensor
Instead of film, digital cameras have a fixed light-sensitive patch called an image sensor. These are designed to produce digital images in a number of pixel dimensions. Many cameras are referred to as megapixel cameras, because they produce image files containing over a million pixels. The bigger the megapixel value, the bigger the print you can make.

LCD Monitor
With the Liquid Crystal Display (LCD) screen, you can preview the pictures you take and use it for real-time framing. Access to the camera's menus and functions are displayed here, too. Playback options usually include full frame (in which one image fills the whole window), thumbnail (several smaller images displayed in the window simultaneously), and slideshow (a series of full-frame images shown one after the other). You can also set shutter speed and aperture values, along with sensor light sensitivity, known as ISO speed (more information on pages 42–43).

Lens
Most digital cameras are fitted with a versatile zoom lens that enables you to compose the shot without changing your shooting position.

Mode dial
The mode dial enables you to quickly switch between camera modes. There will usually be one setting for reviewing the images stored on the memory card, and a number of shooting modes. Consult your camera's manual for details about the modes it offers.

Optical viewfinder
Most digital cameras use a simple optical viewfinder window to frame and compose the image. You'll drain less battery power using the optical finder because the LCD monitor can consume a lot of energy.

Shutter button
Digital cameras have a noiseless electronic shutter that can capture many frames in quick succession.

SHUTTER
BUTTON

COMPUTER
CONNECTOR
PORT

VIDEO
OUT
PORT

STORAGE
MEDIA

Storage media

The memory card stores your images. These come in many different formats and capacities, so make sure you know which type your camera takes. Memory cards can be removed from your camera and inserted into various types of card readers for fast transfer to your computer, or inserted directly into a printer for instant printouts.

Video out port

With a Video out port, you can connect your camera directly to a television and preview all of your pictures before editing and printing.

Zoom control

The zoom control is there so you can frame tightly, using the telephoto (T) end of the lens or frame widely, using the wide-angle (W) end of the range.

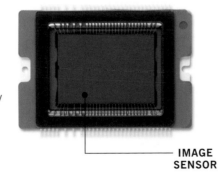

IMAGE
SENSOR

JPEG files

JPEG is a universal file format for shooting and storing your pictures, and it gives you near-perfect image quality when set to the *Fine* or *High* position. JPEG files are compressed to save space.

Sensor speed

The image sensor can be set to compensate for either dim or bright light levels to avoid overexposure (too much light entering the camera) or underexposure (too little light entering the camera).

Image dimensions

The biggest pixel dimension your camera can offer—for example, 3000 x 2000—will give you enough data to make a top-quality print. Smaller sizes, such as 640 x 480, are only sufficient for on-screen use.

Camera presets

Many cameras can be set to apply image enhancements before your pictures are edited on a computer. These should be turned off. Enhancements can be added in your image-editing software, but you can't remove a preset once it's applied.

White balance

White balance is a camera setting that helps you compensate for the color of the light in which you are shooting. Unlike natural daylight, artificial lighting creates a color that is invisible to the naked eye, but it will be picked up by the camera. For general use, keep your camera's auto white balance setting turned on, because this will adjust the camera to cope with most natural daylight and flash shooting scenarios. When using domestic light sources, experiment with your options before committing to one.

Improve your shooting skills

Although Photoshop Elements can make a huge impact on your digital photographs, your job will be a whole lot easier if you begin with a good-quality original image. To do this, you'll need to develop your camera skills. It can take years of practice to be a great photographer, but there are some simple rules that you can follow that will elevate your pictures from everyday snapshots to photographs worth treasuring. Once you have a good base to build on, photographs can be taken into Elements for their final tweaks and improvements.

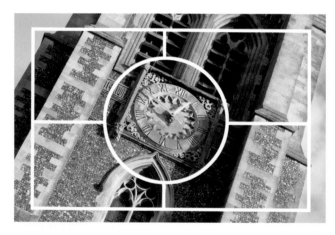

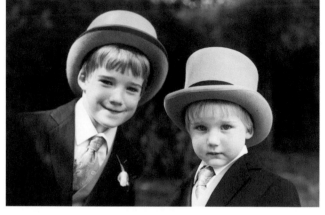

Composition in the viewfinder
There's more to taking a good photograph than just clicking the shutter release. You'll make the majority of important judgments beforehand in your camera's viewfinder—the small preview window that frames your composition. In addition to the image, most cameras' viewfinders also display key information, such as focus and exposure settings.

Big is best
Most amateur photographers never get close enough to their subject, especially when using an older camera. If you are worried about chopping off the heads and feet of your subjects, you are probably standing too far away. A person in a standing position doesn't easily fit into the frame, so don't try and force them. Zoom in closer or change your own position. For portraits, getting closer to your subject can help blur backgrounds and make them less distracting to the eye.

Digital zoom setting
The digital zoom setting works in a very different way from a normal optical zoom lens. Instead of pulling your subject closer like a telescope, the digital zoom enlarges a smaller middle section of your image to make a far-off subject look bigger. Digital photographs taken in this way may appear blurred and of poor quality because extra pixels are introduced by the software. It's usually better to ignore the digital zoom setting on your camera, and just use the optical zoom.

Autofocus problems
Typically, autofocus problems happen if your subject falls outside the central portion of the frame. This makes your digital camera set its focus on a different object in the distance by mistake. Most cameras have an autofocus lock to prevent this from happening. This usually works by depressing the shutter-release button halfway down when the subject is in focus, or by pressing an additional locking button.

Rule of thirds
Often used by painters, the "rule of thirds" theory suggests that an image should be divided up into a grid of nine equal but invisible sections. As long as elements of your photographs are placed on these grid lines, or at their intersections, you will get a visually attractive result.

Hold your camera steady

Improve your shooting position by pulling your elbows in close to your body. If you still feel a wobble, brace yourself up against a wall or another solid object. Even better, if you've got the time, set the camera on a tripod or nearby wall.

Set your point of focus carefully

Pick your focus point before you press the shutter button, and you will be guaranteed a better result than relying on your camera's autofocus to act for you.

Exposure won't always work on auto

When shooting predominantly white or black subjects, or when including bright lights in your composition, most auto exposures simply can't react as well as you would hope. Just like with picking a focus point, you need to tell your camera which part of the subject is the most important.

Think about depth of field before shooting

All photographers need to consider which areas should remain sharply focused and which should be blurred. If too much of the image is in focus, it can create a lack of emphasis on your main subject.

Symmetry
The best kind of balanced composition to try at first is a symmetrical one. Eye-catching symmetrical images are made when near-identical elements are arranged on either side of an imaginary vertically or horizontally centered line. This technique works best with architectural and landscape subjects.

Using Adobe Photoshop Elements

One of the great advantages of digital photography is that you can easily edit your images after you have taken them. Most cameras come with a simple software application for transferring pictures from the camera to your computer, and some of these applications may also allow simple image adjustment, such as rotation or contrast alteration. However, for more detailed adjustments you will need dedicated software. By far the most popular, and the most useful, of all midprice image editing applications is Adobe Photoshop Elements. This software is available for both PC and Macintosh computers.

The advantages of Elements

Photoshop Elements is the little brother of the industry standard image-editing application, Photoshop, but it comes at a fraction of the price. Don't be fooled into thinking that the lower cost means it's missing important features, though. Adobe has carefully selected all of the features that the everyday user won't require (such as color modes that are only used by professional printers), and removed them to leave a simple and easy-to-use package for the digital photographer. They've also added a few new features that are not included in Photoshop.

Another advantage of its heritage is that Elements is ideal for those who intend to graduate to the full version of Photoshop at a later date. It has many familiar palettes and menus, and the workflow and desktop environment are both very similar to Photoshop.

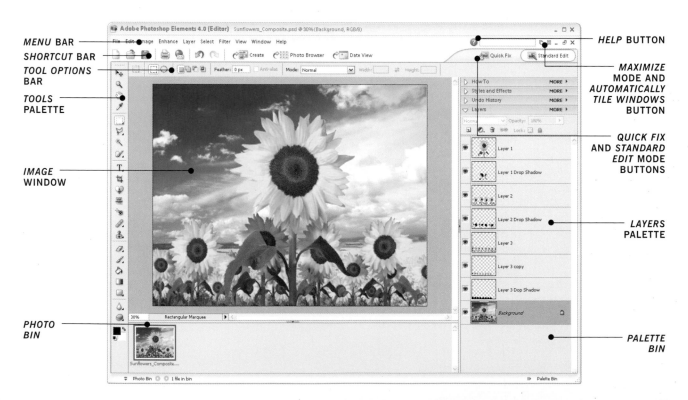

MENU BAR
SHORTCUT BAR
TOOL OPTIONS BAR
TOOLS PALETTE
IMAGE WINDOW
PHOTO BIN

HELP BUTTON
MAXIMIZE MODE AND AUTOMATICALLY TILE WINDOWS BUTTON
QUICK FIX AND STANDARD EDIT MODE BUTTONS
LAYERS PALETTE
PALETTE BIN

If you are new to Photoshop Elements, the package comes with a useful *How To* feature accessible through the *Window> How To* menu. These simple step-by-steps will guide you through the sometimes confusing early days of image editing. There is also a thorough *Help* menu available either by clicking the blue *Question Mark* icon on the *Shortcut* bar, or by typing a subject into the search field and pressing Enter to search the help files for aid on a specific subject.

Another handy feature of Photoshop Elements is its *Quick Fix* mode, accessible by using the buttons at the top right of the screen. If you don't want to delve deeply into the manual controls for adjusting color, contrast, and image brightness, then the *Quick Fix* dialog box presents all the commands in a one-stop shop. In this

dialog box you can see your image before and after applying any fixes, with the option of canceling the fixes at any time.

This book assumes that you are familiar with most of the basic tools, such as brushes and selection methods, that are available in Photoshop Elements, and that you know your way around the

software. Don't worry if you're not an expert user, though, because everything you need to know to use the examples will be explained in easy-to-follow steps. To be sure that you're familiar with the standard screen elements, take a moment to read through the annotated images that are featured on these introductory pages.

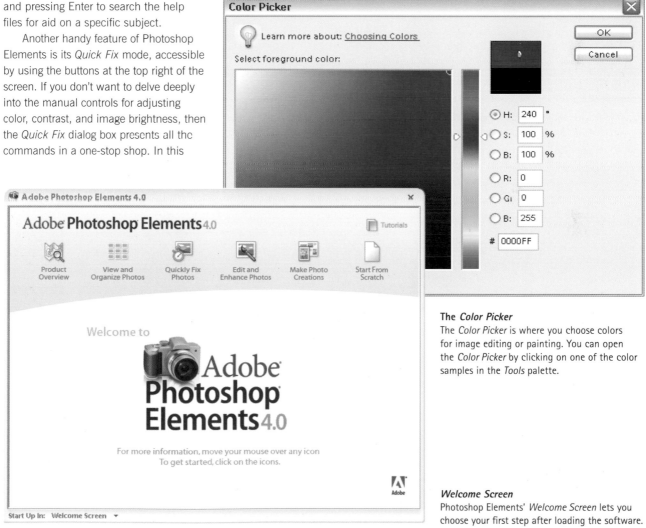

The *Color Picker*
The *Color Picker* is where you choose colors for image editing or painting. You can open the *Color Picker* by clicking on one of the color samples in the *Tools* palette.

Welcome Screen
Photoshop Elements' *Welcome Screen* lets you choose your first step after loading the software.

Common tools and palettes

Photoshop Elements has a well laid out, easy-to-use interface. Its tools are readily available in the *Tools* palette on the left side of the screen, and its filters and effects are categorized in the menu system. All of these are perfectly good for the occasional user but if you are intending to work through many images and perform complex tasks, you may find that clicking between all of these commands can slow you down. To make your workflow quicker, almost all of the available options have a keyboard shortcut (or combination of keys) that you can use.

The following screenshot is a guide to the most commonly used tools and their keyboard shortcuts. Many of the icons conceal other tools beneath them, and these are marked with a small black triangle in the bottom-right corner. These hidden tools can be accessed either by clicking and holding the mouse cursor on the icon in the *Tools* palette, or by holding Shift and pressing the shortcut key to cycle through them.

TYPE T
HORIZONTAL/
VERTICAL/
HORIZONTAL TYPE MASK/
VERTICAL TYPE MASK

CROP C

COOKIE CUTTER Q

STRAIGHTEN P

RED EYE REMOVAL Y

SPOT HEALING BRUSH J
HEALING BRUSH

CLONE STAMP S
PATTERN STAMP

ERASER E
(BACKGROUND ERASER/MAGIC ERASER)

BRUSH B
IMPRESSIONIST BRUSH/COLOR REPLACEMENT TOOL
This also includes Pencil *N*.

PAINT BUCKET K

GRADIENT G

SHAPE U
RECTANGLE/ROUNDED RECTANGLE/ELLIPSE/ POLYGON/LINE/CUSTOM/ SHAPE SELECTION

BLUR R
SHARPEN/SMUDGE
Hold Alt/Option to toggle between Blur and Sharpen.

BURN O
DODGE/SPONGE
Hold Alt/Option to toggle between Dodge and Burn.

PALETTE D
Restores default (black and white); X swaps between the foreground and background colors.

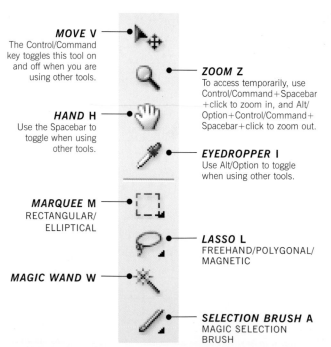

MOVE V
The Control/Command key toggles this tool on and off when you are using other tools.

ZOOM Z
To access temporarily, use Control/Command+Spacebar +click to zoom in, and Alt/ Option+Control/Command+ Spacebar+click to zoom out.

HAND H
Use the Spacebar to toggle when using other tools.

EYEDROPPER I
Use Alt/Option to toggle when using other tools.

MARQUEE M
RECTANGULAR/ ELLIPTICAL

LASSO L
FREEHAND/POLYGONAL/ MAGNETIC

MAGIC WAND W

SELECTION BRUSH A
MAGIC SELECTION BRUSH

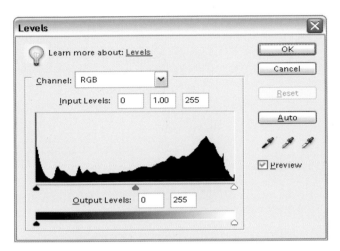

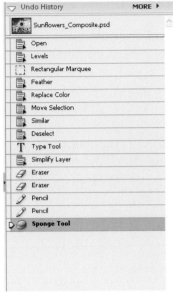

The *Undo History* palette

The *Undo History* function keeps a record of any changes made to your images, allowing you to easily see what you've done, and step back through the changes if you need to undo anything. The number of "states" that the *Undo History* palette records can be set in the *General Preferences* menu. Although you may be tempted to set this to a very high number, be aware that each of these states takes up a portion of your computer's memory, and the higher your setting, the slower your computer will run.

The *Levels* dialog box
Using the *Levels* controls is one of the best ways to alter poor exposures. The histogram shows the range of tones found in the image, from the dark tones at the left to the light tones at the right.

How To palette
The *How To* palette is a handy source of simple step-by-step instructions for basic image-editing techniques.

Help window
The useful *Help* window allows you to find extra tips and guidance during a project and it is fully keyword searchable.

Getting your computer in good condition

To be sure you see the same colors in real life, in the camera, on the computer, and in print, you need to check that all of your equipment is properly set up for color reproduction. The process of correctly setting the color is known as calibration.

Calibrating your computer

Before getting down to the technical side of calibration, set your computer's desktop to a neutral color, preferably gray. Your eye can be influenced by background colors when you're viewing your photographs. Warm desktop colors, such as red, will make your image appear warmer, even though no actual change has taken place. Just as a colored window mount can influence a framed photograph, a busy desktop can be an unwanted distraction.

On a PC, you can change the desktop background by right-clicking on a blank area of the desktop and going to *Properties>Desktop*. On a Mac, this can be changed in the *Desktop & Screen Saver* panel of the *System Preferences* window.

In addition to the basic button-driven color and contrast controls found on your display, your computer also has a software application for more accurate measuring. Thankfully, no scientific knowledge is required because monitor calibration software works by guiding you through a simple step-by-step sequence. By following these steps and setting neutral color balance, contrast, and the all-important tonal midpoint—called gamma—along the way, these careful measurements are saved for use in your imaging applications. With a neutral monitor set at the right gamma, your prints will never emerge darker or lighter than you'd hoped.

If you are using Photoshop Elements on a Windows PC, you will have a program called Adobe Gamma installed. This can be found in the *Control Panel* (*Start>Control Panel*, or *Start>Settings>Control Panel* depending on how your computer is set up). On a Mac, the *Display Calibrator Assistant* can be found in *System Preferences>Displays>Color>Calibrate*. Both applications run through a very similar process, and end up by saving a color profile for your monitor. This profile will then be used by imaging applications to make sure that your pictures display correctly.

Positioning your screen

If you want the most accurate color reproduction on your monitor, then it's worth considering the physical location of the screen. If the monitor is opposite a bright window, then reflections on the screen will play havoc with your color accuracy. If possible, don't position the monitor next to vividly colored walls, or, indeed, wear vivid colors yourself when doing color-sensitive work, as both can create a reflected color cast on your screen.

Display Calibrator Assistant

Be sure to check the *Expert Mode* box in the first panel of the Macintosh *Display Calibrator Assistant*. This will enable you to make more detailed adjustments.

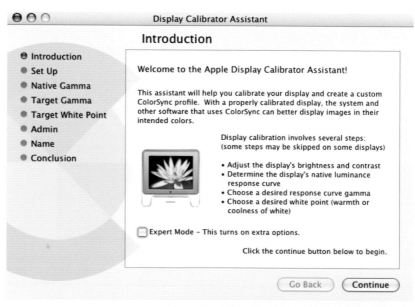

USING CALIBRATION SOFTWARE

Measuring luminance

All calibration software begins by measuring the color response of the display. The first of five measurements are taken, each one guiding you to move the small blue cursors.

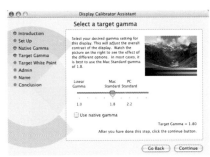

Selecting target gamma

Gamma is best set to 2.2 on a Windows PC and 1.8 on a Mac. This wizard shows the results of each alternative applied to a landscape photo. In this case, the display was set to the 1.8 Mac standard.

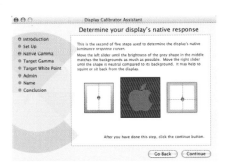

Targeting midtones

Like the Adobe Gamma calibrator, this tool asks you to make the central apple icon merge into the surrounding gray background to further refine a neutral color display.

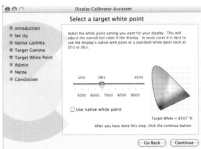

Setting target white point

This setting defines how your computer displays white. The standard 6500 degrees Kelvin (often referred to as D65) is used for most displays and will correspond to most white paper used in printing.

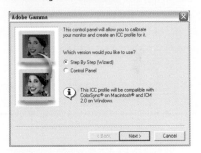
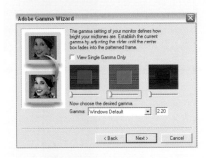

Choosing a printer

There's an enormous range of digital printers to choose from, but how do you judge which kind gives the best results? Understanding a little about how they work will help you decide which you should choose.

How ink-jet printers work

Similar to the way color photographs are reproduced in books and magazines, an ink-jet printer creates an illusion of color using tiny dots of ink. Most ink-jet printers have only four colors (cyan, magenta, yellow, and black), but some photo printers have an additional two colors (usually lighter shades of cyan and magenta) to give even smoother tones.

Different combinations of ink dots create a variety of colors when viewed from a distance, and the human eye merges them to produce continuous tones.

Controlling your printer

In addition to your imaging software, you can control the quality of your printer through its own dedicated software. Besides familiar settings such as paper size and print quantity, ink-jet printers will also have numerous preset options for selecting different media types such as glossy, matte, or film. Using the correct settings is essential because they instruct the printer how much ink to drop and how far apart to place the dots. Picking the wrong media type will give you very poor results.

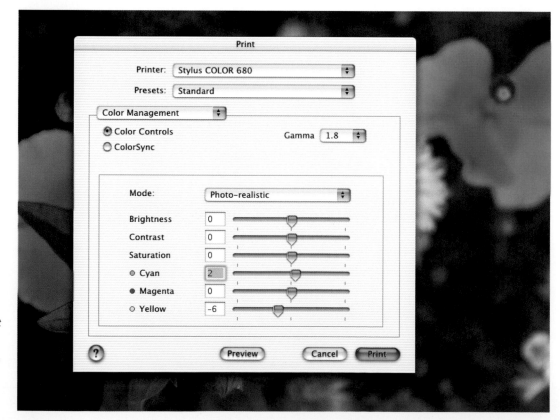

The *Color Management* settings on this Mac's *Print* menu allow detailed changes to the color of the final print. The amount of options available differs with the type of printer.

TYPES OF PRINTERS

For most users, a basic color ink-jet printer is adequate for making printed copies of digital photographs. However, you may want to pay extra for a printer that is capable of making better quality prints.

Home ink-jet

A basic ink-jet is low cost and designed for a range of family uses. It gives good results for printing out reports and school projects, but falls short when trying to mimic the delicate colors in a photograph. Using better quality photo paper can alleviate this, but prints can still appear spotty because of the limited range of inks.

Photo-quality ink-jet

Approximately twice the cost of a home ink-jet, this printer uses the same CMYK colors, plus two extras—light cyan and light magenta. The lighter colors help achieve a better rendition of flesh tones and subtle photographic colors. If you have any extra money in your budget, opt for a printer that uses "lightfast" or pigment inks that add longevity to your pictures by preventing them from fading. These can extend the lifetime of your prints by up to 100 years, and are worth the extra cost if you want to make prints that will last.

Professional ink-jet

Sold at about three times the cost of a photo-quality ink-jet, this printer is aimed solely at professional photographers and designers. Professional ink jets can spray ink at super high resolutions (2880 dots per inch and above), making prints that are indistinguishable from traditional photographs. With lightfast pigment inks, you can make long-lasting and archival-quality prints, but with a high cost of materials. Also keep in mind that pigment printers are often not able to reproduce very vivid, saturated colors—resulting in flatter prints.

Direct printers

Some printers have a built-in port for accepting digital camera memory cards directly. Using the printer's preset software, good results can be achieved without the need for a computer. Many recent devices have built-in LCD displays so you can choose the images that you want to print from the camera.

DIRECT PRINTER

HOME INK-JET

PHOTO-QUALITY INK-JET

PROFESSIONAL INK-JET

Using the Internet as a print lifeline

Just like shopping online, you can now order top-quality digital prints from an Internet-based photo lab. If you're a confident Web surfer and find shopping on the Internet easy, you can make use of the growing number of online digital printing services. Simply upload (send) your digital images to an online photo lab's Web site, such as Shutterfly, that will print your images onto conventional photographic paper and mail them to you the next day.

How it works

After you have uploaded your digital image files, they are received at the other end by a computer linked to an automated digital printer, which is identical to the machines used in photo labs. These printers use a fine laser to "beam" your images onto conventional silver-based color photographic paper. This process avoids the use of a traditional enlarging lens, so common problems such as print scratches, dust, or poor focus never appear on the final results. In fact the print quality is so high that this kind of service matches professional lab output, at a much lower cost.

Another advantage of Internet photo labs is that many of them are global companies that will deliver the photos to anywhere in the world. This allows you to easily send prints directly to friends and family members, no matter where they live.

File transfer

The act of uploading image files is simpler than it sounds. In reality, it's just like sending an attachment with an e-mail. The process varies, but it usually consists of following the instructions on the Web site to locate the photos on your computer, and then just waiting for the files to be transferred. The time it takes to transfer the files depends on two main things: the speed of your Internet connection and the size of the image files.

Compressing your files

If you have a monthly fixed priced Internet connection, the connection speed is less of an issue—unless you're in a hurry. If, however, you have to pay for every second you are connected to the Internet, you'll want to make your files as small as possible before uploading them. The process of making your image files smaller is known as compression, and comes in two main forms: lossless and lossy.

Lossless compression makes the files a little bit smaller, but keeps them at exactly the same quality. Lossy compression can make the files a lot smaller, but at the expense of image quality—the compression routine saves space by dropping details in the image that it considers to be nonessential. JPEG (often shortened to JPG in file names) is the most popular lossy image compression format, and your photos are likely to already be in this format (although at the lowest compression).

You can compress your images in Photoshop Elements using the *File>Save for Web* command. This will give you a preview of how your image will look when it's compressed, so make sure you're happy with the quality before saving and sending the file. Most online photo labs will only accept images saved in the JPEG format. Mac users will need to be sure that their files are saved with the ".jpg" file extension. If this hasn't been done for some of your files, you can simply click on the file name and type the extension at the end. You don't need to resave the file.

HEALTHCHECK

Working out resolution and print size

In order to take advantage of the very high print quality, you must save your images with a resolution of at least 200 ppi (pixels per inch) or your prints will contain visible pixels. Once you're ready to upload your file, go to the *Image Size* dialog box (*Image>Resize>Image Size*) and check that the *Resample* button is deselected. Next set the *Resolution* to 200 pixels per inch, and the *Width* and *Height* will show you the maximum size at which your image can be printed out.

ONLINE PHOTO LABS

There are many online photo labs available—all with competitive deals and prices. It's worth shopping around to find the one that suits you best. Listed below are some popular Web sites offering a photo printing service. If you use a PC, you can order prints directly from Photoshop Elements by going to *File>Order Prints*. This will guide you through the print ordering service from Kodak.

Kodak EasyShare—www.kodakgallery.com
Sony ImageStation—www.imagestation.com
Printroom.com—www.printroom.com
Fujifilm—www.fujifilm.net
Bonusprint—www.bonusprint.com
Club Photo—www.clubphoto.com
Ezprints—www.ezprints.com
Fotki—www.fotki.com
Funtigo—www.funtigo.com
ImageEvent—www.imageevent.com
PhotoShow—www.ourpictures.com
Phanfare—www.phanfare.com
Photosite—www.photosite.com
PhotoBox—www.photobox.co.uk
PhotoWorks—www.photoworks.com
Pixagogo—www.pixagogo.com
Shutterfly—www.shutterfly.com

Doctor, I keep being exposed!

Perfect exposure has always been a hallmark of a great photographer. It's something that comes with patience and practice; however, there are some techniques you can learn to ensure better photos. Photoshop Elements can also help with further improvements at a later time.

General underexposure

Digital photos appear darker than expected when too little light has passed through your camera lens. However, this can be easily fixed using a few simple moves in Photoshop Elements.

The purpose of *Levels*

Never judge a digital photo as it appears on your monitor or you'll be making a subjective decision that can be influenced by many other factors. The amount of ambient light in the room, the monitor setup—even colors reflecting from your clothes and the local environment—could all make your desktop image appear brighter or darker than it is in reality.

The best way of judging the accuracy of your camera exposure and any need for subsequent image editing is to use the *Levels* dialog box in Elements—found under the *Enhance>Adjust Lighting>Levels* menu, or by pressing Ctrl/Cmd+L.

Image brightness is much more measurable in a digital photo than with traditional film through a useful graphic chart called a histogram—the core feature of the *Levels* dialog box. The real purpose of the *Levels* dialog box is to help you carefully process and prepare images for print out and Web page use. And with its two scales for changing contrast and brightness, you'll never suffer from muddy prints again.

The *Input Levels* histogram gives a readout of the image's tonal range. The smaller *Output Levels* scale, found at the base of the dialog, offers you the chance to reduce the contrast of your printouts.

Understanding the *Levels* dialog box

The graph found in the *Levels* dialog box shows the exact tonal range of all the pixels present along a horizontal 0-255 axis, against a vertical scale recording their quantity. Because every photo you take is composed of a different mix of colors, the shape of the *Levels* histogram is unique to each individual image.

There are three triangular slider controls across the horizontal baseline of the graph. At the far left, the black slider is used to set the shadow point. If you move this to the right the image will grow darker. Use this slider to fix overexposed images. The white triangular slider on the far right is used to set the highlight point. If you move this to the left, the image will grow lighter. Consequently, this slider should be used to correct underexposed images. The gray slider in the middle controls the midtones. Use this slider to correct exposure mistakes made while shooting or scanning errors.

Fixing a dark image

The top example on the opposite page shows underexposure created in error by shooting indoors without a flash. The result is a very dark image, but there is enough detail present to rescue the image and make a print. The histogram shape of a dark image shows a marked leaning to the left end of the scale, indicating more blacks and dark grays than lighter tones.

To make a brighter image, simply slide the midtone and highlight triangles to the new positions as shown at right.

HEALTHCHECK

Understanding *RGB*

There is a drop-down menu at the top of the *Levels* dialog box called *Channel*. This menu enables you to change the color range in the image that your *Levels* changes will affect. *RGB* means that you are altering the entire image, or you can choose to alter the different tones separately—*Red* will only change the red tones in the image, *Green* will change the green tones, and so on.

The *RGB* (red, green, and blue) image mode is a universal standard for creating digital photos. Each color has its own 0-255 scale, from black (least saturated) at one end to full color (most saturated) at the other. The color of each individual pixel is created from a mixture of these three ingredients.

Adjusting an underexposed shot

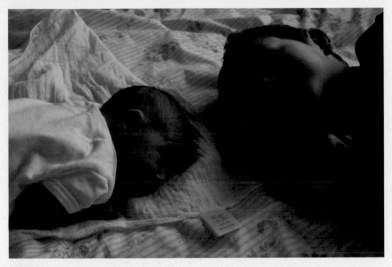

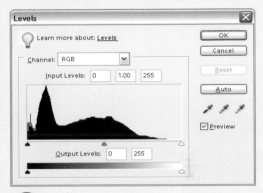

2 A glance at the *Levels* dialog box shows that the image is heavily skewed toward the dark end of the value scale.

1 This image was taken without a flash, so it is underexposed. At the moment, it is unusable, but it can be fixed with a minor *Levels* adjustment.

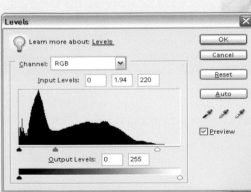

3 Moving the white highlight slider toward the left lightens the image. The gray midpoint slider should then be moved to balance the tones in the image. This image has an obvious midpoint between the peak of dark tones and the mass of light tones.

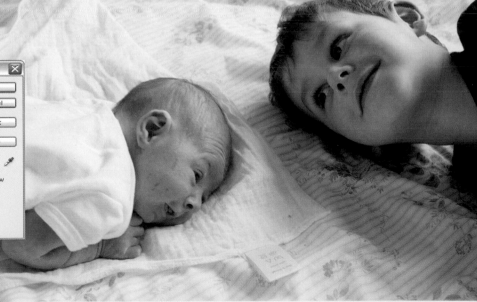

4 With that simple adjustment, the image is ready for printing and sharing with family and friends.

 symptom

Underexposure only in parts

Despite a perfect camera exposure, smaller areas of your photo can sometimes fall under shade and need lightening. You can correct this problem easily using the *Dodge* tool, which can be found in the Photoshop Elements *Tools* palette.

In this example, the original image was darker than expected and the central subjects have black feathers. The main task is to lighten up the two swans, so they become more prominent within the overall image. From the very bottom of the *Tools* palette, choose the *Dodge* tool. This is sometimes found hidden underneath the *Sponge* tool's pop-out menu.

 treatment

Use the *Dodge* tool to fix dark patches

Based on a traditional photographic darkroom technique, the *Dodge* tool is used to gradually lighten pixels to give the impression of more visible detail and better contrast. Used

sparingly it provides excellent results, but if overused the effects become very obvious. The key is to work slowly and use the *Undo History* palette if you make any mistakes.

Once the *Dodge* tool is selected, the top part of Elements' window will display the options for controlling this feature. Set the *Range* to *Midtones* and the *Exposure* to work at 50 percent. The *Exposure* value measures the impact of your edits. Larger values will make a sudden change in one brushstroke and smaller values will make slight, but subtle differences. The three *Range* options of *Highlights*, *Midtones,* and *Shadows* enable you to work on specific tonal areas of your image. In this case, the *Midtones* option is selected so the original black color of the swan is not lightened.

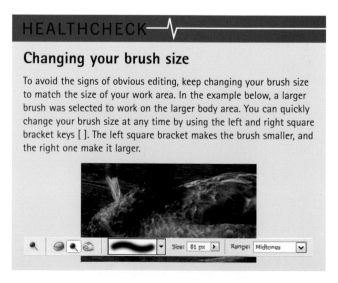
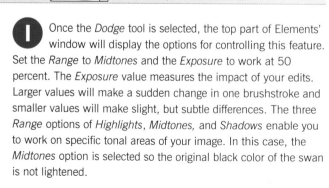

2 Click on the *Brushes* drop-down menu and click-drag the bottom right-hand corner of the window to stretch it across your desktop. Now with all the options visible, choose the 35-pixel-wide soft-edged brush. Softer brushes are much more forgiving of mistakes, and appear less visible after an edit. Once selected, press Enter on your keyboard.

3 Using the *Zoom* tool, zoom into the areas you want to alter and gradually apply the brush across the image in a stroking motion, rather than dabbing single dots. The darker areas will now lighten and become much more visible. If a single stroke makes your image too light, then reduce the exposure to 30 percent and backtrack using the *Undo History* palette.

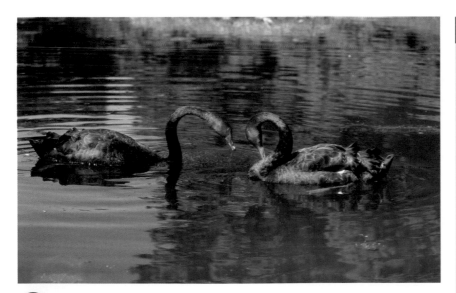

4 Compared to the starting point, the final edited version of the image has much more contrast and the central subjects are emphasized by their lighter tones.

HEALTHCHECK

Using *Undo History*

Undo History is a useful palette that records each command you make, as a separate entry, called a state. The most recent command is displayed at the base of the palette and if you make a mistake, you can simply click on any state above to reverse your command.

You can change the number of history states in the program's preferences, accessed via *Edit>Preferences>General* on a PC, or *Photoshop Elements>Preferences> General* on a Mac. Be aware that each history state takes up a portion of your computer's memory, and setting too high a number can slow down your computer. On the flip side, if you find Elements runs too slowly, you can reduce the number of history states to free some memory.

How to find the right light meter mode

The light sensitive sensor inside your digital camera responds only to variations in brightness rather than the color, size, or shape of your main subject. Consequently, the camera meter often makes an exposure judgment based on an unimportant feature in your shot. Classic mistakes are made when dark subjects are placed in front of bright windows—with the meter creating a perfect exposure of the bright background—while making your figure into a near silhouette. This is an extreme example, but it demonstrates how exposure readings are a compromise value between the darkest and lightest parts of your scene. The skill of a photographer lies in predicting when these extremes of light and dark occur by taking a range of different exposures as insurance against failure.

Auto mode explained

The all-purpose *Auto* mode is the one most people tend to use to the exclusion of all others. In *Auto* mode, the camera makes an exposure judgment based on the available light and translates this into a shutter speed that prevents camera shake—typically around 1/125th of a second—and a midrange aperture setting, such as f/8. The mode doesn't give identical results each time because the changing light levels on location will mean shutter speeds are slowed down when the light falls, or when the aperture value is set at its widest, such as f/4. When *Auto* mode is selected, most of the menu settings that you originally chose, such as white balance, will still influence the photographs.

The downside to using your camera's *Auto* mode is that your results will be dependent on the amount of available light, rather than a creative decision that you make. *Auto* mode is the best option if you prefer to create image files in a raw, unprocessed state to edit later, because other modes may apply corrections that would be impossible to remove. These raw files will need more work, but they will ultimately open the doors to more creative print and color editing while retaining maximum image quality.

A good *Auto Exposure* shot
Subjects with an overall even range of light, such as this landscape, can easily be shot on *Auto Exposure* metering mode because there are no extremes of light and dark.

Metering modes

There are three common metering systems used by digital cameras: Center weighted, matrix, and spot. These modes work by taking readings from different segments of your viewfinder and they can create very different results.

Center weighted

Center weighted metering works by making an exposure judgment based on subjects that are placed in the center of the viewfinder. This is perfectly adequate for centrally placed compositions, but it doesn't work if you intend to frame your subjects off-center.

Spot metering

The more complex spot metering system takes a reading from a small area, typically the tiny center circle superimposed in your viewfinder. Useful for getting accurate light readings from skin tones or other precise elements of a composition, a successful spot reading will emphasize this area over other less important parts of your image.

Matrix metering

The useful matrix or segment metering system is designed to cope with the greater demands of more adventurous photographers. It works by taking individual brightness readings from the four quarters of your frame, plus an extra one from the center. These five readings are then averaged out into a single exposure reading, resulting in a better compromise between light and dark.

Sky good, but land underexposed

A classic exposure dilemma occurs when you are faced with a subject that is broken in two halves: one very bright, and one very dark. This is often caused by the camera's inability to make a compromised exposure to capture the best from both halves. Instead, it automatically sets the exposure to get the best from one half at the expense of the other. Luckily, this problem can be fixed using a few simple software commands in Photoshop Elements.

This example image was shot at dusk, while looking straight into the sky. Camera metering systems can't capture extreme differences between light and dark like the human eye can, so disappointing results like this are common. The digital-camera meter has responded to the brightest area of the image, the sky, and all darker areas are thrown into deep shadow.

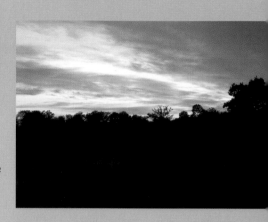

treatment

Use the *Selection Brush* and *Levels* to correct

You don't need to alter the *Levels* across the whole image below, because the exposure settings used for the sky are fine. In this case, you only need to alter the land part of the image, and this can be accomplished by carefully selecting and masking the sky to protect it from some upcoming *Levels* changes, and then correcting the land.

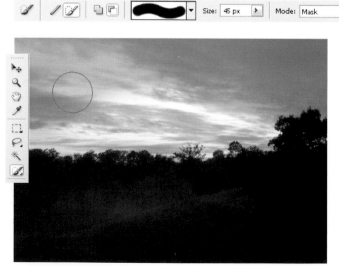

1 Choose the *Selection Brush* tool from the *Tools* palette, as shown at left, and then move to the *Tool Options* bar to set its properties. First choose the *Mask* option from the *Mode* drop-down menu. This mode allows you to paint a virtual cover, or mask, over the areas of the image that you want to protect.

2 Select a large, soft-edged brush from your *Brushes* palette—in this case, 45 pixels—because you want to paint a solid mask without streaks or gaps. Don't be concerned at this stage about the red color of the mask, because this is designed to be a guide and it won't become embedded in your file. Paint over the sky area, but avoid getting too close to the tree line.

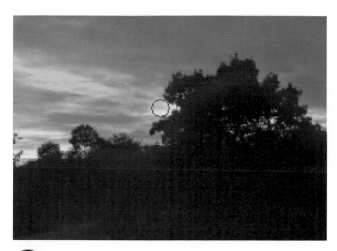

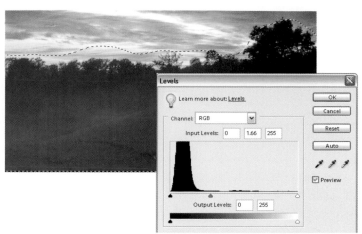

3 Once the solid shape of your mask has been placed, select a smaller-sized brush from your *Brushes* palette and carefully trace around the border between the masked and unmasked areas of your image. Take your time completing this stage, because this will determine the quality of your final result.

4 Run the *Enhance>Adjust Lighting>Levels* command to bring up the *Levels* dialog box, and drag the box to the side of your desktop so you can see the effects of your changes on the image. You'll immediately notice that the red mask disappears, leaving the dotted edge of the selected land area instead. All subsequent edits will now only affect the area within this dotted-edged shape, leaving your sky protected. Move the middle, *Midtones*, slider to the left and watch how the land area lightens up to reveal more detail.

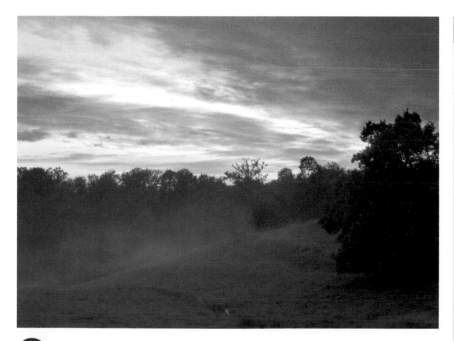

5 The trick to making this kind of project work is to avoid making the land too bright. Use *Levels* to reveal some visible detail, but not so much that the land is as bright as the sky, because this will ruin the original atmosphere of the scene.

HEALTHCHECK

If gaps appear in your mask

Painting a correctly shaped mask the first time can be difficult, so be prepared to go back and make a tighter fit. If halos are appearing at the edges of your mask, it means that you need to repaint it closer to the image border. Retrace your steps using the *Undo History* palette, then use a smaller brush to repaint the mask to remove the gaps before applying the *Levels* command again.

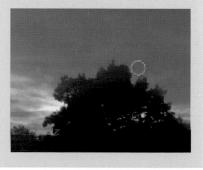

Land good, but sky overexposed

Overexposure occurs when too much light passes through your camera lens and creates paler than expected results. When more light than is required is absorbed by the camera's sensor, you will get little detail and weak colors in your image. The following technique shows you to how rescue an overexposed sky by making a complex selection with the *Magic Wand* tool.

Despite the presence of a rich blue sky in real life, the resulting exposure records the sky as pale blue. However, you can make the sky richer without changing the bright colors of the bottom half of the picture. Because there is a complex edge between the sky and fire engine, making a selection with a brush tool would be far too complex. For this assignment, use a tool that selects pixels by their similar colors rather than by area—the *Magic Wand*.

 treatment

Use the *Magic Wand* and *Levels* to correct

Photoshop Elements' *Magic Wand* tool is great for selecting large areas of similar color. It works by sampling the color underneath the cursor when you click, and then selecting other areas in the image that are close to that color. You can restrict this to select only those areas adjacent to where you click—*Contiguous*—or over the whole image.

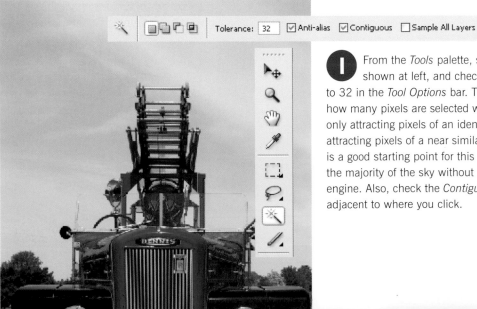

From the *Tools* palette, select the *Magic Wand* tool, as shown at left, and check that its *Tolerance* value is set to 32 in the *Tool Options* bar. The *Tolerance* control determines how many pixels are selected with one click, with lower values only attracting pixels of an identical color and higher values attracting pixels of a near similar color. The default value of 32 is a good starting point for this project because it will select the majority of the sky without picking up the colors of the fire engine. Also, check the *Contiguous* box to only select areas adjacent to where you click.

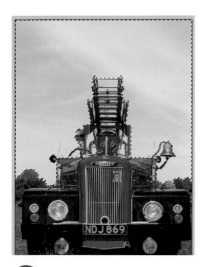

2 Like a magnet with a variable strength setting, the *Magic Wand* can be used to group together all the blue areas into a single selection for editing. Click in the sky and watch how areas of blue pixels are grouped into a selection shape. Shift+click to select any sky areas that aren't already in the selection. See the *Healthcheck* box below for additional information.

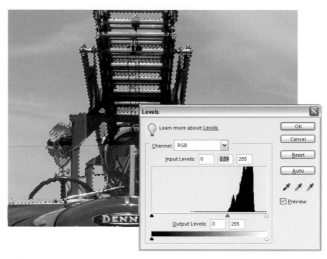

3 With your selection area completed, open your *Levels* dialog box (*Enhance>Adjust Lighting>Levels*) and drag this to one side of your desktop so you can see the effects of your edit. Move the *Midtones* slider to the right. Your sky is now richer and more visually interesting.

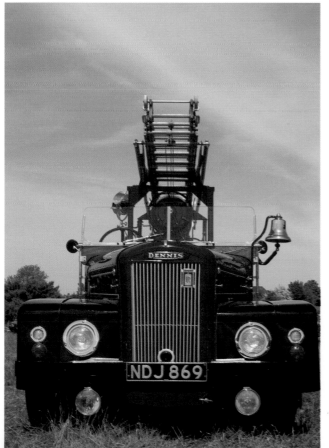

4 After the *Levels* edit, the resulting image looks much better, and has its correct visual balance restored. If there are any visible edges to your edit, use the *Undo History* palette to return to your final selection, then soften the edge by clicking the *Select>Feather* command and use a *Radius* of 2 pixels. Feathering softens the hard edges of selection boxes and blends your fixes in with the original image.

HEALTHCHECK ──√──

Including areas missing from your selection

If any enclosed patches of blue pixels are not included in your selection, then they can easily be added. With your selection in place, hold down the Shift key and a tiny "+" icon appears next to your *Magic Wand* cursor. Next, still holding the Shift key, click into the missing areas to add these areas to the larger selection. If you make a mistake and add something in error, simply retrace your steps in the *Undo History* palette.

How to avoid exposure problems

Perfect camera exposure is made by choosing the right combination of aperture value and shutter speed, and it makes all the difference in your image quality. Despite the many tools available within Photoshop Elements for rescuing your photos, there is no substitute for a good original exposure. A perfect exposure will result in an even balance of highlight and shadow detail and will produce a top-quality printout. Too much or too little light will have a profound effect on image detail, tone, and color reproduction. Consistent, perfect exposure can only be gained through experience. Get to know your camera and how it reacts to light. Experiment with different settings to get a feel for how they impact the final image, and don't be afraid to try settings that you would not normally use. After all, one of the great benefits of digital photography is that you can easily delete mistakes.

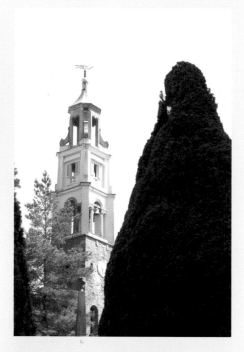

Overexposure and how to avoid it
Too much light creates pale and low-contrast images with burned-out detail that require difficult editing on your desktop computer. In this example, the camera was not able tell which element of the image was the most important, and so it tried to balance the bright background with the dark foreground. The result was a bad compromise with a burned-out background. In circumstances such as these, it's best to take a series of photos with a range of different exposures—a process called bracketing—and pick the best one later.

Overexposure caused by lens flare
In addition to controlling the aperture and shutter speeds on your camera, you must also be aware of your own shooting position in relation to the light. A common mistake is to shoot directly into the sun, which causes an excessive amount of light to flood through your camera lens. The result is called lens flare, and it is caused by too much light. Always shoot with your back to the sun where possible, and, if you can't, use a protective lens hood to minimize the difference in contrast and color saturation when shooting.

Underexposure and how to avoid it

Underexposure occurs when too little light hits the camera sensor and causes dark images with muddy colors. Underexposed images can be rescued with imaging software, but excessive changes will result in the sudden appearance of random colored pixels and a deterioration in image quality. Underexposure frequently occurs when shooting in low light on automatic exposure mode because the camera's shutter-speed range may not extend beyond a few seconds.

In the example above, the light meter was overinfluenced by a very bright patch of light, and it recorded the flowers too dark. This could have been prevented by excluding the light patch from the viewfinder, taking a light reading with the exposure lock function on your camera, and then recomposing the picture before finally depressing the shutter release.

A good exposure

A perfect example of light meter measurement shows fine detail simultaneously in the shadows and the highlights, rich colors, and a wide tonal range. Good natural lighting played a large part in the success of this shot.

HEALTHCHECK

Checking the exposure using the camera's histogram

High-end digital cameras offer the useful benefit of a *Levels* histogram when an image is previewed on the rear LCD monitor, so you can see exactly how an image has been recorded. If you find it hard to judge whether your image file is overexposed, you can check its histogram to make sure. If the shape of the graph leans too far to the left, your image is underexposed. A shape far to the right tells you it's overexposed.

 symptom

Burned-out highlights

Natural daylight is free to use, but it can be unpredictable and difficult to manage. Luckily, the *Selection Brush* tool is perfect for selecting and correcting large areas of washed-out highlights.

Shot in bright sunlight but with one half of the subject hidden under the canopy of a nearby tree, this exposure was doomed to failure from the start. However, it is possible to reduce the bright white burnout with the *Levels* dialog box in Photoshop Elements. Unlike techniques that are applied to the entire image, this task presents a complex challenge: to change one large area and leave the rest unaltered. Unlike dark, underexposed images, there is very rarely any hidden detail lurking within a burned-out highlight, but it can be made much less distracting.

 treatment

Use *Output Levels* to add balance

Although the *Output* sliders on the *Levels* dialog box aren't used as often as the *Input* sliders, they are extremely useful when faced with a job such as this.

Essentially, the *Output* sliders affect the contrast of the image, so first the areas to be edited need to be selected to protect the rest of the image from the contrast change.

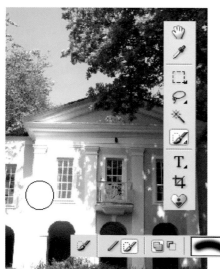

1 To begin, make a soft-edged selection of the offending highlight area. To do this, choose the *Selection Brush* tool from the *Tools* palette, as shown below, then set its size to 300 pixels. By using such a big brush, the large highlight area can be selected with little difficulty. Choose the *Selection* option from the *Mode* drop-down menu. This will create the familiar marching ants dotted selection edge around your brushwork.

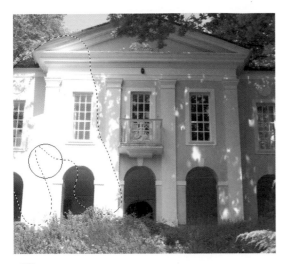

2 It may take some time to become accustomed to the *Selection Brush* tool because the selection shape increases as you push the brush over your image. Depending on the speed of your computer, there is often a slight delay between brushing and the dotted edge appearing, so work slowly and methodically to create a dotted-edge selection shape around the area you want to darken.

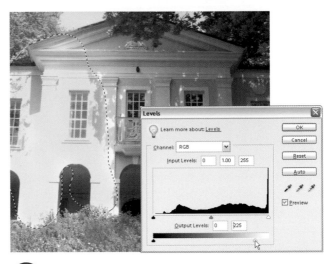

3 The next step is to use the *Levels* dialog box to change the bright whites into darker tones for more successful printing. Open the *Levels* dialog box (*Enhance>Adjust Lighting> Levels*), and with the selection edge still showing, drag the white *Output Levels* highlight slider to the left, as shown above.

4 After reducing the bright highlight in the selected area, the image now works much better as a whole, rather than appearing to be made of two separate halves. The large white patch to the left side is gone, but no additional detail was evident after editing. This file will now make a much better print without the blank white patches.

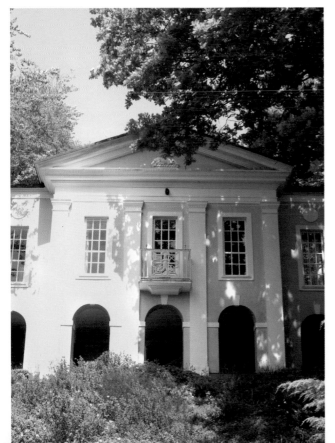

HEALTHCHECK

Using one-stop commands

In some cases, one-stop commands aren't sensitive enough to provide the cure you really need. In this instance, you could try the *Shadows/Highlights* feature (*Enhance> Adjust Lighting>Shadows/Highlights*), but when compared to the *Output Levels* technique used here, it does not provide the same quality end result. The final image looks muddy and flat, with none of the sparkle present in the original image.

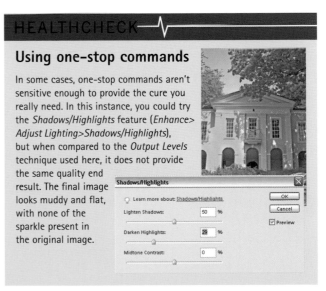

 symptom

Badly exposed dappled lighting

Every digital camera has a light-sensitive meter, which is used to regulate the auto exposure functions and, on more advanced cameras, the manual exposure readout. Light meters can only respond to the brightest values in your subject, regardless of their size, shape, or color, and consequently they can be fooled by everyday situations. Bad exposures occur when the photographer wrongly presumes that the light meter knows the most important element of the picture. However, it can't. Even a tiny lamp, which takes up a small proportion of your composition, will be the dominant influence on the meter.

In this example, the bright highlight patches fooled the camera meter, which responded by making everything else dark to accommodate detail in the brighter areas. In its original state, the image will make a very bad print.

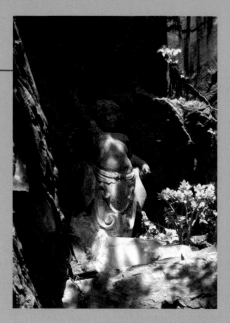

 treatment

Use *Shadows/Highlights* to correct

A light imbalance can be easily solved using Photoshop Elements' useful *Shadows/Highlights* controls. Because the exposure needs altering across the whole image—the dark areas need to be lightened, and the light areas need to be darkened—it can be treated as a whole without making any complex selections.

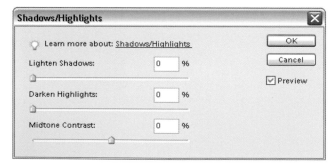

1 Start by choosing the *Shadows/Highlights* dialog box by going to *Enhance>Adjust Lighting>Shadows/Highlights*. By default, the dialog box will open with a +50 setting for the *Lighten Shadows* slider. Before starting, reset this back to zero.

2 Now move the *Lighten Shadows* slider to the right until your image starts to show more detail. Stop when the darkest parts of your image change from pure black to dark gray.

3 Move the *Darken Highlights* slider from zero until the dappled hot spots turn slightly gray. This will reduce the visual impact of the bright areas, and may even rescue some underlying details. Be careful not to use this command in excess, because the highlights will appear false.

HEALTHCHECK

Noise

The by-product of excessive image editing is the appearance of bright, speckled pixels in an image, called noise. Created when contrast and color changes are pushed to the extreme, noise effectively signals the limit of being able to rescue a bad exposure error. If the image is really important, try printing it out at a small size to reduce the impact of the noise.

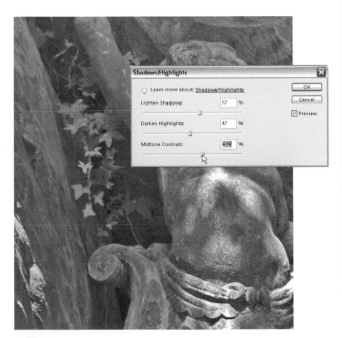

4 The final step is to correct the overall image contrast to balance out the previous two edits. While still in the *Shadows/Highlights* dialog box, increase the *Midtone Contrast* value by moving the slider to the right to a value between 10–20 percent.

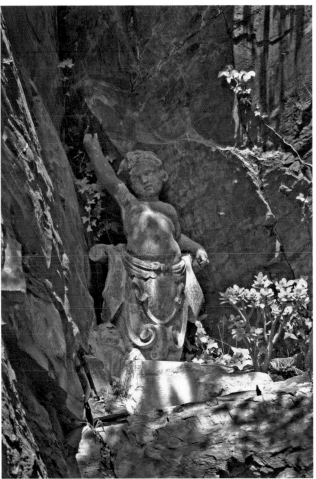

5 Compared to the starting point, the final result has less contrast and is easier on the eye. When printing such a high-contrast image, consider using a matte or watercolor-effect paper to minimize any gain in contrast.

How to compensate for poor exposure

Understanding how exposure works is essential for taking good photographs. There isn't one simple exposure setting. Instead, it's a balance between the lens aperture, the camera's shutter speed, and the ISO rating of the film—even though digital cameras don't use film, they still use a similar ISO rating.

When you are faced with a fantastic photographic subject, a simple trick to get a good exposure is to take more than one shot. Rather than manually changing the settings for numerous shots—which could take time, and you may miss the shot—try letting your camera do the hard work for you. This process is known as bracketing, and it means that the camera will take a number of shots—usually three, but the number depends on your camera model—with different exposure settings.

Understanding the link between aperture, shutter speed, and ISO

These three independent camera settings are intertwined, and when one is changed, the others need to be changed to compensate. In addition to the creative consequences of using these scales, their primary purpose is to allow the photographer to take pictures in a wide variety of lighting conditions.

The ISO scale sets the sensitivity of the image sensor and it works in an identical

Shooting a range of exposure settings

This image was taken with -1.0 exposure compensation. It is clearly underexposed.

At -0.6 exposure compensation, there is a good color range, but there is not enough detail in the dark areas.

The standard exposure for this image provides a good tonal range and detail in highlights and shadows.

way to ISO speed in conventional film. Higher ISO values are more sensitive to light, so at low light levels a higher ISO value such as 800 is recommended so that the sensor can operate with less light than normal. At bright light levels, use a smaller value such as 200. On very basic digital compact cameras, the ISO value may be fixed, but most models have a selection of values such as 100, 200, 400, and 800. Once the sensitivity has been set, you need to find the right combination of aperture and shutter speed to make a good exposure.

The lens aperture is essentially a hole of varying size designed to let more or less light reach the sensor. Aperture sizes are the same on all cameras, and they conform to an international scale described as f-stops, such as f/2.8, f/4, f/5.6, f/8, f/11, f/16, and f/22. The smaller the f-stop, the larger the aperture, and the more light will be let into the camera. Therefore, f/2.8 is the largest aperture and it lets in the greatest amount of available light. At the opposite end of the scale, f/22 is the smallest aperture and it lets in the least amount of light.

The shutter speed scale is also designed to a standard range, but it is measured in fractions of a second, such as 1/1000th, 1/500th, 1/250th, 1/125th, 1/60th, 1/30th, 1/15th, 1/8th, 1/4, 1/2, and 1 second. At the 1/1000th end of the scale, the shutter remains open for a very short time, but at 1/2 second, the shutter remains open for longer. With aperture and shutter-speed scales, a single step along the scale will either double or halve the amount of light that hits the sensor. With the ISO scale, the same steps will halve or double the sensitivity of the sensor. In practice and when using auto exposure functions, you will not need to be aware of this taking place, but when using a camera in manual mode, you will be acutely aware of their relationship.

The exposure compensation dial

Many digital cameras have an additional exposure control called the exposure compensation switch. Identified by the "+/-" symbol, this can be used to counteract lighting situations that would otherwise fool your light meter. It works by allowing more or less light to reach your sensor as follows: To increase exposure, use the + settings, such as +0.3. To decrease exposure, select the - settings, such as -0.6. Each whole number represents a difference of one aperture value, usually referred to as a stop.

Bracketing

A sensible way to approach difficult exposure situations is to shoot a number of exposure variations of the same subject. This is known as bracketing. Bracketing is really an insurance against failure and most situations are easily covered within a five-shot range where two versions are slightly under and two are slightly over. As a starting point try: +1.0 +0.6, normal, -0.6, -1.0, as shown at left. Many cameras will offer an automatic three-shot bracketing mode.

With an exposure compensation setting of +0.6, the colors are shifting too far toward white.

At +1.0 exposure compensation, the shot is completely overexposed and bleached out.

Flare and contrast problems

Many raw digital images need to have a proper contrast established before printing or flat and disappointing results will occur. When the familiar black mountain-shaped histogram in the *Levels* dialog box fails to spread out to both the highlight and shadow end points, a low-contrast result will occur.

This beach image is flat and dull because of low-contrast natural light when the image was shot. You can easily correct this type of low contrast by using the *Input Levels* sliders.

The shot of the clock tower presents the opposite situation because it was taken in natural high-contrast lighting. This image can easily be fixed by using the *Output Levels* sliders found at the base of the *Levels* dialog box.

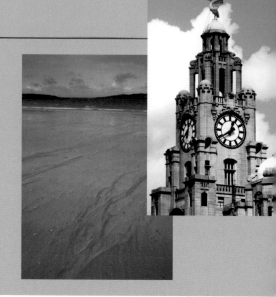

 treatment

Use *Auto Smart Fix* and *Levels* to correct

Areas of extreme high contrast can be problematic when printed, so it's a good idea to minimize all deep blacks and bright whites in order to produce an easier file to output.

For simple alterations, use Elements' *Auto Smart Fix* command, but this may need adjusting. Use the *Levels* command if you require more control.

Using the *Auto Smart Fix* command
The *Auto Smart Fix* command, found under the *Enhance* menu, can be used to fix low contrast or flared images with a single click. The command can be further modified by using the *Adjust Smart Fix* command, as shown at left, to pull the contrast and color into a more desirable balance. Unlike the more versatile *Levels* edits, *Adjust Smart Fix* may not fully respond to the unique nature of your image file.

Adjust Smart Fix		
Learn more about: Adjust Smart Fix		OK
		Cancel
Fix Amount: 197 %		Auto
		☑ Preview

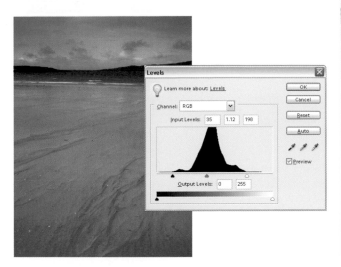

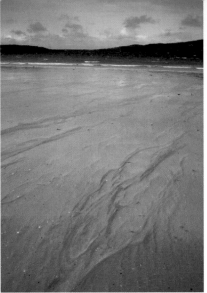

Fixing low-contrast images

Use the *Levels* dialog box to fix low-contrast images. You'll notice that the base of the central graph shape does not reach the end of the line at either the *Shadows* or *Highlights* side, indicating a lack of strong blacks or whites. To create the impression of sunlight that was absent when shooting, both of the *Shadows* and *Highlights* sliders can be moved in until they touch the edges of the graph shape to create a more attractive result. If the image looks too dark, move the central *Midtones* slider slightly to the left to brighten it.

Without any additional color editing or retouching, the corrected image looks punchier and more eye-catching. With an increase in contrast, colors start to look more vivid and subtle texture details, such as those found in the sand, are much more pronounced.

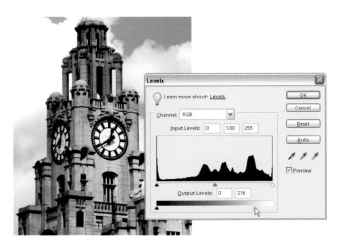

Fixing high-contrast images

Looking at the *Levels* dialog box, you can see huge vertical lines above both the *Highlight* and *Shadow* ends of the scale. This is a telltale sign of a high-contrast image. To correct this, drag both the *Highlights* and *Shadows Output Levels* sliders, found at the base of the dialog box, slightly toward the center of the gradient band. This will change black shadows to dark gray and white highlights to light gray.

Although it is not as vivid as the original version, the corrected image displays enough contrast to make a good-quality print.

Creative backlighting

Backlit subjects are some of the hardest to capture correctly. The exposure required for the light and the foreground subject will exert most cameras, and you may feel compelled to always bring these shots into Elements to correct. However, with a little creative intervention, you can draw out atmospheric results from your subjects by using inventive exposure control settings.

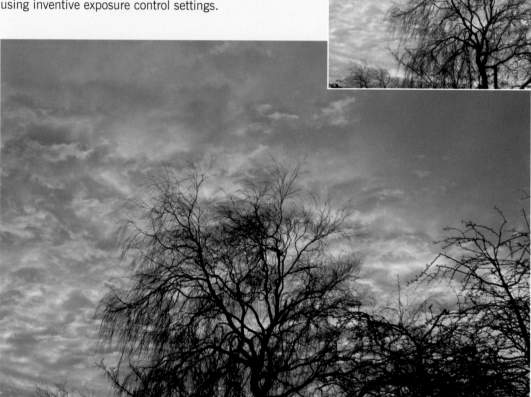

No exposure compensation

-1.0 exposure compensation

Creating a sunset silhouette

Taking a silhouette image is great technique for capturing the delicate perimeter shape of a subject, and it is easy to accomplish. The aim of this technique is to create a pure black solid foreground shape, surrounded by a richly colored background—a sunset is an ideal subject to try. Start by making an initial exposure with your automatic mode, and then examine the results on the rear camera LCD preview screen. Without creative intervention, the results will show details in your foreground shapes and a weak version of your original dramatic atmosphere. Next use your exposure compensation control and shoot another image at -0.6 adjustment, then another at -1.0. Both of these adjustments will allow much less light into your camera and effectively make the image darker. As a consequence, your foreground shape will now become a pure silhouette and any rich colors in the background will become even more vivid. Bypassing the camera's exposure controls allows you to make a sunset scene even more dramatic.

Preserving the atmosphere

In some shooting situations, the light levels are so varied and complex within the viewfinder that you are better off accepting a compromise. In this example, bright sunlight illuminates the side of the girl's face like a burst of flash, but the results are really effective. Never try to remove the traces of a natural light phenomenon by using the camera's flash because it will ruin the atmosphere and create a very different final result. Many cameras are fitted with an auto flash control, which fires off a burst of light when light levels are low. To capture this kind of image, you'll need to make sure your auto flash mode is turned off.

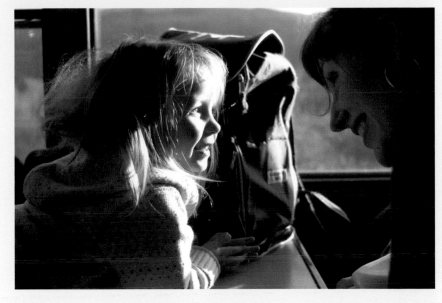

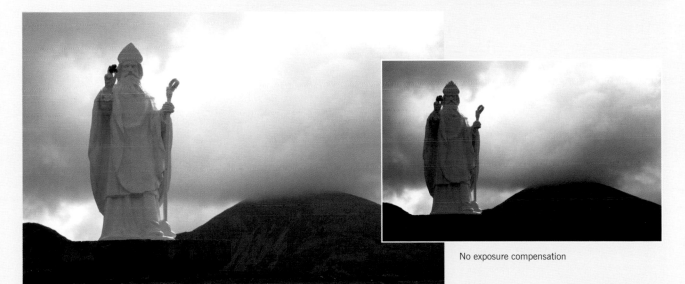

No exposure compensation

+1.0 exposure compensation

Keeping whites white

White subjects are, without a doubt, the hardest tones to record correctly, and they can provide quite a challenge. In this example, the dramatic weather conditions threatened to overshadow the white statue standing in the foreground when shot using auto exposure. The initial attempt shows the camera meter responding to the background clouds and turning the white statue into a murky gray tone.

To solve this problem, shoot another two versions of the same image and use your exposure compensation dial to allow more light to reach your sensor. Start by shooting at +0.6 adjustment, then shoot another at +1.0. When examined later on your computer, you'll be able to see the difference in tone between your three versions and choose the best one to print.

Intrusive backgrounds

If you've taken a great shot in the heat of the moment, chances are that there will be minor focus errors that can spoil the image. The most common of these is background elements in the same plane of focus as the foreground image, which causes an annoying distraction. Photoshop Elements' *Clone Stamp* tool can help you get the most out of these kinds of shots.

Inside this near-perfect shot of two children lies a tiny area that spoils the overall effect. Stuck between the two figures is a small amount of white lettering that is too sharply focused and too visually distracting. The goal is to remove the white letters and make the area much less noticeable, but without leaving any obvious signs of editing.

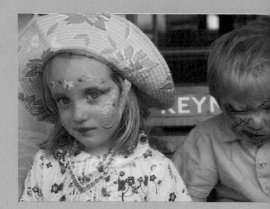

 treatment

Use the *Clone Stamp* tool to remove distractions

In all great photographs, a clear emphasis is the key to success, so it is essential to learn how to minimize distracting backgrounds. When composing portrait photographs, it's extremely important to be aware of the background, and to set the depth of field so that only the necessary parts of the image are in focus.

1 To start the project, select the *Clone Stamp* tool from the *Tools* palette. Be aware that there is another very similar tool within the same pop-out box—the *Pattern Stamp* tool—which is unsuitable for this kind of edit.

2 The advantage of using the *Clone Stamp* tool is that it is applied like a brush, so you can paint away your unwanted areas without selecting them first. The trick is to choose the right brush shape, size, and softness before starting. Click and pull down the *Brushes* menu until it fills the screen as shown at left. Next select a soft-edged brush with a *Width* of about 21 pixels.

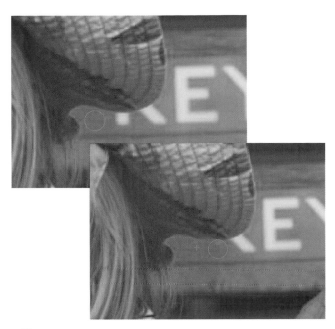

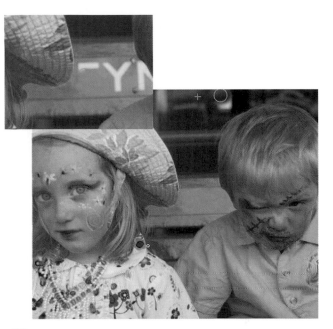

3 To use *Clone Stamp,* first select an area to use as the clone source, then paint over the offending area with this source material. Zoom into your editing area and define the source point by holding the Alt key and clicking the mouse. In this example, the white letters need to be painted over with the blue-gray background color of the sign, so find an area of the background without any of the lettering, and use that as the source point.

Next move your brush away from the source point, and place it over the area you want to remove. Click and drag the brush slowly and carefully over the lettering. Keep a close eye on the tiny cross that will appear each time you paint because this indicates the source point where the clone sample is being taken from.

4 After each brushstroke, take stock of your editing and don't be afraid to backtrack if it doesn't look good. Use the *Undo History* palette to reverse out of an edit and start again.

After working in one area, check for other minor defects in the shot. In this example, two small light patches at the top of the image were also removed to make sure the emphasis was placed on the central characters.

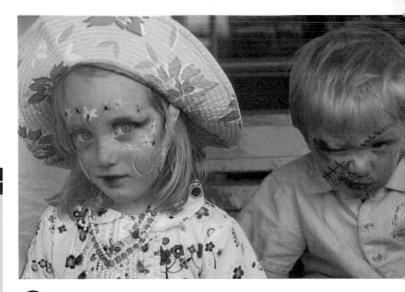

5 With all of the minor visual defects removed, the final result is a much stronger shot that is worth the editing effort.

Dull, gray-colored snow

All digital cameras contain a sensor that calculates the optimum amount of light required for an exposure. Unfortunately when shooting white subjects, the camera meter overcompensates and records the white tones as a dull gray. To make your snow landscape shots look as white as you remember them, you can either edit the images later, or fool the light meter by using the camera's exposure-compensation—sometimes referred to as EV—controls.

The EV setting allows the user to deliberately override the exposure set by the camera in fixed increments. By setting a positive value, images will be produced slightly brighter and by setting a negative value, slightly darker images are produced. If you have any doubts about the likelihood of an exposure working out, a useful process is to shoot several identical images, each with a different brightness variation. This process, called bracketing, is often used by professional photographers to be sure they have at least one perfect shot when faced with challenging circumstances. If you don't have manual EV controls on your camera, you may have an automatic bracketing feature. Check your camera's manual to see what's available.

 treatment

Correct color by using bracketing or *Levels*

To see exactly how variations in metering create a different final result with snow scenes, look at the three examples below. Bracketing is a great boon to photographers, and it should be used where time and memory-card space allows. If these are not available, you can fix the color cast using the *Levels* dialog box.

No correction
This shot was taken with the camera meter in a normal setting with no correction applied. The result is a very dark and dull shot that pushes the white areas into gray and spoils the overall effect.

+0.6 EV correction
This example was shot with +0.6 EV correction that allows extra light onto the sensor. The effect is brighter and shows much more detail in the midtones, but it still lacks an overall atmosphere.

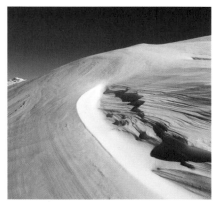

+1.3 EV correction
The final version was created with +1.3 EV correction, which records the brightest areas exactly as they appeared at the scene.

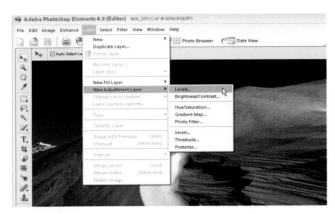

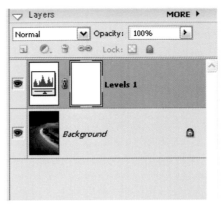

1 If you can't make exposure compensations while shooting you can easily rescue brightness by using an adjustment layer in Photoshop Elements. Adjustment layers are a special kind of layer that contain settings rather than actual pixels. These layers can be attached to an image layer in Elements to alter the appearance of that layer without actually changing its content. Adjustment layers can be changed or removed at any point in the future without affecting the image quality of the original.

There are many kinds of adjustment layer, and each relates to a specific type of adjustment. For example, you can make *Levels* adjustment layers, or *Brightness/Contrast* adjustment layers. To create a *Levels* adjustment layer, go to *Layer>New Adjustment Layer>Levels*.

2 The adjustment layer sits immediately at the top of your *Layers* palette. To edit an adjustment layer again at a later point, simply double click on its *Layer* icon. To remove it, simply drag the adjustment layer into the *Layers* palette *Wastebasket*.

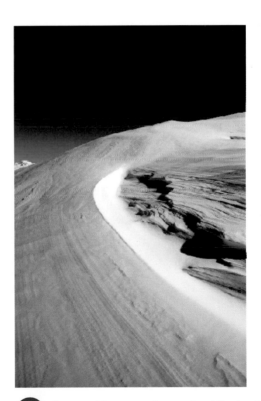

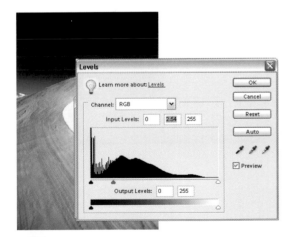

3 Start by moving the triangular white *Highlights* slider slightly to the left so that it sits at the base of the graph. Next move the central *Midtones* slider to the left, and watch your dull gray snow start to brighten up.

4 Compared to a correction made while shooting, this Elements rescue is not bad at all. Be aware, though, that you'll be able to do much less creative editing after this type of extreme rescue. The better the original exposure, the more editing you can do in Elements before the image quality starts to wane.

Water creates a bland image

Water scenes can produce memorable images, but water can also take on the color of the sky. This is fine when you have a bright blue sky, but it isn't good when you have a dull sky and a large expanse of dull water. When shooting, you can try and counteract this by taking photos at different times of day. When shooting in the early morning, natural light has a bluish color cast, which creates cold colored results. At noon, with overhead sunlight, a more neutral color will be produced. But at the end of the day and in early evening, daylight becomes redder or warmer.

This example shows good composition and subject, but it looks very uninspiring because of the overall flat, gray tone to the image.

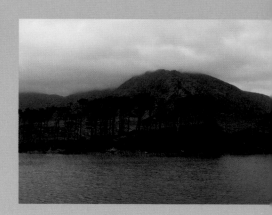

 treatment

Add rich colors and tones with *Hue/Saturation*

A good alternative to color correcting a weak shot is to apply an overall single color tone with Photoshop Elements' *Hue/Saturation* command. There is more to this correction than simply altering the color of the image. Be sure to make any necessary contrast corrections before applying the *Hue/Saturation* command.

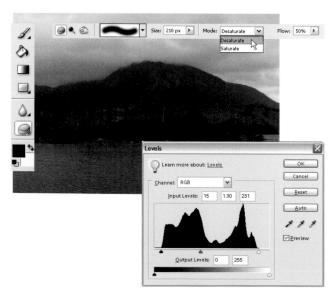

1 The *Sponge* tool can be used to make targeted adjustments to the color saturation in your image. By default, it is set to *Desaturate* mode, but this can be altered in the *Tool Options* bar. With many dull color images, a slight edit using the *Sponge* tool in *Saturate* mode can raise the intensity of some colors. With this example, however, the *Sponge* edits show only a minor improvement. It is a better decision to alter the tone of the entire image.

2 Start by applying a brightening command, *Levels* in this case, to the entire image before any new color is introduced. New tones will be more visible in the gray areas, so these need to be lightened first.

3 Next create a *Hue/Saturation* adjustment layer (*Layer> New Adjustment Layer>Hue/Saturation*) that lies above your background image. This will give you maximum flexibility to change colors and tones without committing to a final decision too soon.

Once established, the dialog box offers you full control over individual and global color changes. Be sure that you are editing with the *Channel* set to *Master*, as shown above, selected at the top of the dialog box.

4 Add a check mark to the *Colorize* button, found at the bottom-right corner of the *Hue/Saturation* dialog box and watch the image immediately change color. You can use two sliders to edit your image into a more desirable color: *Hue* and *Saturation*. The third slider, *Lightness*, alters the tone of the color selected using the other two sliders. For a natural-looking result, push the color toward blue.

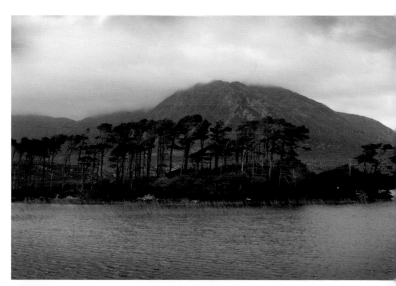

5 Alternatively, push the *Hue* and *Saturation* sliders toward brown to create a sepia effect. Aim for a subtle and gentle tone, because printers will often have trouble reproducing variations in highly saturated colors. When finished, click *OK*.

As a by-product of this kind of edit, you may see some areas becoming darker than desired. To correct this, use the *Dodge* tool, set between 30–40 percent *Exposure* to make amends.

6 Compared to the starting point, this example edit is much more eye-catching, and all traces of poor shooting conditions have been masked by creative editing.

Doctor, I'm all over the place!

In this chapter, we'll show you how to cure the most common ailments. We've all ended up with blurry group shots, or images that seemed perfect as you peered through the viewfinder, but once you got home it looked as if a tree were growing out of the subject's head.

Poor composition

The art of photography involves subtlety, emphasis, and dynamic composition, and the best prints should stop you in your tracks and make you study them closely. Composition is without a doubt the hardest photographic skill to pick up, but it will improve with experience. If poor composition is letting your photographs down, you can alter them to some extent in Photoshop Elements by using the *Crop* tool. With adventurous crops, large sections of original pixels are discarded, resulting in the potential for smaller, but more interesting prints.

The example image shown here displays a common problem caused by shooting a photograph from an awkward viewpoint. Vertical lines within the image are all converging to a peak beyond the top of the image frame, drawing the eye out of the photograph.

 treatment

Use simple software crops

Many composition problems can be fixed by creatively cropping the image to straighten verticals and make it more pleasing to the eye. It isn't possible to remove all of the converging verticals in this image without cropping out the majority of the shot, but the image is significantly improved by straightening the central line.

I From the *Tools* palette, choose the *Crop* tool and make sure that its preset options in the *Tool Options* bar are set to zero. Click the tool into any corner of the image and drag across to the other corner to create a new rectangular shape. Next keep your finger on the Shift key and drag any corner toward the center to create a smaller shape, but one that has the same proportion as the original.

2 Let go of the corner handle and click into the center of the rectangle. Move it around your image. The area masked in dark gray will be lost after the crop.

3 Once you have excluded all unwanted areas, you can modify the crop by rotating the rectangular shape. Bring the cursor near a corner point until it turns into a crooked arrow, and then click and drag either clockwise or counterclockwise to create a straight edge that corrects one of the leaning verticals.

4 Although the crop has straightened only one vertical line, the edit creates a much more appealing end result. Distracting components have been removed by reestablishing a brand new edge across the top and bottom of the frame.

HEALTHCHECK

Cropping reduces your potential print size

Digital recomposition inevitably means the loss of some areas of original pixels, therefore reducing the potential to print at a larger size. The more you crop off, the smaller your final print will become.

symptom

Dull background

This image is not a bad photo per se, it's just a bit clichéd. The "beautiful blue sky over white mountain snow" shot has been overdone, so you may want to replace the dull blue sky with a more exciting one.

Unlike word processing, where words are simply highlighted before they are changed, pixel images are more challenging. Editing is based entirely on selected image areas that you define by one of a number of methods. If a selection is not made, the manipulation won't work. Selections are like fenced-off areas of your image and they restrict any subsequent editing to those areas, protecting the rest of the image from unwanted change. Most image-editing packages offer a range of tools for defining selection areas by shape, and the better applications also offer the ability to select similarly colored pixels.

treatment

Replace with careful cutting and layering

You were introduced to the *Magic Wand* tool on page 30, and saw how it makes selections based on color. It is also useful in this project. Always spend time making the best

selections you possibly can—an accurate selection may be time consuming, but it will pay off later; sloppy or badly selected areas will make your work look less believable.

1 Open the two source images in Photoshop Elements, so their thumbnails appear at the base of the desktop as shown above. During the edit, the simplest way to switch between images is to click on the tiny thumbnails.

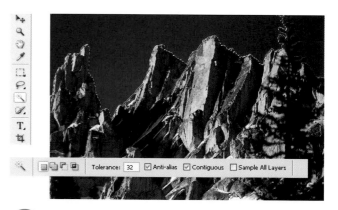

2 Select the *Magic Wand* tool, setting its *Tolerance* to 32 in the *Tool Options* bar, and selecting the *Contiguous* option. Click anywhere in the blue sky and watch a ragged selection shape appear.

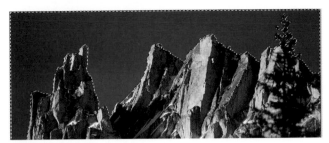

3 After the first attempt, several blue pixels will remain outside the selection. These can be added to the main shape by pressing the Shift key and clicking again with the *Magic Wand* in the unselected areas. Afterward, the selection shape should include all of the blue sky pixels and be ready to accept the new sky. If you have selected too much, retrace your steps in the *History* palette.

4 Click on the second source image to bring it up on the desktop and use the *Select>All* command to select the entire image.

5 Next use *Edit>Copy* to copy the whole selection to the clipboard, so it is ready for pasting into the other image.

6 Click back into the first source image and with the selection still active, go to *Edit>Paste Into Selection*.

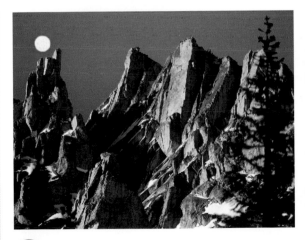

7 After the *Paste Into Selection* command, you will see that the new sky has only appeared within the selected area. If necessary, the pasted item can be dragged into a better position by using the *Move* tool.

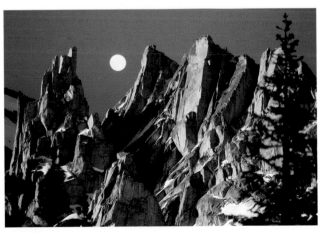

8 The end result shows a convincing combination of the two images in one new composition.

Intrusive background

You will often find that the subjects of your photographs don't stand out well enough from the background. With more preparation time this photo could have been captured with a wider lens-aperture setting to blur out the background. However, the shot was taken quickly and now needs careful editing to reduce the intrusive background and make the most of a good central subject.

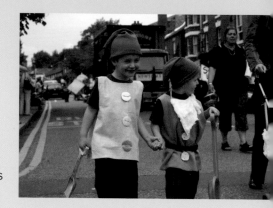

You can remove unwanted figures in a photograph using a straightforward Photoshop Elements edit that swaps sharpness for blurring. The simplest tool for applying selective blurring is the *Blur* tool. It works in a similar way to the standard brush tools, and it is best used to make minor background corrections when unexpected details take the emphasis away from your main subject.

 treatment

Use blurring to reduce the emphasis

The *Blur* tool merges surrounding pixels into softer and less contrasty patches, which can look obvious when applied to larger and more prominent areas. Blurring out is easier than retouching with the *Rubber Stamp* tool, it retains original pixel colors and hides any mistakes made by the photographer.

1 Start off by double-clicking the *background layer* icon in your *Layers* palette to rename it. This allows you to move the background layer into a new editing position later on.

2 Next you need to make an identical copy of this newly renamed layer by using the *Layer>Duplicate Layer* command. You'll now have a two-layered image.

3 Photoshop automatically names layers in a numerical sequence, but the names are not always easy to recognize. Click on the *Duplicate layer* icon and rename it *Blurred layer.*

4 Click and hold the *Blurred layer* icon and drag this below the *Layer 0* layer to alter the stacking order. Because both layers are identical, there will be no change to the appearance of the displayed image.

5 Next hide the uppermost layer by clicking the *Eye* icon next to the layer in the *Layers* palette. Make sure that the bottom *Blurred layer* is now active, as shown in the *Layers* palette above. This photo is now ready for work.

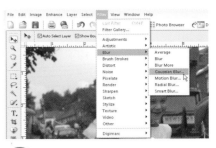

6 Choose *Filter>Blur>Gaussian Blur* from the menu.

7 Move the filter's dialog box to one side, so you can see the effect you are creating. Next move the *Radius* slider to between 10 and 20 pixels until your image starts to blur as shown above. Avoid going too far, or the result will be unrealistic. Click OK.

8 Click the uppermost layer's *Eye* icon in the *Layers* palette to turn the layer on. Also click on the layer itself to make it active. Next choose the *Eraser* tool, and set it to *Brush* mode and 100 percent opacity. Choose a large brush to work on the larger areas first.

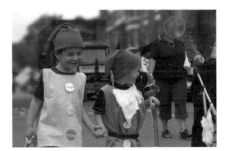

9 With the large brush selected, erase the background of the uppermost layer to reveal the underlying blurred layer through the holes you have created. Avoid going too close to delicate edges at this stage.

10 Choose a much smaller brush, and then zoom in to see the edges of the main subjects close up. Continue to apply the *Eraser* tool carefully around the edges, retracing your steps in the *History* palette if you make any mistakes.

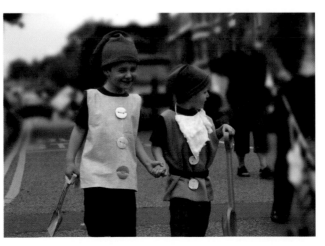

11 After all the cuts have been made, the central subject shows up more clearly against the carefully blurred background.

Unwanted detail

In many cases, unwanted details can't be simply blurred out as they were in the previous example. The first step in these situations is to try and crop out the offending areas, but if those areas lie over the main subject of the photograph, they will require an alternate fix.

In this photograph, the bars at the end of the bed are ruining the image. Cropping the bars away would remove too much of the image, altering its balance and composition. For complex rescue projects such as this one, there's no simple quick-fix solution. The repair will require some work, but it will be well worth it.

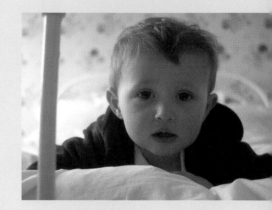

 treatment

Replicate backgrounds with the *Clone Stamp*

The answer is to remove the bars that frame the child and replace them with a replica of the background wallpaper that would be seen if the bars weren't there. This is a tough job because of the varying brightness of the background. There is no quick method—the only option is to copy part of the background and paste it over the unwanted bars.

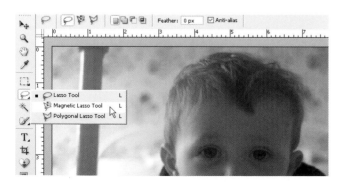

1 Start by selecting the *Magnetic Lasso* tool from the *Tools* palette, and make sure that its properties in the *Tool Options* bar are set to zero. The *Magnetic Lasso* works as a cross between the *Magic Wand* and the *Lasso*, and it "locks" itself against edges of sufficient contrast.

2 Click and drag the *Magnetic Lasso* into the chosen area and watch how it grips against the sides of your shape. Draw around the entire shape, and then close the selection by joining the last point up with the first point.

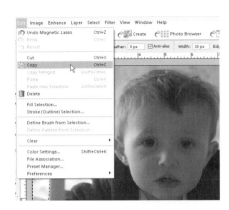

3 Next create an identical copy of this shape to reuse by using the *Edit>Copy* command.

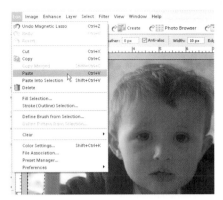

4 *Edit>Paste* the selected area onto the image. It will be placed down exactly over its original place, but on a new layer.

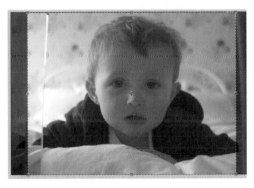

5 Select the *Crop* tool and drag it around only the areas that you want to keep. The shaded areas will disappear once you have committed to the edit.

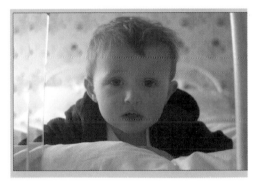

6 Choose the *Move* tool, and drag this new item into place over the unwanted bar on the left-hand side. Try and obscure as much of it as possible.

7 To iron out any visible join between the pasted section and the original, zoom in close, check that you are working on the uppermost layer, and then choose the *Eraser* tool. Set its brush size to about 80 pixels, and then gently rub away the edges until you have made a better blend. You may have to use the *Clone Stamp* tool to fill some areas, such as the child's sleeve.

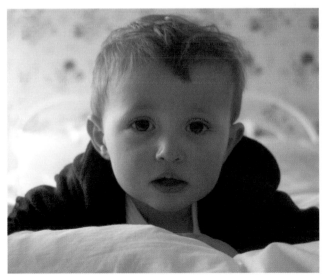

8 At the end of the process, the image is a much tighter composition with little evidence of unwanted areas.

Missing detail

With the ability to view your intended shot on a digital camera's screen, composition errors occur less frequently than with traditional film cameras. There is, however, the odd occasion where you find that an important part of the image has been cropped out. This could be because it was a rushed shot to capture a moving subject, or because the camera was placed on a surface that wasn't quite as steady as you thought. Many compact cameras still have a traditional viewfinder, and because of its position in relation to the lens, the resulting photo may turn out a little different than what you imagined.

This image was incorrectly framed when shot, and as a result, part of the boy's head and left hand are missing. Normally this would be a ruined photo, but with Photoshop Elements we can fill in the missing areas.

 treatment

Rebuild composition errors with the *Clone Stamp*

By using the selections, layers, and cloning techniques available in Photoshop Elements, problem areas of your pictures can easily be replaced or repaired. In this image, the missing areas of the boy can be cloned, and new background sea and sand can be created to fill the resulting white space and complete the picture.

1 Increase the workspace. Select *Image>Resize>Canvas Size*. Check the *Relative* box. This will increase the size by the value stated, rather than specifying exact pixel dimensions. Enter 200 pixels for both the *Width* and *Height*. Click the bottom right arrow in the *Anchor* grid. When the canvas is increased, the extra space is created in the top left of the image. Click OK to perform the change.

2 Choose the *Selection Brush*. Choose a small brush. Set the *Hardness* to 98 percent. This will feather the edges slightly to avoid a harsh line. Draw a selection to create an area where the top of the head should be. Overlap the existing hair a little for blending purposes. Press Ctrl/Cmd+D to deselect.

3 Select the *Clone Stamp*, and choose a small, hard brush. Position the cursor near the bottom of the existing hair. Hold Alt/Option and click once to set the sampling area.

Now move the cursor to where the empty selection overlaps and paint in the hair texture. Follow the natural direction, resampling occasionally to give a realistic effect. The left side is colored by the sun. This area has been painted by using shorter strokes, sampling the same area repeatedly.

4 Select the *Rectangular Marquee*. Position the cursor as close to the boy as possible without overlapping. Click and drag to select an area of the sea. Make it slightly taller than the gap at the top of the image.

Hold Ctrl/Cmd+Alt/Option. Drag the selection up to fill the white space and drop it in. A copy of the area is created. Go to *Image>Rotate>Flip Selection Horizontal*. This prevents the area from looking like an obvious copy. Deselect with Ctrl/Cmd+D.

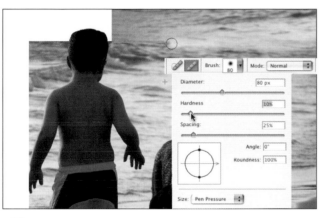

5 Take the *Healing Brush* tool and select a medium brush. Set the *Hardness* to around 10 percent. Choose a clear area of the sea near to the right edge. Hold the Alt/Option key, and click to set the sample area. Reposition the cursor across the hard edge of the patched area and paint a line all the way across. This smooths and blends the area. Repeat the process to build up the remaining areas of space—use smaller sections for awkward areas.

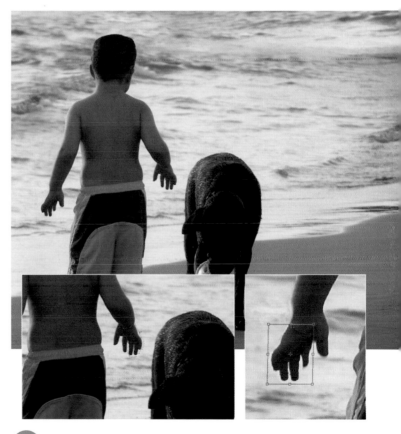

6 Finally, repair the left hand. Make a loose selection on the right hand with the *Lasso* tool. Press Ctrl/Cmd+J to create a layer from the selection. Go to *Image>Rotate>Flip Layer Horizontal*. Hold Ctrl/Cmd, and click and drag the new layer into position. Press Ctrl/Cmd+T to enter *Free Transform* mode. Hold Ctrl/Cmd, and drag the top-middle handle and skew the layer to the right a little. When the two match, press Enter to set the transformation. Use a soft *Eraser* to remove any excess material from the layer.

 symptom

Overcast sky

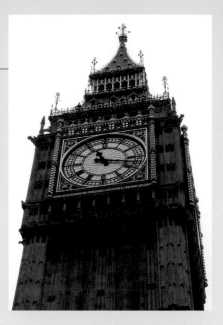

Although the weather can be predicted with a fair degree of accuracy, it has a nasty habit of changing when you least want it to. The last thing you want is a dreary sky ruining an otherwise beautiful picture, especially if it shows a once-in-a-lifetime event such as a wedding or a graduation ceremony.

With a few simple steps, though, an unwanted sky can be removed and replaced with a bright and vibrant one. It's surprisingly quick and easy to do.

 treatment

Delete a dull sky with the *Magic Eraser*

Rather than select the old sky and replace it with a new one, this example makes use of a different tool to delete the old sky first. While the *Magic Wand* selects areas similar to where you click, the *Magic Eraser* deletes them. Because it's a destructive tool, it's important to start by making a copy of the background layer.

1 Duplicate the background by going to *Layer>Duplicate Layer*. Give the layer a new name for quick reference. You can hide the background layer by clicking the *Eye* icon next to its thumbnail in the *Layers* palette.

2 Select the *Magic Eraser* tool from the *Tools* palette. It's one of the options in the *Eraser* tool's menu. The *Magic Eraser* works in a similar way to the *Magic Wand*, but rather than making a selection based on the area you click, it removes it. The default *Tolerance* setting is fine for this example, but uncheck *Contiguous* mode.

HEALTHCHECK

How the pixels can disappear...like magic

The *Magic Eraser* works in a similar way to the *Magic Wand*. The *Tolerance* setting defines the tonal range to be removed. With *Contiguous* mode set, only pixels that fall within the *Tolerance* value around the cursor are removed. When unchecked, all pixels in that range, anywhere in the image, are deleted simultaneously.

66 **Doctor, I'm all over the place!**

3 In this image, the strong contrast between the sky and the clock tower means that the sky can be removed with only a single mouse click, but more complex images may take a little more time. Because we have hidden the background layer, the erased parts show through as a checkerboard.

4 Open the image containing your new sky. Select the entire picture with *Select>All*, and then copy it to the clipboard using *Edit>Copy*.

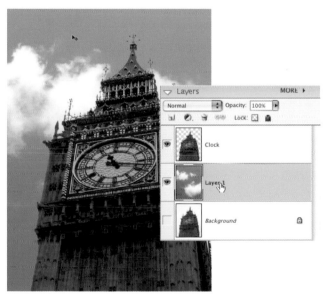

5 Switch back to the original image and select the background layer by clicking its thumbnail. Next paste in the new sky using *Edit>Paste*. The new sky will appear on its own layer. Because the new sky is larger than the original document, it can be positioned using the *Move* tool.

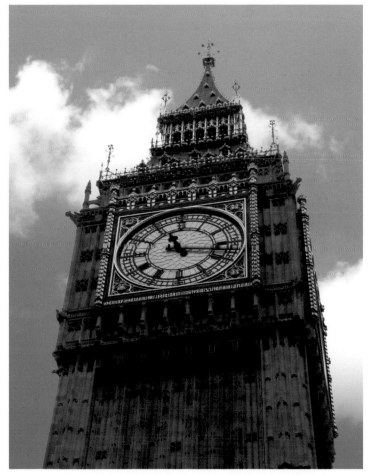

6 The final image is a great improvement over the original, and it's almost impossible to tell that the photo has been manipulated at all. Looking back on your vacation photos in a few years' time, you may even forget that you ever had bad weather!

Poorly arranged group shot

Group shots of people are often difficult to compose. If you get the chance, it's usually better to try and organize the group on location, but sometimes that's just not possible. In this example, a small group of kids have decided how they want to stand. The resulting composition is a little erratic, and the simplest solution is to rearrange them using Elements.

The simplest method to recompose this group is to bring them tighter together. The gap above the crouching boy can be closed up by moving both him and the boy in the striped T-shirt to the left to join the other two children. The area behind them can then be repaired with the *Clone Stamp* and *Healing Brush* tools. We'll also look at creating new shadows for the children that have been moved, to tie them more realistically into the picture.

 treatment

Rearrange people using cutting and layers

Using the *Lasso* and *Selection Brushes*, two of the children will be removed from the background and placed on individual layers. These layers will then be repositioned with the *Move* tool, and blended with the main image. Replacement shadows will be added on another layer using a paintbrush, and the photo reframed using the *Crop* tool.

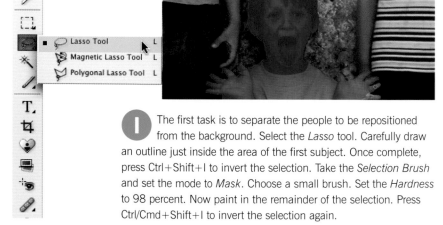

1 The first task is to separate the people to be repositioned from the background. Select the *Lasso* tool. Carefully draw an outline just inside the area of the first subject. Once complete, press Ctrl+Shift+I to invert the selection. Take the *Selection Brush* and set the mode to *Mask*. Choose a small brush. Set the *Hardness* to 98 percent. Now paint in the remainder of the selection. Press Ctrl/Cmd+Shift+I to invert the selection again.

2 Press Ctrl/Cmd+J to create a new layer from the selection. Double click the label in the *Layers* palette and rename it. Click the layer's *Eye* icon to hide it, then click the background layer's thumbnail to make it active. Next you need to replace the background.

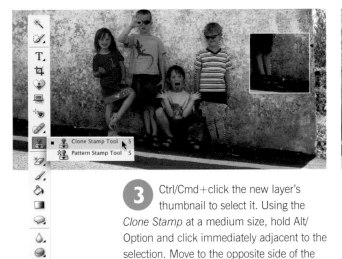

3 Ctrl/Cmd+click the new layer's thumbnail to select it. Using the *Clone Stamp* at a medium size, hold Alt/ Option and click immediately adjacent to the selection. Move to the opposite side of the selection and start to clone out the content.

4 Press Ctrl/Cmd+D to deselect. Take the *Healing Brush* and place the cursor on the background, close to the area to be repaired. Hold Alt/Option and click to mark the sampling area. Paint over the hard edges where the *Clone Stamp* was used.

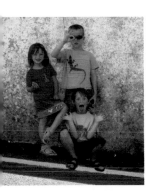

5 Make the layers visible again by clicking their *Eye* icons. Select the *Move* tool and reposition the first person by clicking and dragging. Try to hide any areas of missing detail where the layers have been cut out such as the second boy's leg. Repeat with the other figures. There may still be small areas that cannot be hidden. Use the *Clone Stamp* and *Healing Brush* to repair these patches.

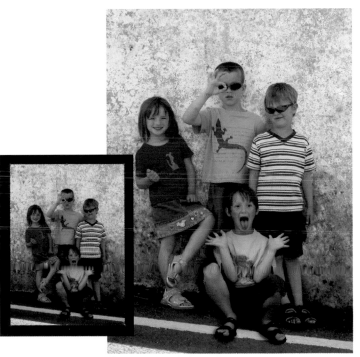

New Layer		
Name: Shadow		OK
☐ Group With Previous Layer		Cancel
Mode: Normal	Opacity: 100 ▸ %	
☐ (No neutral color exists for Normal mode.)		

6 The repositioned people look too flat and obvious. Select the background layer and go to *Layer>New>Layer*. Name it "Shadow." Select the *Brush* tool and choose a medium, soft brush. Set the *Opacity* to around 50 percent. Select *Black* as the foreground color. Lightly brush in some shadows, using the original image as a guide to the direction in which they should fall. Stay behind the figure and use the very edge of the brush to create a soft effect.

7 Select the *Crop* tool and click and drag the boundary to create a suitable frame around the image, then press Enter to apply. Finally, go to *Layer>Flatten image*. This merges the layers, and you can now save the final image.

Composition lacks symmetry

Composition is another term for a photographer's skill in organizing a subject into a balanced and attractive position in the camera viewfinder. This example lacks symmetry—your eye is drawn at an odd angle through the image.

For immovable subjects, such as a landscape, composition is dictated by your own shooting position and your choice of camera settings. For more pliable nearby subjects, such as people, composition can also be determined by your organization skills. The easiest kind of balanced composition to make is a symmetrical one. Start by framing the main elements of your composition in the center of the viewfinder until a balance is achieved along the vertical or horizontal axis. Architectural and landscape subjects work well with this approach.

 treatment

Shoot and plan for better symmetry

You can make significant changes to your composition by using Photoshop's transform tools. This set of tools works by rearranging whole areas of your image to comply with straight edges, or to correct perspective. When you have a shot that almost works, but not quite, you can tweak the perspective into perfect symmetry.

1 Start by arranging your image in the main window so you can clearly see its edges, as shown above. If necessary, double-click on the background layer in the *Layers* palette to convert it to a normal layer, then choose *Image>Transform>Free Transform*.

2 When the *Free Transform* command has been applied, a thin box line with tiny handles at each corner will surround your image. Place your cursor near any of these handles and click and drag in a circular motion to rotate the image clockwise or counterclockwise to suit your needs.

3 With the *Free Transform* still active, hold down the Shift+Alt/Option keys, and then move any of the corner handles inward to create a crop. The image will be scaled without distorting the shape, with the center acting as the pivot point.

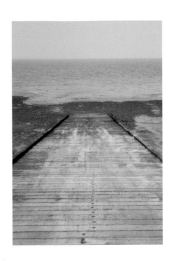

4 After this simple transformation, the final image has improved in shape and balance.

Use *Distort* to correct symmetry

Sometimes it's just not possible to get in the right shooting position because of obstructions or problems with access. With this example, the photographer was forced to stand to the left of the archway, when a more central position would have created a balanced result. The way to correct this is to use the more sophisticated transform commands.

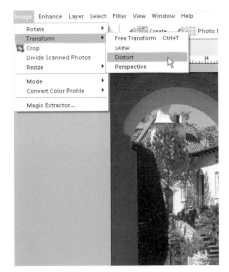

I To apply the transform to the entire image, use the *Select>All* command first. From the *Image>Transform* menu, choose the *Distort* option. This tool gives you the chance to push and pull perspective in any direction you choose.

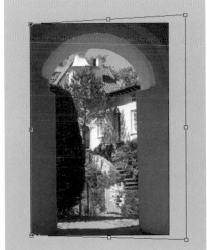

2 Pull both of the right-hand Transform handles outside the image, into the gray surrounding area, as shown above. This will allow you to correct any skewed lines and match them up with the other half of the image.

3 The angles and lines have been corrected easily without creating any visible damage to the image, and it's now much more symmetrical compared to the original.

 symptom

Lack of interest

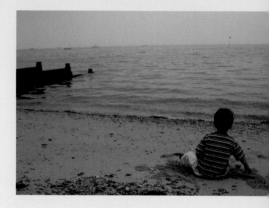

Even though a photo maybe technically correct, the composition can still let it down. This example is a little stretched across the horizontal and does not have enough space at either side of the main subject. Apart from the purely symmetrical formula seen on page 68, the other popular guideline you can use to make compositions is the rule of thirds.

 The rule of thirds suggests that an image should be divided up into a grid of nine equal, invisible sections and that as long as the main elements of the photo are placed on the lines of the grid, or at their intersections, a pleasing composition will result. Although you may not have achieved perfect composition on location, you can easily make most images fit into the rule of thirds with a few Photoshop Elements tweaks.

 treatment

Correct according to the rule of thirds

You can overlay gridlines on your image and move and crop the photo to achieve the most dynamic composition. Photoshop Elements doesn't have a built-in tool to help you visualize the rule of thirds grid, but it's a simple task to make one yourself on a separate layer using the *Line* tool constrained to draw 90 degree lines.

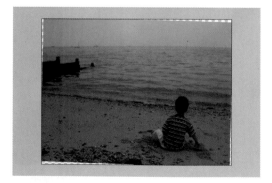

1 First correct the horizon line so it's parallel with the top of your photographic image. This example was dropping slightly to the left, so it was rotated clockwise to compensate. Use the *Edit>Transform>Free Transform* menu to do this.

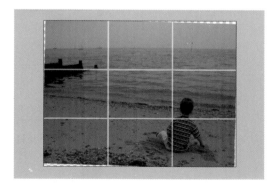

2 Create a new layer and then use the *Line* tool to draw a simple grid over your image. Create nine boxes as shown above. If you hold down the Shift key when drawing, you will always be guaranteed a 90 degree line. This grid will help you achieve better composition.

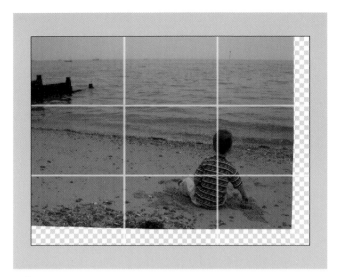

3 Click back onto your background layer, and then select the *Move* tool from the *Tools* palette. Next click and drag your image into a new position within the grid to conform to the rule of thirds. In this example, the image needed moving up and to the right.

4 While still working on the background layer, paint in any missing parts of the image that have been created when recomposing. Use the *Clone Stamp* tool to make a seamless join between new and old areas. Zoom in closely to ensure that you are doing a careful job. If you can see any areas of your image repeating, pick a new source point for the *Clone Stamp* and paint over them again.

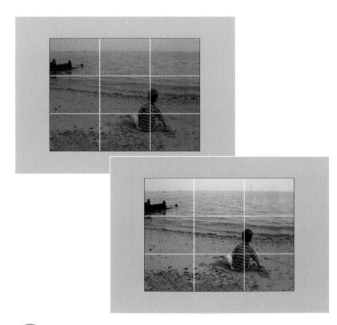

5 After editing, turn off the grid layer by clicking on its *Eye* icon in the *Layers* palette. Your image will now be better composed and ready for any additional editing, such as a minor *Levels* correction (see pages 26–27) to rescue image contrast.

6 With careful editing, the new parts of the image do not look awkward, and the overall composition looks much better.

Lack of emphasis

Some images are the opposite of the previous example: The composition of the physical details in the photo are fine, but the lighting is all wrong, throwing the composition out of balance. In this image, the photo is bland overall and lit by unspectacular light. The editing task is to apply dark and light to the image to break up the overall monotonous appearance. If done well, the image can take on a completely new life.

Dodging (making parts of the image lighter) and burning (making parts darker) can help to make a photo look more three-dimensional. In addition offending areas can be made less noticeable by burning, therefore placing more of the viewer's attention on the main subject. For minor problems caused by shadows or camera exposure, dodging can brighten things up.

 treatment

Fix image balance with *Levels* and *Dodge* and *Burn*

Rather than use separate tools to "paint" onto the image, it's often better—if you're working on a large area—to select the part that needs changing, and then use the

Levels controls to lighten or darken the image as necessary. To mimic the look of a hand-printed photograph, apply this technique gradually over several steps.

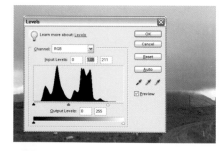

1 Start by using the *Levels* dialog box to lighten the entire image. It's much easier to selectively darken a light image than vice versa, and this first step builds in the extra prospect of contrast. Move the *Highlight* and *Midtone* sliders to the left to brighten the whole image.

2 Next drag out the corners of your workspace to provide a blank gray border around the edges of your image. Use the *Navigator* palette to zoom in and out until your image occupies a similar space to that shown above.

3 Choose the *Lasso* tool and drag this around the sky without getting too close to the land area. Be sure that the selection extends right up to the edges of the image.

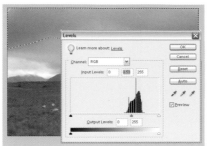
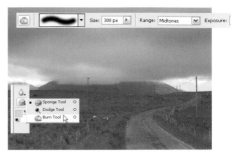

4 With the selection still in place, apply a *Select>Feather* command. Enter a *Feather Radius* value of 100 pixels to create a soft and invisible selection edge. This will make your forthcoming tonal edit blend in better.

5 Open the Levels dialog box (Ctrl/Cmd+L) and drag the *Midtone* slider to the right to darken it. You'll notice the sky becoming more oppressive and interesting in your image. Repeat this process two more times, making smaller selections that retreat to the top of the image each time. This will create a graduated but natural-looking scene.

6 To make more improvements, select the *Burn* tool from the *Tools* palette. Set the tool at 30 percent *Exposure* and use a large brush.

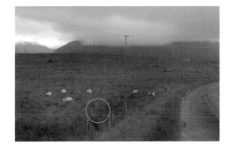

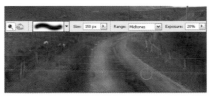

7 Drag the *Burn* tool across the naturally occurring lines in your composition to create emphasis effects. Apply the tool in several short strokes to build up depth gradually.

8 Swap to the *Dodge* tool and choose a 20 percent *Exposure* setting. Now selectively brighten areas in your image following the contours of natural lines and shapes.

HEALTHCHECK

Emphasis essentials

For all images, darkening the edges helps to draw attention to the photograph's central characters. Empty blank spaces can easily be burned in to prevent the viewer's attention from wandering. This is best achieved by repeatedly diminishing selections in the same area.

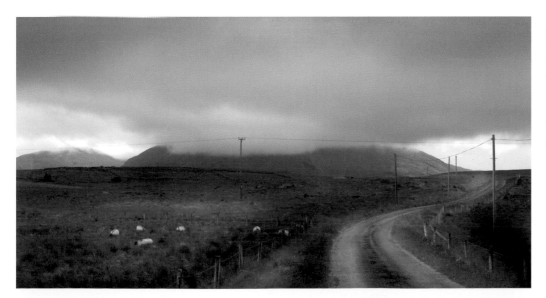

9 The final piece looks much more eye-catching than the original starting point and, although the natural light was poor, the edits have created an illusion of contrast.

Images look terrible when printed

You may find it tempting to print out your digital photos at the largest size your printer allows. The problem with this is that your original image may not be suitable for printing at that size. As the print size gets bigger, you need more pixels to keep top-quality image sharpness. Unless you're starting with a very high-resolution image file that simply needs cropping down to the right size, most images will need to be resampled in the *Image Size* dialog box until they become big enough.

In this project, you'll see how to increase the size of a small image, enabling you to make a bigger print. Commands that involve adding or taking away pixels from your original image will always result in some loss of detail and sharpness along the way, so try to minimize this type of work if possible.

 treatment

Resample using the *Bicubic* method

The simplest solution for a bad print is to "resample" rather than "resize" your image. Always use Photoshop Elements' *Bicubic* method of resampling when working with your photographic images. If the result looks soft, follow this with an *Unsharp Mask* filter command to remove any blurring.

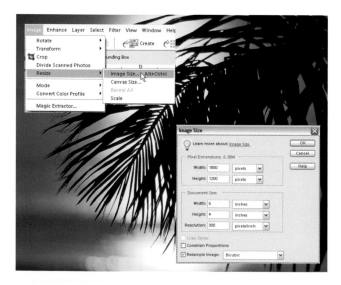

I First, see how many pixels are in your original print. This can be established by opening the *Image > Resize > Image Size* dialog box as shown to the left. At the base of the dialog box are the *Resample Image* and *Constrain Proportions* options. If you keep the *Resample Image* option unchecked, and alter the dimensions of an image, its resolution will change accordingly. This is because Elements only uses the pixels available within the image, so if you make the image bigger, Elements makes the pixels bigger—leading to visible pixelation in extreme cases.

With *Resample* checked, Elements adds extra pixels when image size is increased, coloring the new pixels so that they blend in with the original pixels beside them. This reduces pixelation, but can cause softness in your photographs.

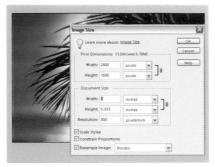

2 Without *Constrain Proportions* selected, you can alter the entire shape of your shot by mistake, as the example above shows. Be sure to, keep this option checked to ensure that your image is kept at the correct proportions.

3 Using the options shown above, you can resize and keep the correct shape for print out later. The *Bicubic* option, shown at the base of the dialog box, determines how new pixels will be colored when resampling, and will give the best quality results for photographic images.

4 Once the photo is displayed in your *Print Preview* dialog box, there is another opportunity to resize your image file. The current paper size and orientation are shown in the *Preview* window, with the unedited image file. To change the size of the image, simply type a new size into the *Scaled Print Size* text boxes.

5 An alternative and visually easier way of repeating the previous step is to keep the *Show Bounding Box* option selected. Next simply pull any of the image corners outward to enlarge or inward to reduce the image size.

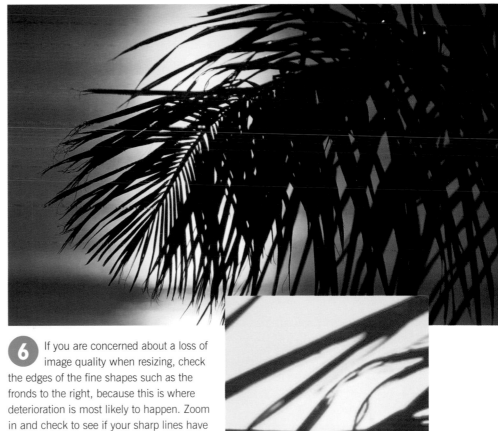

6 If you are concerned about a loss of image quality when resizing, check the edges of the fine shapes such as the fronds to the right, because this is where deterioration is most likely to happen. Zoom in and check to see if your sharp lines have broken up. If they have, you've gone too far.

Controlling depth of field using the aperture

As mentioned on page 43, the aperture is the circular opening inside your camera lens that controls the amount of light passing on to the CCD (Charge-Coupled Device) sensor. Apertures are primarily used to moderate light levels for a successful exposure, but they also have a creative effect. To enable photography to happen under variable lighting conditions, lenses are manufactured with a built-in range of apertures, measured on the internationally recognized f-stop scale. The smaller the f-stop, the larger the aperture, and the more light will be detected by the sensor. When available light levels are low, a large aperture such as f/2.8 should be selected, and when the light is too intense, a small aperture such as f/22 should be used.

Your camera's aperture settings can usually be controlled by a button on the back of the camera, or by a setting in the camera's menu. Note that aperture sizes can only be set when the camera's manual or aperture priority exposure mode is selected. In other modes, such as auto or shutter speed mode, the camera will decide on the right aperture value to make a correct exposure. Many point-and-shoot digital cameras only have a reduced aperture scale available, such as f/4 and f/11, but higher-end cameras have the full range. The circular opening is manufactured precisely to allow an exact quantity of light to pass through. Moving one step up the scale will halve the amount of light exactly, and moving one step down will double it.

Depth of field is a term used to describe the plane of sharp focus set between the nearest and farthest parts of a photographic subject. Depth of field is controlled by two factors: the aperture value selected on your lens, and your own distance from the subject. Small aperture sizes, such as f/22, will create a greater depth of field than larger aperture sizes such as f/2.8.

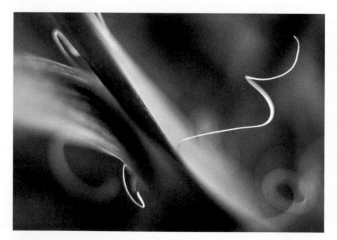

Creating a shallow depth of field
This effect is used to blur out a distracting background and allows greater emphasis to be placed on the main subject. It can be created by selecting a large aperture, such as f/2.4 or f/4, and framing the subject tightly in the viewfinder. Used by wildlife and sports photographers, this creative effect won't work on subjects that are too close to the background.

Focusing on an off-center subject
In this ultra close-up, the lens is focused on the tiny hairlike strand that projects outward. Because the focus point is not central, you'll need to use your camera's focus lock to hold this point before recomposing the shot.

Creating deep depth of field

Greater depth can be achieved by using smaller aperture values such as f/16 and f/22. This effect is commonly used by landscape and architectural photographers when a photograph needs to show sharp detail from the foreground to the background.

Finding a focus in a deep landscape

In this type of setting, the best place to set your focus is one third into the zone. Although estimating this exact point through your lens is difficult, it is the depth that will create maximum depth of field for your chosen aperture.

Maximizing subject detail

In addition to influencing the depth of field, aperture values also have an effect on the amount of fine detail recorded. A lens will record the sharpest detail if it is set to the value in the middle of its aperture scale. On a lens that ranges from f/2.8 to f/22, the sharpest results will be produced at f/8.

Bringing out the fine details

To maximize the amount of fine detail in your shot, place your focus one third into the zone, and set f/8 as your shooting aperture.

Distracting background in portraits

When taking portrait shots, the background is usually not important. You will notice that photos from your school's yearbook or taken in a professional studio often have a mottled or plain backdrop so they do not distract the eye from the subject. This solution, though, is not practical for everyday pictures.

In this photograph, although the subject is extremely bright and colorful, she is still lost in the confusing mass of branches in the background. The backdrop needs to be less prominent and the central figure should be in sharp focus.

 treatment

Use blurring to alter the depth of field

The situation can be fixed with a medium or shallow depth of field. Most cameras will have built-in scene mode settings such as portrait and macro, which change the settings

accordingly. Using these modes can produce acceptable results but in a much less controllable manner. Fortunately, the effect can be mimicked in Elements.

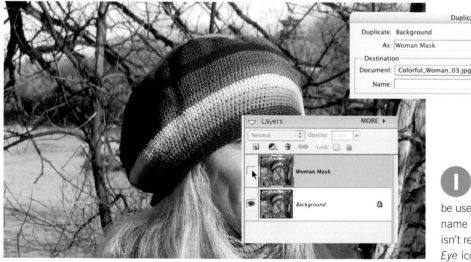

1 Open your image and select *Layer>Duplicate Layer*. This will be used as a mask for the original image, so name it "Woman mask." The mask layer isn't required yet, so hide it by clicking the *Eye* icon in the *Layers* palette.

2 Switch back to the original image by clicking on its thumbnail in the *Layers* palette—the brush icon denotes the active layer. Now select *Filter>Blur>Gaussian Blur* and set the *Radius* to 7.5 pixels. This has blurred the image sufficiently but hasn't completely destroyed the detail.

3 Click the mask layer's thumbnail to make it active, and select the *Lasso* tool. Draw an outline around the woman. When you're finished, use *Select>Inverse* to invert the selection, and press the Backspace key to clear the selection. Deselect the selection with *Select>Deselect*.

4 As you can see, the effect is dramatic. All that remains is to clean up the area around the woman. Select the *Eraser* from the *Tools* palette, and choose a hard round brush—around 30–40 pixels is a good size for this image. Press Shift+[a couple of times to give a slight softness to the brush, and carefully brush out the remaining sharp areas. Once complete, use *Layer>Merge Layers* to merge the two layers and you're done.

HEALTHCHECK

Depth of field can be determined in three ways:

❶ **Camera-to-subject distance:** The closer you move toward your subject, the more out of focus the background becomes.

❷ **Focal length:** Longer focal lengths (telephoto lenses) decrease the depth of field.

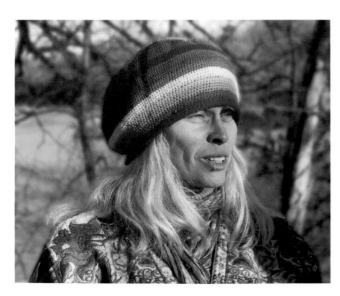

5 The final image is a huge improvement over the original. The subject stands out in the foreground, and the background is subtle and no longer distracting.

❸ **Aperture size:** The larger the aperture (a lower f-stop number, such as 3.5), the shallower the depth of field will become.

Doctor, I can't stop flashing!

The flash is an incredibly useful device. It can light up nighttime shots or fill in shadows to bring out the detail in your pictures. Unfortunately, it also has its share of problems—the most well-known, of course, is red eye. Luckily, flash problems can easily be fixed in Elements.

Reduce red eye from the start

One of the most irritating and undesirable problems when using the camera's flash for photos of people is red eye (or green/yellow eyes in animals). This usually occurs because the subject's pupil is dilated due to low light or darkness and doesn't have a chance to react to the sudden bright burst of the flash. The red color is caused by the light reflecting off the blood vessels in the retina at the back of the eye.

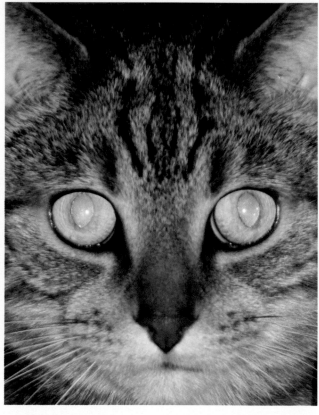

Red eye isn't just a problem with pictures of people; it affects animals as well, although the eye color is usually a green or yellow rather than red.

Red eye is an all too common problem in flash photography, but it can be avoided by following a few simple guidelines.

The cause of camera red eye

Compact cameras are often the worst red eye offenders. Their size means the flash is close to the lens and therefore, the light is projected from the flash at an acute angle. This becomes more prominent if the shot is taken from a greater distance. Some manufacturers offset the angle of the flash to counteract this. Larger, higher-end cameras and digital SLRs generally have a pop-up flash that increases the angle and avoids the situation.

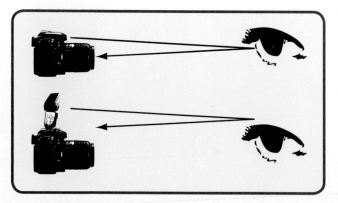

Taken from the same distances, the compact camera's (top) flash projects forward. The angle causes the reflection to bounce back to the lens. With the higher pop-up flash (bottom), the light is less direct, avoiding red eye.

Hardware red-eye reduction fixes

Most cameras have a red-eye reduction mode. The most common form fires the flash two or three times at a lower voltage before taking the photograph. This reduces the size of the subject's pupils with the first flash of light, leaving less of an area to reflect back when the main flash fires. Another type of reduction is a gentle torchlike beam, often accompanied by a timer on the camera's display. This has the same effect: preparing the pupil for the burst of light before it happens. Of course, these modes are only effective if the person is looking directly at the camera. You should also warn your subjects if your camera uses the preflash method, because they may look away or blink when the actual shot is taken, thinking that the first preflash was the real one.

There are other preventive measures that can be taken. The first and most obvious choice is to try and find a better-lit area, therefore negating the worry of red eye. If this isn't possible, try not to use the flash. A slower shutter speed and a tripod will allow you to take a shot in lower light conditions. However, the subject has to remain still to avoid blurring, and the final image may not be the same as you would expect to get from a flash.

If you have to use the flash, try taking two shots in succession, you can discard the first, if necessary. You can also ask the person to avoid looking directly at the camera—though this may not be the effect you're after. Moving closer to the subject may also help, because this broadens the angle of the flash so there is less chance of it reflecting directly back into the lens. However, this may cause too much glare on the subject, so try to combine it with some kind of diffusion. Many flash units can be fitted with diffusers that spread and soften the light. The downside of this is a reduced range and effect. If possible, also try to use an off-camera or bounce flash.

This photo was taken with a flash in fairly low lighting conditions. As a result, the subject has noticeable red eye. In this situation, it may have been avoided by using the camera's built-in red eye reduction mode. Also, because it was a posed shot, taking a second photo immediately afterwards could have prevented the problem.

The red eye has been removed using Elements' *Red Eye Removal* tool. This is a quick and easy process requiring only a few clicks of the mouse. See pages 94–95 for more solutions.

Burned out foreground

The flash on a camera emits a short but very bright light. When used at a reasonable distance, the effect illuminates the subject evenly, allowing the shot to be taken in diminishing light. If, however, the camera is too close to the subject, the light can obliterate foreground objects. White surfaces especially, such as walls or clothes, can reflect the burst back at the camera, causing hot spots and a loss of detail and contrast.

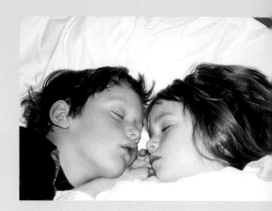

These photos are not necessarily ruined. In this example, the white bed linen has reflected the flash back. Although the children's faces are evenly exposed, there is a distracting glare on the foreground of the image. By making selections, the more pronounced parts can be adjusted using the *Levels* dialog. In many cases, even detail that appears to have been lost can be recovered.

 treatment

Darken hot spots using selections and *Levels*

There are many ways to avoid this problem while you are taking the photo. Repositioning the angle of the shot, increasing the distance between you and your subject, or using a flash diffuser to soften the light can all work, but they require forethought and preparation. Luckily, the *Levels* command in Elements does a good job, too.

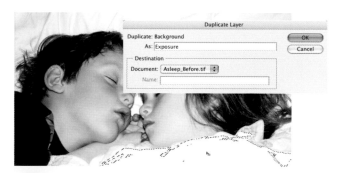

1 Go to *Layer>Duplicate Layer*. Name the new layer Exposure. Select the *Magic Wand* from the *Toolbox* (keyboard shortcut: W). Now go to the *Options Bar* and set the *Tolerance* to 10. This value determines the similarity of the pixels to include in the selection. Make sure *Contiguous* is enabled, then click the cursor in the brightest area of the foreground.

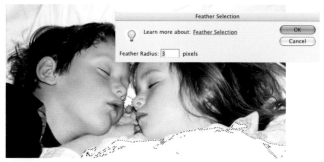

2 Check for any other prominent areas, such as between the children's faces. Hold the Shift key then click to add these areas to the selection. Go to *Select>Feather*, and enter a new value of 3. This will prevent any hard edges from forming and will make a smoother blend.

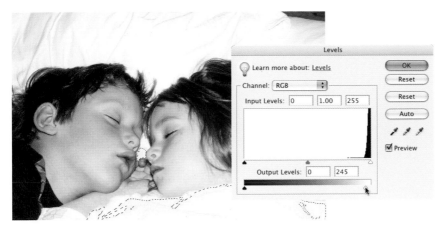

3 Bring up the *Levels* dialog by selecting *Enhance>Adjust Lighting>Levels* or by pressing Ctrl/Cmd+L. Drag the left-hand (*Shadows*) arrow to the right. Stop when the middle arrow (*Midtones*) reaches the left edge of the histogram. To complete the process, drag the right-hand *Output* slider a little to the left. A decrease of 10 works here. Too much will leave the area looking flat.

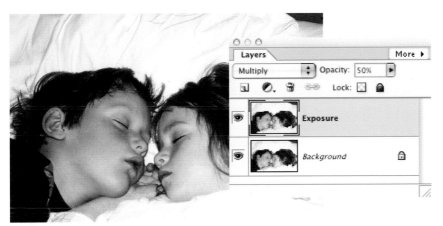

4 Press Ctrl/Cmd+D to deselect. Set the layer's blending mode to *Multiply*. By default, the effect is a little harsh, so go to the *Layers* palette and lower the layer's opacity to 50 percent. This takes more of the glare from the white areas and adds richness to the colors.

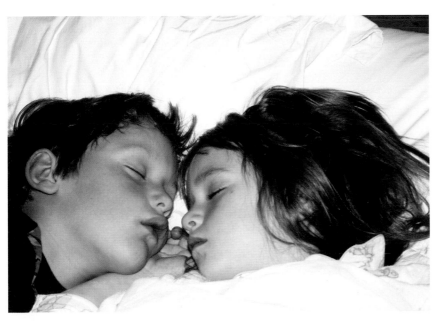

5 The finished image is a marked improvement over the original. The tone of the faces is still warm and natural, but the harshness has been taken out of the bed linen in the background. The burned out highlights have also been removed from the children's hair in the process, leaving a much more balanced result.

Banish dark backgrounds

It can often be difficult to balance the exposure when using the flash. Dark backgrounds often cause a problem. While the subject may be well lit, the area behind them may be underexposed or completely black. This is because of the speed at which the flash fires.

Generally, the camera's standard automatic mode sets the exposure time to the fastest possible sync speed. This gives the camera's sensor only enough time to expose the foreground. It does not have time to capture the rest of the scene lit by residual or ambient light. The solution is to use a slow sync flash, sometimes called "slow shutter sync." Some digital cameras have this as a separate flash or shutter setting, allowing you to set the shutter speed manually (usually labeled: Tv or M). Other cameras include it as part the *Night* or *Night Portrait* camera setting. Consult your manual for the correct method for your particular model.

Slow sync flash is often used to cure those photographs where the flash illuminates the main subject in a dark scene, but leaves the background black. With slow sync, the shutter is kept open longer, allowing the maximum light and detail from the background to be recorded before the flash fires and illuminates the main subject. The downside of this method is that the camera must be steadied with a tripod. Otherwise the pictures will be prone to blurring due to camera shake. Also, it should only be used with posed rather than spontaneous shots because of the slow shutter speed.

In many instances, poorly exposed backgrounds can be recovered using Elements. There are several tools to perform this task. Some filters also work better than others, depending on the image. The following examples show some of these methods and how to correct problems if they occur.

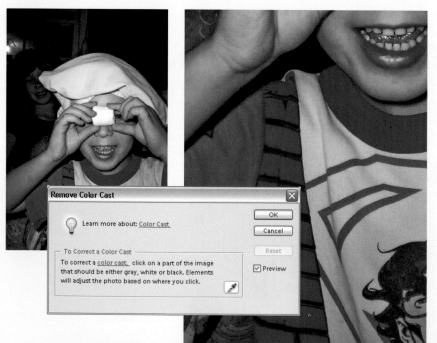

Auto Smart Fix (*Enhance>Auto Smart Fix*) has been used to adjust the image. It has worked well, but has left a slight green-blue cast. This can easily be fixed with the *Remove Color Cast* tool (*Enhance>Adjust Color>Remove Color Cast*). Click the cursor on an area that should be pure white—in this instance, part of the child's T-shirt—and Elements will alter the color balance to remove the cast.

Alternatively, you can use the more controllable *Adjust Smart Fix* command (*Enhance>Adjust Smart Fix*). This allows you to control the level of effect by adjusting the slider.

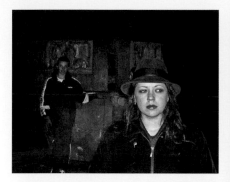

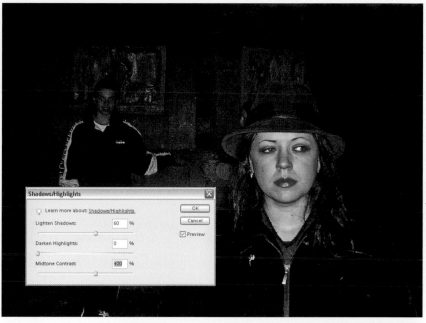

This image was shot in complete darkness. In this case, using *Auto Smart Fix* has caused it to look overprocessed. The best tool for this type of image is the *Shadows/Highlights* correction tool (*Enhance>Adjust Lighting>Shadows/Highlights*). The background is brighter and the colors remain vivid. The dialog's sliders can be adjusted to fine-tune the effect.

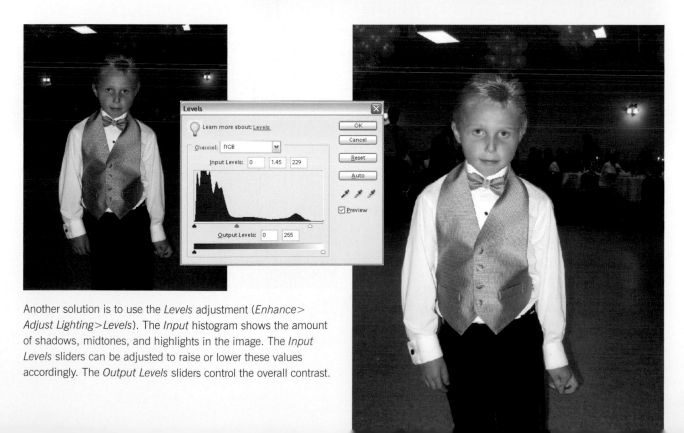

Another solution is to use the *Levels* adjustment (*Enhance> Adjust Lighting>Levels*). The *Input* histogram shows the amount of shadows, midtones, and highlights in the image. The *Input Levels* sliders can be adjusted to raise or lower these values accordingly. The *Output Levels* sliders control the overall contrast.

Overuse of flash

One of the main problems with flash photography is overexposure. The scene can become too brightly lit and heavily contrasted. If the subject is close to a wall or another solid background, the sudden burst of light can also throw heavy shadows. There are numerous ways of preventing this from happening at the time—use of a flash diffuser to soften the light, for instance—however, this isn't always an option on some cameras, particularly those with built-in flash.

Elements has many tools for fixing the exposure of an image. A lot of images can be fixed by using a single filter or adjustment. Sometimes however, the contrast of the photo is too varied to apply a single solution. The image at right has been blown out by the flash. The subject's face is far too bright and the colors are a little washed out.

 treatment

Correct contrast through *Shadows/Highlights*

This kind of problem requires a multistep repair process. Using layers, blending modes, and filters in sequence, the detail can be brought back and the tones evened out.

The goal is to achieve a much more natural-looking image ready for printing. There is also some red eye present in the photo that can be removed.

1 An attempt to apply an adjustment to the background alone would produce harsh and unrealistic results. Start by duplicating the background layer. Select *Layer>Duplicate Layer*. Name it "Adjustment" for reference.

2 Go to the *Layers* palette and set the blending mode of the new layer to *Multiply*. This has an instant effect. The flash glare is almost completely removed.

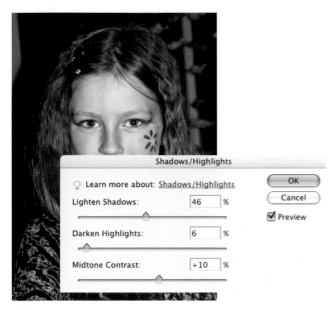

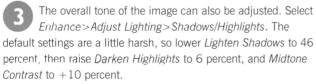

3 The overall tone of the image can also be adjusted. Select *Enhance>Adjust Lighting>Shadows/Highlights*. The default settings are a little harsh, so lower *Lighten Shadows* to 46 percent, then raise *Darken Highlights* to 6 percent, and *Midtone Contrast* to +10 percent.

4 There is also a little red-eye present in the photo. The *Red Eye Removal* tool can be used on each eye as a final enhancement to the image. See pages 96–97 for more information on removing red eye.

5 The final image is a great improvement over the original. The colors have been returned to their natural hues and there is no trace of the white blowout that was ruining the photograph at the starting point.

Visible flash

Although you can try to avoid it, there are times when a flash has to be used. You might be taking photos at a party or visiting a museum, where the ambient lighting isn't sufficient and the camera's Automatic mode causes it to fire. In these conditions, it can be difficult to avoid reflections from surfaces such as glass or shiny paintwork, especially when the subject is shot straight on.

Reflected glare can often obliterate part of the photo, leaving ugly blue or white hot spots. This is often the case with compact cameras, where the flash unit is mounted within the body and therefore, very close to the lens. SLRs and higher-end compact models may have a pop-up unit that sits a little higher, and may reduce the effect slightly. In this image, the flash has reflected from the sunglasses, causing an ugly glare.

 treatment

Removing hot spots with the *Healing Brush*

Most cameras have exposure-compensation tools, but these are generally used to counter the overall brightness, rather than the direct light caused by a reflection. Assuming the damage isn't too great, it is possible to remove the flash glare and replace the lost detail using Elements' selection tools and clone brushes.

1 Start by duplicating the background layer (*Layer>Duplicate Layer*) and zooming in on the affected area. Select the *Zoom* tool and drag an outline by clicking and holding the mouse to encompass both lenses of the glasses. This will allow you to work on the image more accurately.

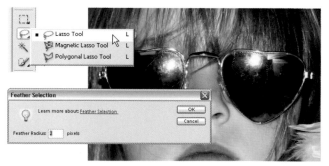

2 The first stage of the removal process is to isolate the areas to be fixed. Use the *Lasso* tool to draw an outline around the outside of the reflection in the left-hand lens. Then, holding Shift while drawing, add the right-hand selection. Next use *Select>Feather* with a value of 2 to slightly soften the edges. This protects the rest of the image from being overwritten.

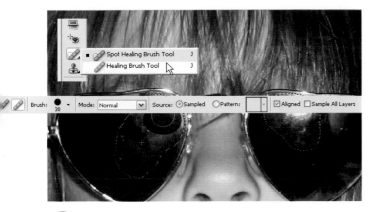

Using the *Healing Brush*

The *Healing Brush* attempts to blend the source pixels into the destination by sampling the area immediately surrounding the brush. This can cause unexpected results when it encounters heavily contrasting areas. By creating a selection, the pixels outside the boundary are ignored, preventing unwanted textures and tones from being included.

3 Select the *Healing Brush* tool with a medium-sized hard brush. Hold the Alt key (Option on a Mac) and click the area just below the glare to use it as the source. This will help to retain the texture. Next use the brush to repair the more pronounced parts of the glare. Repeat this step for the second lens.

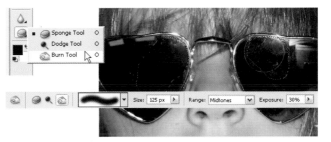

4 Although the areas of glare have been removed, they are still a little too bright. Use the *Burn* tool to fix this. Choose a fairly large, soft brush with the mode set to *Midtones* and a fairly low *Exposure*. Make a few long sweeps with the *Burn* tool over the area to darken it down and blend it in further. Once complete, deselect the area by using *Select>Deselect*.

Combating oversaturation

You may find the colors become oversaturated when the *Burn* mode is set to *Midtones*. Switch the mode to *Highlights* and brush over the affected areas to reduce this problem.

5 Now that the lenses have been fixed, the final step is to clean up the frames. Zoom right in and use the *Clone Stamp* tool with a very small, hard brush. Hold the Alt key (Option on a Mac) and click the adjacent areas to set source points, then carefully brush away the reflections in the metal. Because of the frame's shape, using long strokes would result in the areas becoming broken up. It's always best to repair parts such as these in small stages.

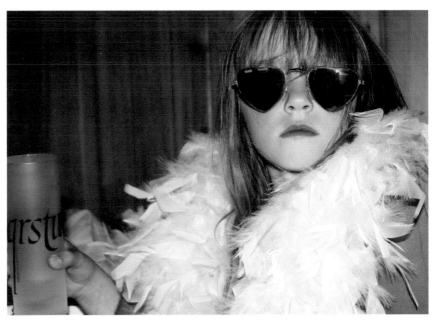

How to avoid flash problems

There are many types of camera flash available. Most compact consumer cameras have a built-in unit, while high-end consumer and SLR cameras may also have the option to mount another flash by means of a hot-shoe connection—the fitting that holds a small portable flash— on top of the body of the camera, or on a bracket to the side. There are also handheld flash models available that operate by cable or, in some cases, wireless. Although it's often best to try and avoid using the flash, sometimes it's unavoidable.

When you find yourself in a situation where a flash is required, there are still many tips and tricks that you can use to ensure that you get the best picture.

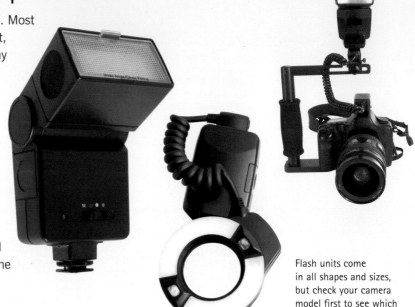

Flash units come in all shapes and sizes, but check your camera model first to see which unit will work best.

Common built-in flash problems

Compact cameras, because of their size, tend to have the flash mounted very close to the lens. The direct angle of the flash can cause red eye, glare, and reflections. SLRs and high-end consumer cameras tend to use pop-up units that sit higher and help to reduce the occurrence of these problems.

Compact camera flashes also have a fairly limited range because of their smaller size and lower power. Depending on the aperture size, focal length, and ISO, the maximum effective distance is approximately 35-40 feet. This can lead to underexposed images. Their size also affects the coverage of the light. Scenes may often become dark around the edges, especially with wide-angle shots.

If your camera has a long zoom or a lens-attachment accessory, it can partially block the light emitted from the flash, causing exposure problems and shadows.

If your camera can support an accessory flash, it is always better to use one. They are more powerful, and they also have a wider spread. Many hot-shoe mounted units can be rotated and tilted, allowing you to alter the horizontal angle so that the light is not directly facing the subject. For indoor shooting, they can also

be angled upward. This is called bounce flash. The light is fired at the ceiling and reflects down on the subject, giving a more even, dispersed illumination. Handheld flash guns are the most versatile because they can be positioned away from the camera.

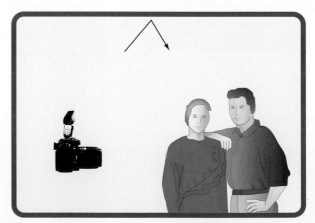

Bouncing the flash off a ceiling down onto the subject helps to reduce glare and provide more even lighting.

General flash photography problems

Long distance

One of the most common mistakes is to use a flash for photographing landscapes, cityscapes, or in an auditorium or sports field. Not only is the distance simply too great for it to have any effect, the camera will also compensate the exposure in anticipation of a bright flash—it's likely that it will only record a completely dark image. Moving closer to the subject may help, but it's not always possible. The only solution is to use a long exposure and a tripod.

Dark or black backgrounds

A typical photo scenario may be someone in front of a famous landmark at night. Although the background itself may be lit, the resulting image will be of a brightly lit subject, but with a completely black background. This is because the camera does not have time to record the ambient lighting. In these situations, a slow-sync flash is needed. Many cameras have a setting built in, often referred to as *Night Portrait* mode. In this mode, the flash is fired and the shutter speed is reduced, allowing the camera to record the subject lit by the flash, as well as the background lighting. Because of the longer exposure time, the camera will need to be steadied on a flat surface or with a tripod.

Shadows

Another problem is heavy shadowing. This often happens because the subject is located near another surface and/or the flash is too close. Try to reposition yourself or your subject away from other objects. Another solution is to fit a diffuser onto the flash to soften the light, though this can often only be done on independent flash units. This also can prevent unwanted glare. Take care, however, because this will greatly reduce the effective distance of the flash—sometimes by as much as half. Creative use of any available ambient lighting can also help reduce any harsh shadows.

Reflections

Avoid shooting surfaces such as glass or glossy paintwork directly. The flash will cause unsightly glare that will reflect back to the camera. Try to position yourself at an angle, or use a bounce flash or diffuser.

Close-up

Photographing people or objects close-up can be very problematic. This is especially true with a built-in flash. The burst of light is too powerful and will almost certainly lead to overexposed images. If possible, use a slightly longer focal length to allow you to increase the distance between yourself and the subject. It's also worth considering that the flash unit takes a little time to charge both initially and between shots. Some cameras may prevent you from taking the shot until the flash is ready. There is also the risk of the flash not firing, resulting in an underexposed image. Be sure to have it ready in time, otherwise you may miss your opportunity.

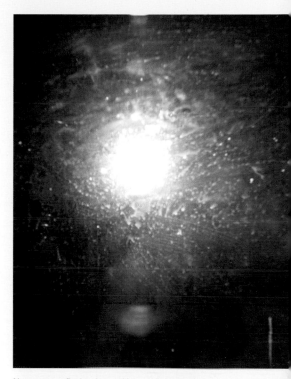

Never use a flash when taking a photograph through a window. The light will bounce back from the glass straight into the lens.

The mode dial of a typical camera, showing the symbol for *Night Portrait* mode, which is used for slow-sync flash photography.

Red eyes on a subject

Red eye is one of the main problems you may encounter when taking photos of people in low light or complete darkness using a flash. This phenomenon can also occur when taking photos of animals, where in most cases the eyes come out as a bright green or yellow. This all too common occurrence appears in varying levels of intensity. Sometimes it's barely noticeable but it can also be highly pronounced and ultimately ruin the shot.

In this photograph, the red eye detracts from what is an otherwise fine shot. The low-light conditions demanded that a flash be used to illuminate the image, but it bounced back from the eyes, creating the obvious and unsightly red eye. There are several methods of avoiding red eye when taking a picture, but they are by no means infallible.

 treatment

Use the *Red Eye Removal* tool

Fortunately for the digital photographer, it is a simple task to remove red eye using Elements. The quickest and easiest method is to use the *Red Eye Removal* tool. This is a one-step fix that can be applied in two ways: by clicking the mouse once, or by dragging its bounding box over the affected area.

1 The first step is to zoom in on the eyes so that you can see the problem area in detail. Select the *Zoom* tool; position the cursor slightly above and to the left of the left eye; and click and drag to the bottom right, surrounding both eyes.

2 Select the *Red Eye Removal* tool from the *Tools* palette. For the first eye, simply click the cursor anywhere in the affected area. After a brief pause, the red will be replaced with black. Notice how the tones and highlights are retained.

3 The alternative method of using the *Red Eye Removal* tool is to use its selection box. Click and drag the selection over the red pupil. Again, the software will calculate the area and replace it with black. You may need to experiment with the *Pupil Size* and *Darken Amount* sliders to achieve the desired results.

4 The final result is a marked improvement over the original. Without the ghoulish red glow, the portrait is restored to its natural condition.

Automatic red eye correction

Red Eye removal is even easier with Photoshop Elements 4. The software can be set to automatically remove red eye from images as they are transferred from your camera or card reader to the computer. If you already have images in need of repair on your computer, they can be selected in the File Browser and retouched without opening them first.

When images are imported into the File Browser, Elements will automatically begin scanning them for red eyes. If it finds any, it will fix them and store the fixed image as a version set. This means that the new image is a separate file on your hard drive, so you can always go back to the original photo, but Elements has linked them together in its File Browser.

The automatic procedure won't capture every instance of red eye, and it won't handle pets with green eyes, but it's a good start.

 symptom

Photo needs fill-in flash

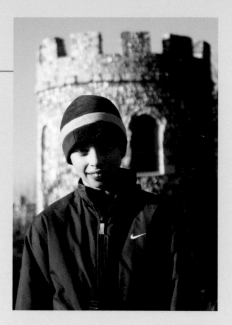

Using a flash is normally associated with shooting in dim light or complete darkness. However, there are also many other situations where it can be used. In strongly lit conditions, such as bright sunshine, heavy shadows can be cast on your subject and cause their features to be hidden. A flash can help soften or eliminate these problems by evenly lighting the scene from the front. This is more commonly known as fill-in flash.

Many cameras have specific modes, often referred to as *Backlight*. Some also use the light meter's reading to automatically use fill-in flash. Most cameras give you the ability to force the flash to fire. Of course, neither the camera or the photographer are infallible. In this image, the bright sunlight caused half of the boy's face to be thrown into shadow.

 treatment

Use the *Shadows/Highlights* adjustment

The *Shadows/Highlights* adjustment gives you the ability to individually control the levels of highlighting, shadows, and overall contrast. Normally, this would be applied to the entire image but for the fill-in effect, you only need the foreground to be adjusted. The solution is to use a selection to isolate the subject.

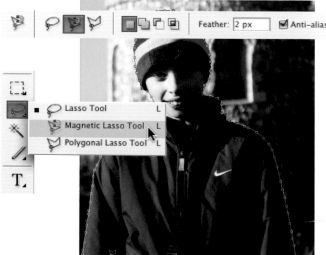

Select the *Magnetic Lasso* tool by clicking its icon in the *Toolbox*. Now go to the *Options Bar* and set a *Feather Radius* of 2 pixels. This will avoid any harsh borders. Set the *Width* to 3 pixels and the *Edge Contrast* to 70 percent. This insures the tool will adhere to the outline. Starting at the bottom of the image, carefully trace the outline. When you reach the opposite side, hold the Alt/Option key and click the mouse once. This temporarily changes the mode to the *Polygonal Lasso* and will give you a straight connection. Move the cursor back to the starting point and click again to complete the selection.

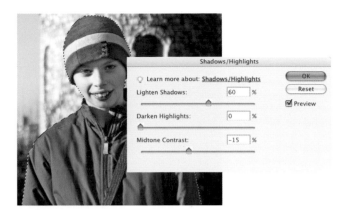

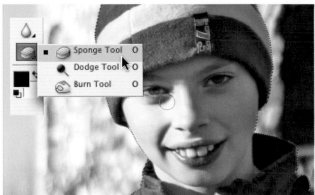

2 With the selection in place, only the inside area will be affected. Go to *Enhance>Lighting>Shadows/Highlights*. Although the default settings show a marked improvement, they are not quite right for this image. Set the *Lighten Shadows* value to 60 percent. Now set the *Midtone Contrast* to -15 percent. This gives a more balanced tone to the image.

3 The lighting is more even now but there is still a difference in the coloring of the face. Select the *Sponge* tool and set its mode to *Desaturate*. Choose a medium, soft brush with a fairly low *Flow* amount—around 30 percent is sufficient. Gently brush over the more saturated areas to balance the tones a little more evenly.

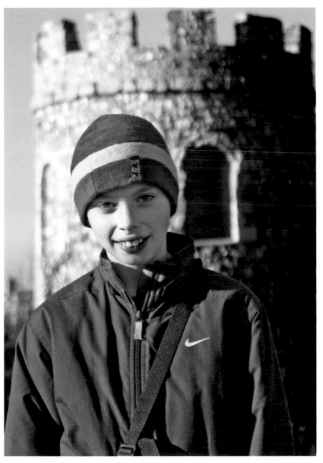

4 The final stage is to restore some rich color back to the boy. Go to *Filter>Adjustment>Photo Filter*. Pick the *Warming 85 Filter*. Adjust the *Density* to around 30 percent. Make sure the *Preserve Luminosity* box is checked and click OK to make the changes. Finally, hit Ctrl/Cmd+D to deselect.

HEALTHCHECK

Accurate selections with the *Magic Wand*

The *Magnetic Lasso* is a good way to make accurate selections quickly. Sometimes in areas of low contrast, the software cannot accurately define the border and may veer away from the outline. Use the Delete/Backspace key to remove any unwanted nodes to retrace your steps. You can also place points manually by clicking the mouse. This is useful when working on small, tricky areas.

Flash freezes movement

Slow-sync flash is designed to leave the shutter open for a long period to enable the camera to capture both the subject and its background. It can be achieved by using a preset mode such as *Night Portrait* or by manually setting the shutter speed—if that is an option. This can create some stunning effects. When the shot is taken, the main subject will be remain static but movement, especially light sources, will leave a trail that is often a long, blurred stream. This can give a great sense of action to the photo.

If your camera does not have this mode or the setting was not used, the effect can also be created after the shot. In this example, the girl and her sparkler have been frozen by a fast-sync flash. Although you can see she's running, the sense of movement has been lost.

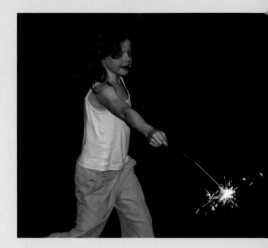

 treatment

Use clone tools to add dynamism

Using Elements' selection and clone tools, a copy of the sparkler's glow can be repeatedly duplicated to create an undulating stream. A blur filter and blending mode is used to enhance the effect. The resulting image has the appearance of a slow-sync image, and the girl appears to be running into the photograph's frame.

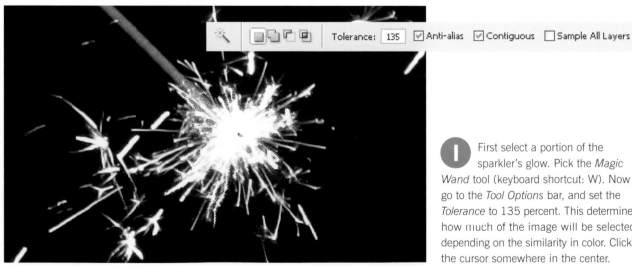

1 First select a portion of the sparkler's glow. Pick the *Magic Wand* tool (keyboard shortcut: W). Now go to the *Tool Options* bar, and set the *Tolerance* to 135 percent. This determines how much of the image will be selected, depending on the similarity in color. Click the cursor somewhere in the center.

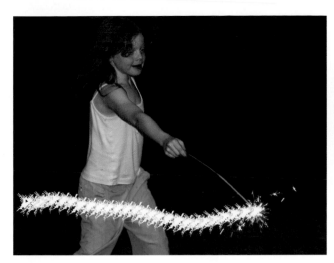

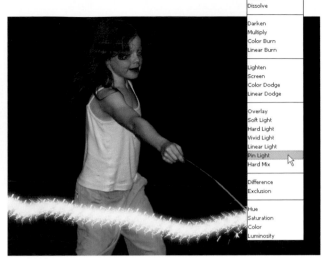

2 Press Ctrl/Cmd+J. This creates a new layer from the selection. Hold Ctrl/Cmd and click the new layer's thumbnail in the *Layers* palette. This loads the selection again. Now hold Ctrl/Cmd+Alt/Option, and click and drag the selection to create a duplicate. Position it just behind, but overlapping, the original sparkler. Repeat this process several times. Add an increased sense of movement by creating a long, curved trail. Press Ctrl/Cmd+D to deselect.

3 Click the first trail layer's thumbnail to make it active, then Shift+click the last trail layer's thumbnail to select all of the trail layers. Go to *Layer>Merge Layers* to merge all of the trails into one layer. Set the blending mode of this layer to *Pin Light* from the drop-down menu. This enhances the color of the trail, and brings back the fiery orange and yellow hues.

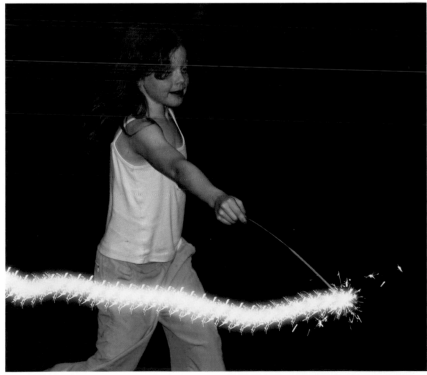

4 Go to *Filter>Blur>Gaussian Blur* and set the *Radius* to 19 pixels. Click OK to apply the effect. This gives the trail a slight haze and indicates movement.

Subject's eyes lack highlights

The eyes are a natural focal point of the face, whether in real life or in a photograph. Even isolated from the rest of the person, they can convey a multitude of expressions and moods. In any type of portrait, it's very important that the eyes are bright and in focus. Dull, lifeless eyes can take away the subject's spirit and leave the photograph lacking in appeal.

Generally, because our eyes have a natural glaze, they will pick up reflections and light. However, these can be a distraction and end up overpowering the picture. This usually happens when a flash is used, or the subject is shot in very bright conditions. Conversely, there may be no highlight at all, leaving the image lacking in vitality. This image has small highlights in the center of the eye, but they need some enhancement.

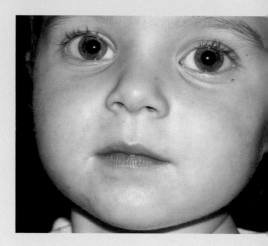

 treatment

Add catchlights using brushes and opacity controls

The *Clone Stamp* and *Burn* tools can be used to clean up the original highlights, and a low-opacity brush on a new layer can be used to create a softer glint. Take care to make sure the highlights match the direction of the light in the photograph, and that the highlights in the image correspond to one another.

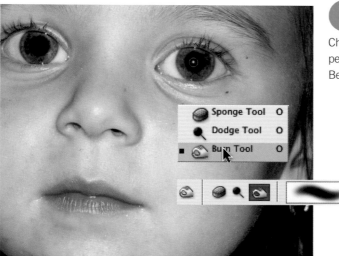

1 First darken the pupils and remove the central highlights. Use the *Burn* tool set to a medium-sized, hard brush. Change its mode to *Highlights*, and set the *Exposure* to 30 percent. Paint over the highlights until they disappear completely. Be sure to darken the rest of the area a little to match.

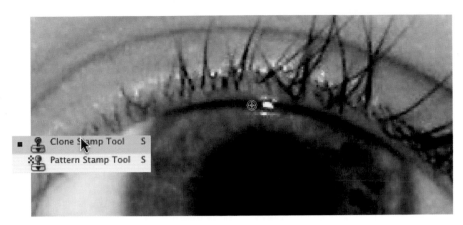

2 There are also spots of light elsewhere on the eyes. Zoom in to see the detail, and then select the *Clone Stamp* tool set to a small, hard brush. Hold the Alt key (Option on a Mac), and click an area next to the highlight to take a sample of that area. Then click on the highlight to paint over it.

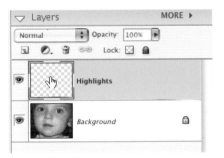

3 Create a blank layer for the new highlights by selecting *Layer>New>Layer*. This will allow you to fine-tune the results, if necessary. Use a fairly large, soft brush with white as the foreground color, and a low opacity (around 30 percent). Again, rather than painting, click the mouse a few times to build up the effect.

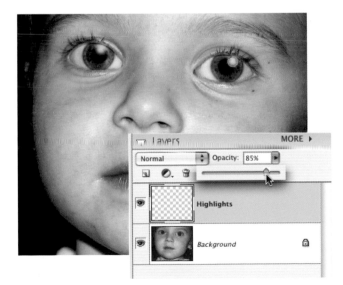

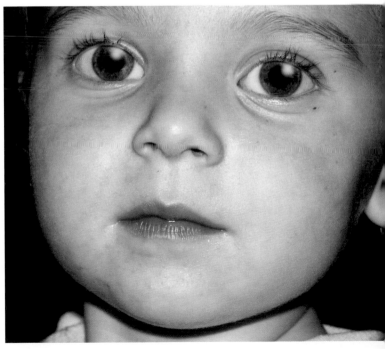

4 Although the dabbing method allows more control over the effect, it can still become a little overpowering. If you want to create a softer effect, you can lower the layer's overall opacity and tone down the highlights.

Doctor, I've got the shakes!

Whether it's a heavy camera, a windy day, or just an overly enthusiastic shutter finger, camera shake affects every photographer. Although the only fail-safe cure is to rest your camera on a tripod or other prop, there are some things you can do to minimize shake on handheld shots.

Photo is out of focus

You can generally rely on a digital camera's autofocus system for excellent results. However, certain conditions can cause the system to lock onto the wrong area of the scene, often blurring the intended subject.

Areas of low contrast are a common cause of this problem. The camera cannot sense a well-defined area and will therefore target the best alternative. Many high-end consumer and SLR models have the option to set the focus point manually, providing greater control over the shot. Of course, if you forget the settings have been altered, they may be mistakenly retained for the next shot.

In this example, the camera appears to have focused on the child's leading shoulder. This has caused the rest of the image to become noticeably softer and, as a result, the eye is drawn away from the child's face.

 treatment

Sharpen poor originals with the *Unsharp Mask* filter

Depending on the amount of blurring, it is often possible to recover—and in a lot of cases, enhance—the image. With careful use of Elements' selection tools, layers, and the *Unsharp Mask* filter, the picture can be rectified. The depth-of-field is retained and the focus is shifted back to its intended subject. This results in a more attractive image.

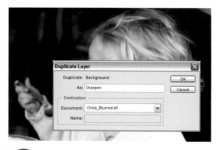

1 Start by duplicating the background layer. Go to *Layer>Duplicate Layer*. Name this new layer "Sharpen." By working on a copy, you have more control over the effect. It is also easier to correct mistakes.

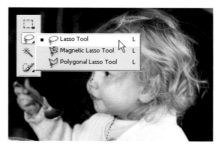

2 The next step is to isolate the foreground area of the image. Select the *Lasso* tool (keyboard shortcut: L). Now draw a rough selection around the area closest to the camera. At this stage, keep the selection inside the target area.

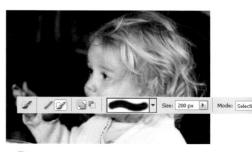

3 Pick the *Selection Brush* or press A on the keyboard. Choose a medium-sized brush. Set its hardness to 50 percent. Now begin to paint around the selection. Try to get as close as possible to the edges of the subject.

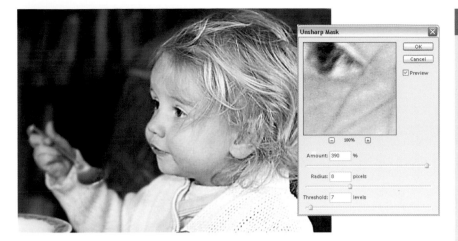

The *Unsharp Mask* filter

The *Unsharp Mask* filter (USM) is a very powerful tool. It works by measuring and enhancing contrasting areas of the image. Used carefully, it can give impressive results.

The filter's dialog has a *Preview* area that can be zoomed and panned to inspect the detail. The effect can also be previewed on the main image to compare the before and after results. There are three sliders that control the effect:

Amount: 390 %

❶ Amount: This governs the overall strength of the filter. The percentage values range from 0 to 500.

Radius: 8 pixels

❷ Radius: This setting controls how many pixels around the detected edges are affected. Higher values may be needed when working on large images.

Threshold: 7 levels

❸ Threshold: Setting a nonzero value controls how the filter determines the edges within the image. Increasing the value lessens the overall effect. This can be useful for selectively sharpening the image.

It's worth noting that the results displayed on your screen can differ from how the image will look when it is printed. Usually it is not quite as harsh.

4 With the selection complete, go to *Filter>Sharpen> Unsharp Mask*. Begin by raising the *Amount* to 390 percent. Next set the *Radius* to 8 pixels and the *Threshold* to 7. Finally, set the layer's blending mode to *Luminosity*. This will remove any unwanted speckles of color.

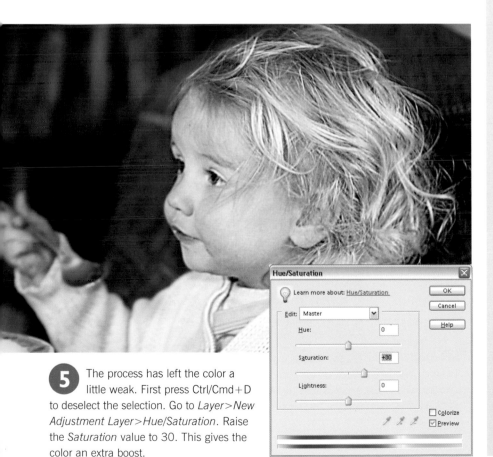

5 The process has left the color a little weak. First press Ctrl/Cmd+D to deselect the selection. Go to *Layer>New Adjustment Layer>Hue/Saturation*. Raise the *Saturation* value to 30. This gives the color an extra boost.

symptom

Camera shake

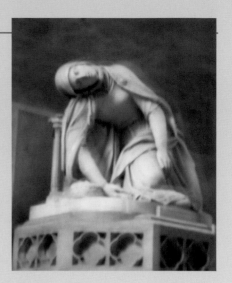

One of the main advantages of a digital camera is the ability to see your photo immediately after you've taken the shot. Unfortunately, it's not always possible to view it in great enough detail to be sure the image is completely sharp. It can be a big disappointment to download your photos, only to discover that some of them are suffering from blurring, because of camera shake.

This image was taken handheld in a church and no flash was used. As a consequence, it has suffered from a lot of blurring caused by camera shake. There was also a fair amount of noise because the camera automatically increased the ISO level. This was removed beforehand (see pages 134–135) because any noise artifacts present can be accentuated during the sharpening process.

treatment

Use masking and sharpening to rescue the image

In many cases, it's only necessary to recover the main subject. First the image is sharpened with *Unsharp Mask*. The *Magnetic Lasso* tool is then used to trace the outline and isolate it from the rest of the image. The *Clone Stamp* and *Healing Brush* tools are used to remove the ghosting in and around the subject.

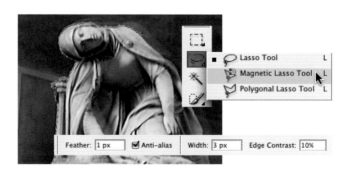

1 Duplicate the background layer (*Layer>Duplicate Layer*). Name this new layer "Sharpened." Now go to *Filter>Sharpen>Unsharp Mask*. Use the dialog's sliders to set the following values: *Amount,* 360 percent; *Radius,* 4.0 pixels; *Threshold,* 0 levels. These settings will vary depending on the amount of blur and shake present in the image.

2 Select the *Magnetic Lasso* tool (keyboard shortcut: L). Set *Feather* to 1 pixel. This will soften the final selection. Set the *Width* to 3 pixels and the *Edge Contrast* to 70 percent. These final values control how the tool judges the outline. Now find an area with a sharp edge and begin to trace around the edge. Keep within the ghosted parts of the image. Make your way around and back to the starting point to complete the selection.

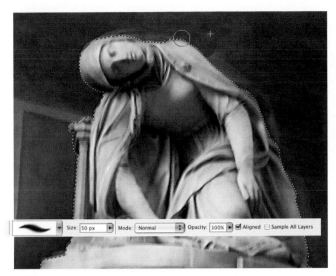

3 Press Ctrl/Cmd+Shift+I to invert the selection. The subject is now separated from the rest of the background. Select the *Clone Stamp* tool (keyboard shortcut: S), and choose a small to medium hard-edged brush. Position the cursor adjacent to an area of ghosting, then hold the Alt/Option key and click the mouse. This defines the sample that will be used to repair the area. Now reposition the cursor over the ghosted part and paint over it. Continue around the outline, taking fresh samples to avoid repetitive patterns.

4 The ghosting has now been removed, but not blended in. Select the *Healing Brush* (keyboard shortcut: J). Pick a medium-sized, hard brush. Again, use the Alt/Option key to sample the area next to the section you want to blend. Rather than painting directly over the whole area, click in the middle, where the hard edge appears. This will blend it in with the rest of the background. Continue on making fresh samples until the area is complete.

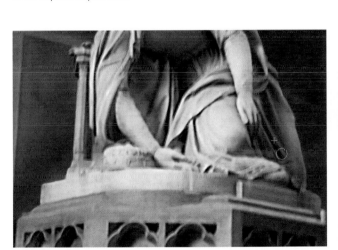

5 As a final step, areas of ghosting on the subject can be cleaned up. Press Ctrl/Cmd+Shift+I to invert the selection again—taking it back to its original state. Now use the same combination of the *Clone Stamp* and *Healing Brush* to repair the more noticeable areas, such as the statue's arm in this image. You might also want to check and repair any stray areas of the outline.

Avoid focus problems

A common cause for bad focus is when the camera's auto-focus system is misled into targeting an area in front of or behind the subject. Bright or low-light conditions can cause the camera to lock onto the strongest point of contrast. Most cameras will warn you via the display or an LED when it cannot lock onto a focus point, and some will not let you take the shot at all in certain modes. This is a great help in preventing many out-of-focus shots, but it doesn't stop the camera from focusing on an alternate, unwanted part of the image.

The simple solution would be to switch the camera to manual focus, but not all models have that feature.

One technique is to focus on an area that is the same distance away as the subject and then use the focus lock feature of the camera to fix the focus at that distance, before repositioning the shot with the correct subject. See pages 116–117 for more information on using focus lock.

For close-up shots where the subject is within arm's reach, such as macrophotography, it can help to use something like a credit card, or another small object, held in front of the camera at the same distance as the subject so it has something to lock onto—then take the object out of the shot once the focus is achieved.

This shot of a bee collecting pollen is out of focus because the camera targeted and fixed the wrong area of the scene.

Minimizing camera shake

Camera shake, another common focus problem, occurs when the shutter speed is slow, because it is open for a longer amount of time, and any camera movement will be recorded as trails and ghosting. This is also increased dramatically by zoom lenses—the longer the focal length, the more pronounced the distortion.

Posture is very important, too. Holding the camera with both hands is essential. Keep your elbows pressed against your chest because this helps to support your hands and keep them steady. If possible, try and lean against a solid surface, such as a wall or lamppost, effectively creating a "human tripod." If the shot and composition allows, you can also try crouching or sitting to lower your center of gravity.

Using a tripod is the best way to avoid camera shake. Tripods are an essential part of any photographer's kit. Their primary function is to keep the camera steady, so whether you have an SLR or a micro-compact, at some point you'll probably need to use one. There are numerous types available, ranging in size from tabletop versions to full height.

On average, you can handhold a camera at medium focal lengths with a shutter speed of 1/60th of second or higher; anything less, and the picture may be blurred as a result of camera shake. One very common use of slow shutter speed is night or low-light photography, where a flash is unsuitable or even prohibited. Long exposure times are needed and it's unlikely you will capture a sharp image without any support. Similarly, landscapes require smaller aperture sizes to maintain overall sharp focus that may also need slower shutter speeds.

Using a long zoom lens often calls for the use of a tripod—these lenses can be fairly heavy—and because of the focal length, where even the slightest movement will be accentuated.

Because of the low lighting and long zoom, this image of a bat eating fruit has suffered badly from camera shake.

HEALTHCHECK

Choosing the correct shutter speed for a shot

The following table is a guide to the minimum shutter speeds that should be used to avoid shake when handholding the camera.

Focal Length	Steady Hands	Unsteady Hands
Wide angle	1/30th second	1/60th second
Medium Wide	1/60th second	1/25th second
Zoom	1/125th second	1/250th second
Long Zoom	1/250th second	1/500th second

The problem with using faster shutter speeds is that the shot could end up underexposed in all but the brightest of conditions. Using a flash is one way to avoid this; another is to increase the ISO speed, but you risk the photo having more speckles of color.

Posed shots look dull

Although tripods are great for preventing camera shake, they do have other problems. Because of the time it can take to set up a shot using a tripod, spontaneity can be lost and portrait sitters can easily grow bored. Although the resulting photograph may be technically correct, it may be lacking that certain spark required to make a great picture.

Nothing seemed to go right on the day of shooting this example image. One of the legs on the tripod stuck and took a good five minutes to fix. During this time, the sun sank behind a bank of clouds that refused to budge, and the sitter rapidly started losing patience.

 treatment

Use a tripod more creatively

Rather than give up and call it a day, try experimenting with some more creative tripod work. Something that can be a lot of fun is taking several shots of a scene, with the subject in different poses, then blending them together using Elements. This can work especially well if you can set up some kind of interaction between the "clones."

1 Begin by opening all of the "clone" images that you took. There are three in this example. Decide which order to use the images. Generally, the person farthest from the camera should be the background layer; in this instance it's the boy with the watering can.

2 The image of the boy on the bench is the next farthest, so bring its window to the foreground. For quick access, you can use Elements' *Photo Bin* to select images. First you'll need to copy it to the background image. Go to *Layer>Duplicate Layer* and select the name of the document from the drop-down menu. Name the new layer "Boy on Bench" for convenience.

3 Switch to the background image again and you will see the new layer in the *Layers* palette. The area around the boy needs to be erased to allow the background image to show through. Use the *Selection Brush* to outline the boy. In images like this, it's worth selecting shadow areas that you want to keep as well, such as around the boy's legs.

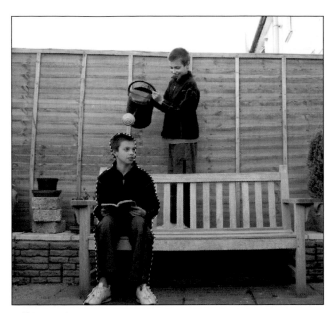

4 Once complete, use *Select>Inverse* to invert the selection, then press the Backspace key to clear the unwanted area. By using a soft brush, the selected edges will blend into the background where there may have been some slight tonal differences.

5 Finally, repeat the process with the third image to complete the effect. This is only a basic example, but with a little more work, you can have more interaction, or maybe change the color of the clothing for variety.

Using a long zoom to improve shots

Zoom (or telephoto) lenses are essential when you are unable to get close enough to adequately fill the frame with your subject. There can be many reasons for this: There may be restrictions in place that prevent you from getting close, such as at a sporting event, or a zoo where they generally try to keep the animals away from the public for safety reasons. You might also favor wildlife photography, in which case, the subject may be too timid for you to approach without it running or flying off. Air and sea shows are another good example. By their nature, it's usually impossible to get within a reasonable distance, and without a decent amount of magnification the resulting images may be disappointing. In addition to capturing distant objects, zoom lenses are excellent for achieving shallow depth-of-field effects, where the subject remains in sharp focus against a softer background.

Although long zooms are generally associated with SLRs, many compact and higher-end consumer cameras have lenses with a respectable maximum focal length. These tend to be advertised by their magnification level, rather than the traditional measurement in millimeters. For example, a camera with a 38mm lens and 3x optical zoom would have a maximum focal length of 114mm. Some cameras may also be accompanied by digital zoom, a term which is often misunderstood. Optical zoom is the physical extent of the lens. Digital zoom is created with the camera's software. It takes the central part of the image and increases it to fill more of the frame, effectively multiplying the amount of magnification. For example, if the camera has an additional 3x digital zoom, the effective length would be 342mm. Unfortunately, there will be image degradation when you use a digital zoom.

This image was shot with an SLR equipped with a zoom lens and the clarity is retained.

This image was shot with a compact camera at its full digital zoom capability. There is a noticeable amount of image degradation.

This image was taken with the compact's maximum optical zoom and upsized using Elements. Again, there is more pixel distortion than with digital zoom.

The drawbacks of long zooms

The main problem with using a separate telephoto lens is its size—some can be very large and weigh an enormous amount. This is because of the amount of optical components needed. These large lenses often need to be supported by a tripod to reduce strain on the camera body. It can also be difficult to focus on distant objects, especially if the scene is busy or the subject lacks contrast with its surroundings. In these cases, it may be better to use manual focus (if available) or find a nearby area on which the autofocus can lock before repositioning the camera to frame the subject. The main problem that photographers encounter with long focal length is camera shake. This usually occurs with slow shutter speeds, and it is greatly increased because of the amount of magnification used. Camera shake is also particularly prominent when using the digital zoom. The best way to avoid this is by using a tripod, or by resting the camera on a solid surface, such as a wall.

Telephoto lenses can be large, heavy, and very expensive. Always shop around to find the best lens for your camera, and be sure that you are comfortable with using it. You may find yourself purchasing a new camera bag and tripod as well to enable you to use the lens.

When using a long zoom lens, always use a tripod or brace yourself against a solid surface to prevent camera shake.

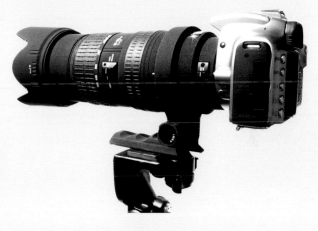

Larger lenses may come with their own tripod attachment to accommodate their extra weight. Always use these, because using these lenses with a standard tripod attached to the camera instead can damage the lens fitting.

This diagram shows the difference that a long lens makes to camera shake. Both cameras are tilted between +/-4 degrees, using the center of the body as the pivot point. The first image represents a short focal length. Movement at the end of the lens is present but slight. The second image represents long focal length where movement is greatly accentuated.

Prefocus your shots

There are two main methods of controlling the focus of your images. SLRs and some compact/high-end consumer cameras have manual focus built in. This is altered by a focusing ring on the lens itself, or by utilizing the control panel on fixed-lens models.

Nearly all cameras have an autofocus system. Using either an infrared beam (active autofocus) or by analyzing the contrasting areas of the image itself (passive autofocus), the camera uses small motors to adjust the elements of the lens and obtain the sharpest image. In addition to a high level of accuracy, the main benefit to the photographer is the incredible speed at which focus can be attained.

There may be times when full autofocus can be more of a hindrance than a help. To counter this, most cameras have a focus lock feature. Generally, this is achieved by holding the shutter-release button halfway down. Using this mode, the camera locks on to the subject but does not actually take the shot. The following are examples of when this feature can be used.

Prefocus as a curative measure

In certain situations, the camera may not be able to lock onto the subject. This might be due to low levels of contrast, such as very dim or bright scenes. Large, featureless areas may also cause problems. Conversely, scenes with a lot of detail may cause confusion and the camera may not be able to fix on one particular part, or it may focus on the wrong area entirely.

This can be overcome by using a prefocus method known as "focus and recompose." Find an area in the viewfinder that is at the same distance from the camera as the intended subject. Make sure that the camera can focus on it. Lock the focus, then reposition the camera so that it's targeting the right area. You can now take the picture.

When the central area of your subject contains a lot of detail that may cause problems for the camera's autofocus mechanism, try prefocusing on a less fussy area of the same subject first.

In this example, the focus was first locked on the man's shirt, and then recomposed in the center of the frame when the photo was ready to be taken.

Using prefocus creatively

Prefocusing techniques can be used in many creative ways. Photographing moving subjects such as race cars or other sports events can be tricky. Obtaining focus as they pass in front of the camera is not always possible, especially when they are traveling at a high speed. Focus on a spot a little way in front of the subject. Then, as it passes, take the picture, or follow it if you are attempting to pan with the subject. The same technique can be applied to nature photography. Try prefocusing on an object, such as a bird feeder in the garden or a flower that attracts insects. Almost the instant the animal appears, you can take the picture. This method also helps to avoid motor noise and possible reflections from the lens scaring more timid creatures away.

Another reason for using prefocus is for setting up a shot where the scene will be predominantly dark. A child's birthday party is a good example. You may want to capture the cake and candles but the camera might have difficulty focusing on them—although some cameras use a focus aid, such as preflash. To correct this, first frame the image and lock the focus with the lights on, then when it comes time to take the picture, you can be sure the photo will be sharp.

Many SLR cameras will have a switch on the lens to change from auto to manual focus. Use the autofocus first, then switch to manual. The camera will remain locked in without the need to hold the shutter button.

Hyperfocal distancing

Many cameras have a landscape mode built in. In this mode, the focal point is set to infinity, meaning that the farthest point of the scene will be sharp, such as a distant mountain range. Most of the image will be in focus, but it will start to lose its sharpness as it nears the foreground.

Hyperfocal distancing is a technique used extensively by landscape photographers. The aim is to achieve the greatest depth of field from the lens. In other words, keeping as much of the scene in sharp focus as possible. Using the infinite focus landscape shot as a reference, the hyperfocus point is the area at which the scene starts to blur.

True hyperfocal distancing is only possible with a manual focus camera because it relies on fairly complex math to work out the required focal length. However, a similar effect can be achieved using the focus and recompose method. Generally, the focus starts to deteriorate at around two-thirds of the entire scene, so focusing on a point one-third of the distance in front of the camera and then repositioning to the horizon can produce sharper images, but not as sharp as using true hyperfocal distancing.

First Focus Distance

Hyperfocal Distance

This diagram illustrates where to focus when trying to judge the hyperfocal distance. The focus is first locked one-third of the way into the image, and then recomposed to the horizon.

High-speed subjects look static

Panning is the technique photographers use to capture movement, such as race cars or anything else where the subject needs to be sharp and the background out of focus. This technique adds a great sense of dynamic motion.

The best way to achieve this is to prefocus on a point where the subject will pass. Then, as it reaches that area, take the shot and follow its path. Try to match the speed as you turn. This requires a fairly long exposure, because a fast shutter will freeze the subject and its background. Make sure there are no potential obstructions in the vicinity, such as trees or buildings.

This example image highlights the problem of simply using a fast shutter instead of panning—the feeling of movement has been removed.

 treatment

Inject some dynamism with *Motion Blur*

The sense of speed can be returned to the image with Photoshop Elements. Using the selection tools, the subject can be kept sharp, while the background is sped up with judicious use of the *Motion Blur* filter. Faking the motion with this technique happens to make the image seem more real.

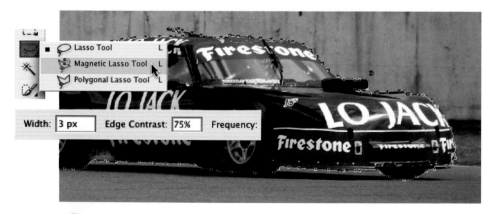

① The first thing to do is isolate the subject from the rest of the image. Access the *Magnetic Lasso* tool from the *Tools* palette by clicking and holding the cursor on the *Lasso* icon or by pressing Shift+L to cycle through the *Lasso* tools.

The *Magnetic Lasso* tool has options enabling you to fine-tune the selection process; the two settings that need to be changed in the *Tool Options* bar are *Width* and *Edge Contrast*. *Width* sets the radius of pixels to sample. Set it to 3 in order to keep a stricter hold on the outline. *Edge Contrast* defines the level of contrast to measure between the background and the object being selected.

Choose a good starting position—somewhere with an obvious, high-contrast edge—and click once to set the first point. Then follow the outline of the car with the mouse cursor. Be sure to keep as close as possible to the car so that the selection will stick to the edge. When you reach the starting point again, click to create the selection.

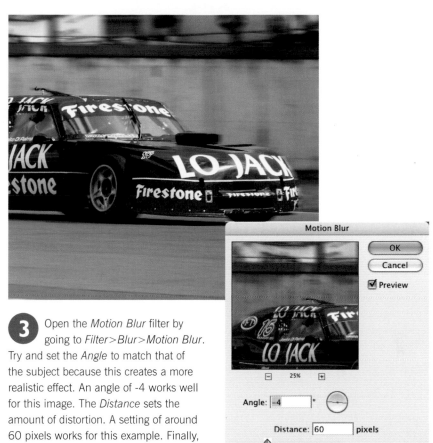

2 The selection can sometimes stray from the object's outline, particularly around intricate areas. These can be fixed with the *Selection Brush* tool. Set the brush's *Hardness* to 99 percent to slightly soften the edges, and choose *Mask* as the mode. Paint the areas that fall outside the outline, then go to *Select>Inverse* to invert the selection. Paint in the missing inner parts using a softer brush to select the shadows.

3 Open the *Motion Blur* filter by going to *Filter>Blur>Motion Blur*. Try and set the *Angle* to match that of the subject because this creates a more realistic effect. An angle of -4 works well for this image. The *Distance* sets the amount of distortion. A setting of around 60 pixels works for this example. Finally, click OK to apply the filter.

HEALTHCHECK ⎯╱\⎯

Removing ghosting

You may notice areas of the subject that have some ghosting. This can be removed with the *Clone Stamp* tool, if necessary. Leave the selection enabled and the outline will be protected from being overwritten.

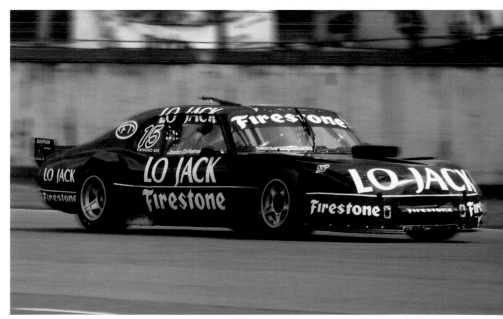

Doctor, I'm feeling off-color!

Since color is an integral part of photography, it's easy to assume that a camera automatically captures the correct color. However, that isn't the case. Your eyes naturally compensate for changes in lighting, but a camera records exactly what it sees—often resulting in a color cast.

Photo is too green or blue

If you have a great photo that is spoiled by dreary lighting conditions, it can be easily fixed using Photoshop Elements' *Color Variations* controls.

Before altering an image, you should think about what has caused the poor lighting so you can approach the correction the right way. Color changes dramatically when natural light is variable. Under bright sunshine, color is vivid and eye-catching. But if a cloud drifts in front of the sun the same scene can look bland and uninspiring. Although this image features a strong composition with an interesting vista down the center of the frame, it lacks color because a cloud blocked the sun at the moment it was shot. The aim of the following correction technique is to lighten up the overall image, and then mimic the effects of warm sunshine on the subject.

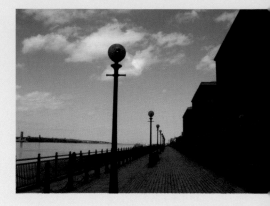

 treatment

Use *Variations* to correct color

Unless you are prepared to wait for weather conditions to change on location, the best remedy is to edit your image file on your computer. With a clever combination of *Brightness* and *Color Variations* commands, you can invent a sunshine effect on even the most dimly lit image files.

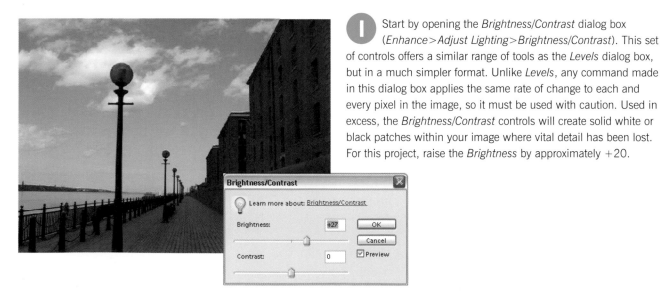

I Start by opening the *Brightness/Contrast* dialog box (*Enhance>Adjust Lighting>Brightness/Contrast*). This set of controls offers a similar range of tools as the *Levels* dialog box, but in a much simpler format. Unlike *Levels*, any command made in this dialog box applies the same rate of change to each and every pixel in the image, so it must be used with caution. Used in excess, the *Brightness/Contrast* controls will create solid white or black patches within your image where vital detail has been lost. For this project, raise the *Brightness* by approximately +20.

2 The *Color Variations* dialog box (*Enhance>Adjust Color>Color Variations*) is a one-stop color correction shop that's simple to use, and provides every opportunity to change your settings or revert back to your original starting point.

At the top of the dialog box are two versions of your image: the starting point and your current work in progress. At the base of the dialog box are the various color controls offering you the option of adding or subtracting color casts from your image. On the left-hand edge are two critical controls: the tonal range buttons and the *Adjust Color Intensity* slider.

For general color casts, always apply your corrections to the *Midtones* and set the *Adjust Color Intensity* slider to halfway, as shown at right. To correct a cast, click on any of the eight preview images to apply a color change. You can click on the same image more than once to keep correcting the color and if you go too far, press the *Reset Image* button. For this example, the *Decrease Blue* preview was clicked twice in succession, followed by one *Increase Red*.

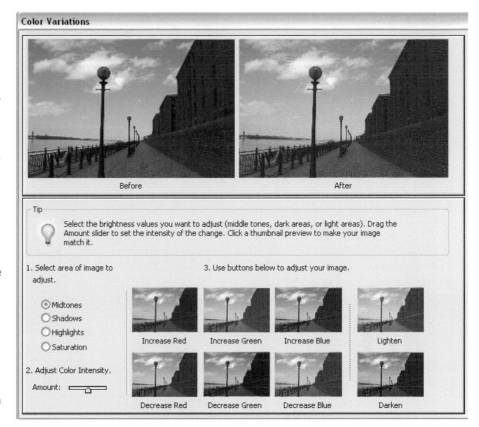

3 The end product bears little resemblance to the murky starting point and now looks much more lively. Notice how much detail has been restored to the brick walls and the intensity of the blue sky. The advantage of editing in this manner is that it's all accomplished without the need for complex selections or masks.

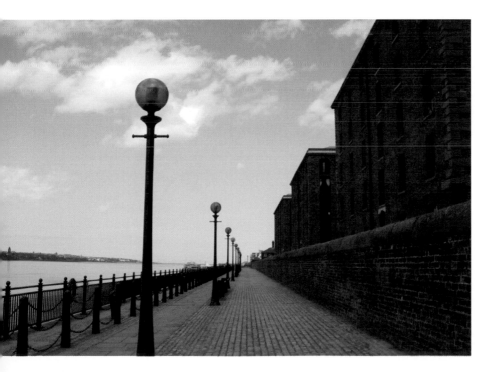

Poor color saturation

If possible, you should use a proper shade or skylight/UV filter fitted onto the camera lens when you're shooting on location. These low-cost devices can make a radical difference in the way color is captured and preserved in your image file, because they filter out unwanted light that dilutes color and contrast. Unfortunately, some compact cameras don't allow you to use these devices, but Elements can help make up for it.

In this example, a great vantage point was found to capture a vast open landscape during the autumn season, but the raw file looked very disappointing when opened on the computer. Gray predominates the scene, and the other more interesting colors look washed out and subdued. The goal is to enhance these vibrant colors without creating a too obvious result.

 treatment

Boost the image color with the *Saturation* command

The most irritating aspect of these poor color situations is that the unwanted light is often not visible when shooting, and it's only when you return to your computer that you realize a mistake has been made. A simple *Saturation* command in Elements will correct this kind of shooting error and restore your file to its original glory.

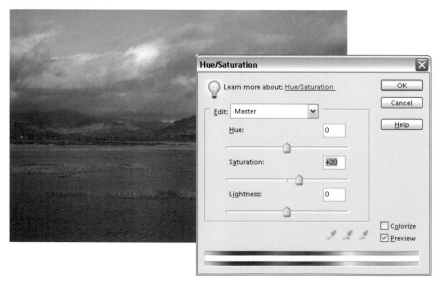

Located under the *Enhance> Adjust Color>Adjust Hue/ Saturation* menu, the *Hue/Saturation* dialog box is full of useful tools to help restore color to your image. Start by dragging the dialog box to one side, so you can see the effects on your image. Make sure the *Master* channel option is selected in the *Edit* pop-up menu found at the top of the dialog box. Next click on the *Saturation* slider and move this +20 steps to the right.

When editing the *Master* channel, all colors within the image are changed at the same rate—in this case by having their intensity increased. Notice how the image immediately starts to look more vivid.

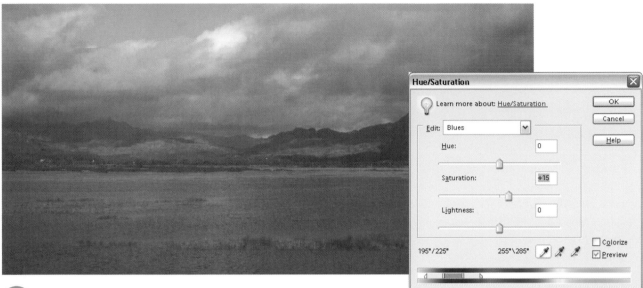

2 To further enhance your image, try selecting an individual color from the *Edit* menu. In this example, *Blues* was chosen as the sole edit color, so it could be brightened while other color values were left unchanged.

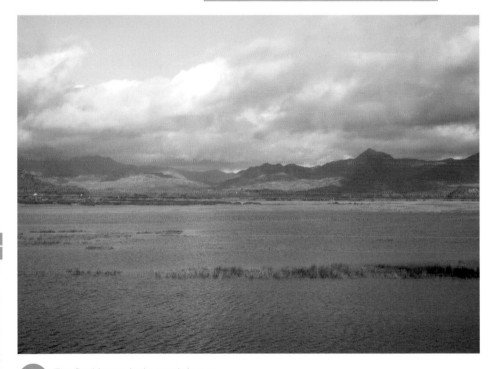

HEALTHCHECK ⟋

Keep your lens clean

A dirty camera lens can also result in washed out color caused by grease smears from fingers. A dirty lens will block vivid colors from entering the camera and create very disappointing results. To keep your lens in top condition, clean it with alcohol-based lens or eyeglass wipes, moving the tissue around the lens in a very gentle circular motion. If you have particles, such as sand or dust, on your lens remove these first with a compressed air canister or a soft dry artists' sable brush.

3 The final image looks much better when compared to the starting point because most of the bland gray tones have been removed. The individual blue edit also had an effect by boosting the tiny amount of blue in the water areas. And it was all accomplished without the need for a complex selection.

symptom

Blue snow or shadows

Even the best photographers end up with color casts on their prints, but the real secret is knowing how to correct these problems without significantly degrading the image quality.

Perhaps the hardest color cast to remove is one that seems embedded into the highlight areas of an image. These are sometimes caused by artificial lights, such as fluorescent tubes, or when interior scenes are captured with the wrong camera white-balance settings. This example showcases another common color cast problem—snow scenes that are the wrong color.

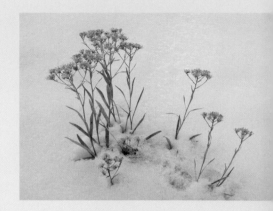

treatment

Correct with the *Remove Color Cast* command

Color casts make an image look dull and muddy, and they prevent the bright colors you'd expected from standing out. This image should be bright white, but instead it's a murky blue. The key to this edit is to work slowly and not overdo the color correction, or you will simply move the problem elsewhere rather than solve it.

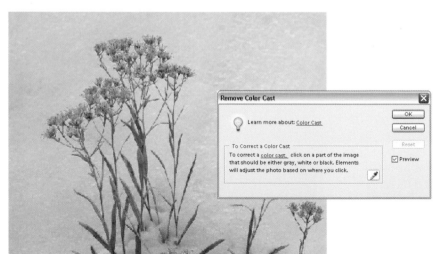

 The *Remove Color Cast* command is found within the *Enhance>Adjust Color>Remove Color Cast* menu. It works by making an educated guess about the embedded cast, so you don't need to make a judgment. The command asks you to identify a highlight, shadow, or midtone point and then allows you to click a tiny dropper tool onto your image. If the right tone is selected, then all color casts are removed from your highlights instantly.

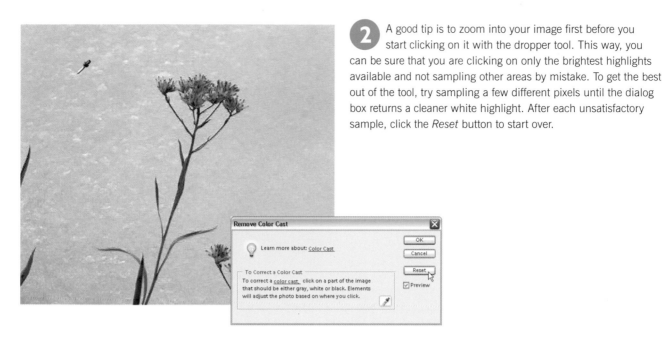

2 A good tip is to zoom into your image first before you start clicking on it with the dropper tool. This way, you can be sure that you are clicking on only the brightest highlights available and not sampling other areas by mistake. To get the best out of the tool, try sampling a few different pixels until the dialog box returns a cleaner white highlight. After each unsatisfactory sample, click the *Reset* button to start over.

3 The fully corrected image shows no sign of the metallic blue-cyan cast that was present at the beginning and, as a consequence, other colors that were suppressed are now much brighter. After removing the dominant colors from a poor original, you will always find that the other image colors appear much more vivid.

HEALTHCHECK

The color wheel

Color casts can be easily removed as long as you know the fundamental principles of the color wheel. In all color reproduction there are six colors broken into three opposite pairings: Red and Cyan, Magenta and Green, and Blue and Yellow. When color casts appear, they are caused by an exaggerated amount of one of these six colors. Casts can be removed simply by increasing the opposite color until it disappears completely. There's no mystery to the process, just a common-sense approach.

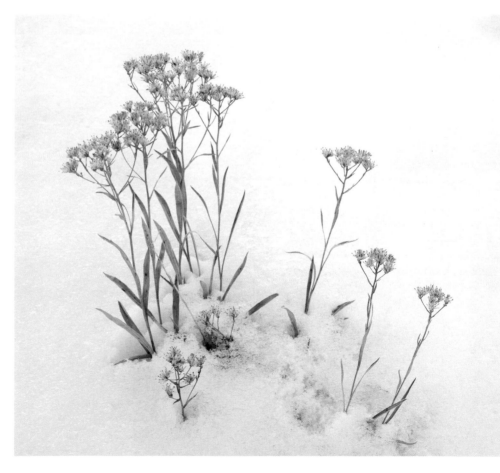

Avoiding white-balance problems

Light is measured by its color temperature using the Kelvin scale. This ranges from red at its warmest to blue at its coolest. The midpoint of this scale is pure white. When you look at an object, such as a sheet of paper, you know from experience that it's supposed to be white, regardless of the lighting around you. A digital camera records its images using the primary colors red, green, and blue, and has no experience to fall back on. From this information, it tries to measure and balance the color levels to create the most natural-looking image. However, as far as the camera's concerned, pure white will only be produced when all three primary colors are equal, anything else will be an off-white.

Some cameras have a custom white balance setting. A reference, such as a white wall or card is shot and stored in the camera, and used to alter the settings.

Another feature is white-balance bracketing. This mode takes a number of shots (usually three) at the same time, but applies different white-balance settings to each. These are generally preset using the camera's menu and give a spread from warm to cool.

Scene modes also alter the white balance. Sunset, for example, will shift the scale toward the cooler end, while a beach/snow setting will shift down to compensate for the higher level of blue.

When you are taking photographs in RAW mode, if your camera supports it, the light information is stored on the camera exactly as it enters the lens and can be adjusted once it has been downloaded onto your computer. Your photo-manipulation software is programmed with the camera model and can apply different settings automatically.

WHITE BALANCE SETTINGS

Unfortunately, light sources are very rarely pure white, and different types of light can upset the camera's white balance. This will result in images with a red or blue color cast. Most cameras have the facility to set the white balance depending on the lighting conditions, so you can control how the shot is recorded. The following images have been taken in a neutrally lit studio to illustrate the effects of some of the standard white-balance camera settings.

Tungsten
Lightbulbs give a warm, yellow cast, so this mode increases the temperature toward the blue end of the scale.

Fluorescent
These lights give a cooler, blue light, so this setting adjusts the temperature toward the warmer end of the scale.

Daylight
Use this setting for a clear, sunny day. There is a slight blue cast so the temperature is lowered slightly.

Flash
This setting is also used for midday sunlight and is almost pure white, so very little adjustment is made.

REMOVING COLOR CASTS

Unwanted color casts can be removed using filters and *Levels* adjustments.
The following images were shot under a tungsten lamp, which is a warm light.

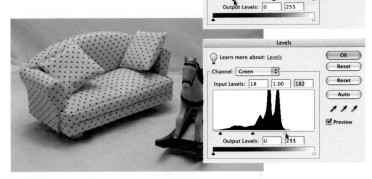

1 This image has been shot using the *Daylight* setting and has been given a warmer cast. The *Levels* dialog box can be used to fix this kind of problem. This is the most controllable adjustment filter because each color channel can be manipulated individually. This is accessed from *Enhance>Adjust Lighting>Levels*.

2 Select *Red* from the *Channel* drop-down menu, and drag the left-hand slider across until it reaches the point where the histogram starts to rise.

Now select the *Green* channel. Two adjustments are needed: drag the left-hand slider to the very first upward point, then do the same with the right-hand slider.

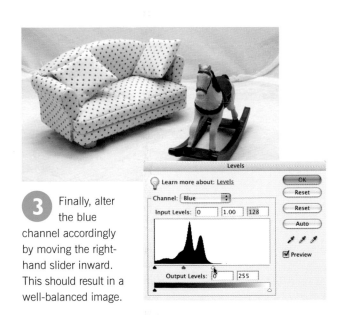

3 Finally, alter the blue channel accordingly by moving the right-hand slider inward. This should result in a well-balanced image.

Camera setting too cold

The camera was wrongly set to Fluorescent, and has over-compensated for the white balance. The *Remove Color Cast* dialog box, accessed by selecting *Enhance>Adjust Color>Remove Color Cast*, is the perfect tool for this job. Click the dropper tool on an area that is known to be white—such as the highlights on the sofa's cushion—and the global white balance is altered to match.

Lifeless or missing color

Shooting on location can be frustrating when small areas of your subject fall into shade and end up duller than you expected. Luckily, the color intensity, or saturation, of each individual pixel in a digital photo can be raised or lowered with ease. This project will show you how to do this as simply as using a brush.

 The original unretouched image for this project was shot on a cold winter morning and it did not display vivid colors or contrast. Although the muted color palette of the image is attractive, small individual areas can easily be enhanced to add more visual interest to the shot.

treatment

Use the *Sponge* tool to resaturate

The goal is to raise the color saturation of just a few leaves within the composition. You can enhance the color intensity of individual areas of any digital photograph by using Photoshop Elements' versatile *Sponge* tool, which has two modes. The first mode desaturates colors, the second saturates them.

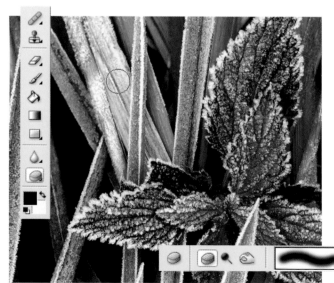

I To begin, select the *Sponge* tool, which is found at the base of the *Tools* palette within the same pop-out menu as the *Dodge* and *Burn* tools. The *Sponge* tool can work in two different modes: *Saturate*, to intensify color or *Desaturate*, to drain it away. For this project, choose the *Saturate* mode.

 Zoom into the part of the image you want to edit, then select a large soft-edged brush, around 200 pixels. Finally, set the *Flow* value to 50 percent. The *Flow* properties allow you to set the amount of change that occurs with each brushstroke. Lower values create a slight increase in color saturation and will require many individual brushstrokes to take effect. Higher values create an instant change with a single application, but will appear obvious and poorly applied.

 Size: 210 px ▶ Mode: Saturate ✔ Flow: 50% ▶

2 Be sure that your *Undo History* palette is open (*Window>Undo History*), so you can backtrack if you make any mistakes. Use a soft-edged brush to prevent harsh boundaries between saturated and unsaturated areas.

Apply the brush gradually and watch how the color values are boosted with each individual stroke. It's much better to edit your image in this way, using a lower *Flow* value and plenty of brushstrokes, rather than in a few quick moves.

3 Just like arranging shapes in your camera viewfinder to create a pleasing composition, use the same approach for deciding on color saturation.

Apply this kind of edit sparingly to your image, so that the overall emphasis on the main subject is strengthened rather than diluted. In this example, the central cluster of leaves and a few other blades of grass were intensified. This enhancement helps lead your eye into the center of the image.

HEALTHCHECK

Calibrate your monitor

If you haven't taken the time to color calibrate your computer monitor, you can't really tell if your image colors are weak or strong. All monitors need to have their contrast, brightness, and color balance set to a common standard using simple calibration wizards such as Adobe Gamma. A quick 15 minutes setting up your monitor will save hours of future frustration and the unnecessary waste of paper and ink. See pages 18–19 for more details on monitor calibration.

Daylight color casts

Surprisingly, the color of natural daylight is far from consistent and can vary depending on location and time of day. It's possible to remove these unwanted casts using Photoshop Elements' *Color Variations* controls to tweak the shadows, midtones, and highlights separately for better effect.

The time of day and choice of location can have a dramatic effect on color reproduction—even an innocuous canopy of trees can cast an unnatural green color across any portrait sitter unlucky enough to be positioned underneath. In this example, a richly colored arbor of trees acted like a giant green filter to the natural daylight, creating an unflattering green cast over the bride. Luckily, these wedding photos can be saved with a few clicks of the mouse in Elements.

 treatment

Fix skin tones by enhancing *Midtones* and *Highlights*

Unlike digital cameras, the human eye is mostly self-correcting when faced with subtle changes in light color, so the photographer would not have been aware of the unwanted cast until the image file was viewed later on. With such a severe cast embedded into both highlights and skin tone, the problem calls for a two-step solution.

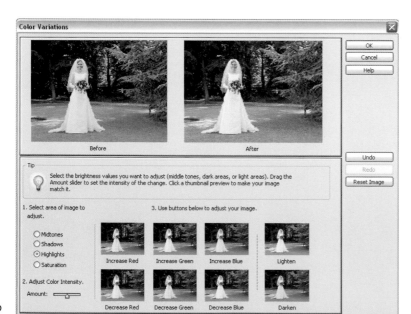

1 Choose the *Color Variations* tool from the *Enhance>Adjust Color* menu. The first step is to change the selection area of the image that will be adjusted from the default *Midtones* to *Highlights*. In an image where large areas of white have been colored, it's best to clean the highlights first. To remove a green cast, click on the *Decrease Green* option and keep clicking until the whites appear clean in the *After* preview panel. If a single click overcorrects your cast, click *Reset Image*, then reduce the *Amount* slider and start over.

132

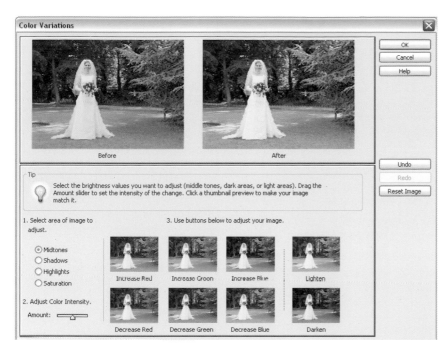

2 To complete the color removal process, change the adjustment area back to *Midtones*, and then apply a single *Decrease Green*. Your image should now appear fully corrected, but it may be a little cold looking. To correct this, apply a single *Decrease Blue* to add yellowish warmth to the final result.

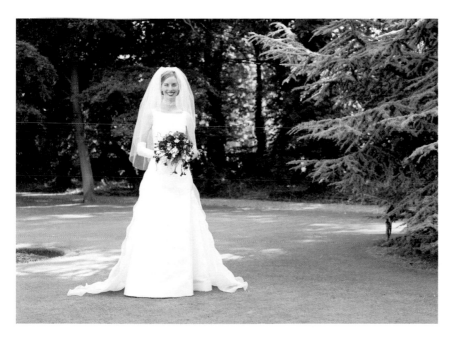

3 Compared to the original starting point, the end product looks much more flattering and really captures the natural lighting conditions. After the green has been removed, the reds look more vivid, and the skin tones look much better. A good indicator of overcorrection is to examine any neutral-colored areas within the image, such as the small area of gray path at the left of this image. If overedited, this would take on the color of the correction—it would appear redder than normal.

Image contains intrusive noise

Noise generally occurs when the camera's ISO rating is set to a high value—such as 400 or above. This makes the camera more sensitive to light, allowing you to shoot in lower light conditions and retain the ability to use a smaller aperture and/or fast shutter speed.

The downside to this extra sensitivity is that it can cause noise to appear on the image. In many cases, the level of noise is not high enough to cause any adverse effects. Sometimes it can even enhance the picture, especially if it's converted to black and white. With many photos, however, noise can potentially ruin the image. Blotches of discoloration and contrasting specks can be very pronounced—particularly if the image is enlarged. This photo is a good example of how noise did not appear until the image was enlarged as a print.

 treatment

Remove with the *Despeckle* and *Reduce Noise* filters

Elements has a number of tools to help rectify the intrusive noise problem and while it's not always possible to remove the discoloration completely, the effect can be greatly reduced to produce good quality prints. As with many post-shot operations, there is often a need to process the image in a number of stages.

1 This photo was taken without a flash and as a consequence, is quite dark. After adjusting and enhancing the lighting, a close look revealed that the image had a lot of noise. This noise can spoil the image if printed as is.

2 Because the noise and grain is very pronounced, the image needs to be processed in two stages. First select *Filter>Noise>Despeckle*. The *Despeckle* filter finds and softens high contrast grainy areas and attempts to retain as much detail as possible.

3 Now that the harsher effects have been reduced, the color distortion and softer noise can be adjusted. Go to *Filter>Noise>Reduce Noise*. Set the *Strength* to 8. A value of 60 has been used for *Preserve Details*. Finally, *Reduce Color Noise* has also been set to 60 percent. As with many of Elements' filters, the settings will vary greatly depending on the image, so experiment until you find the right balance for your image.

HEALTHCHECK

The *Reduce Noise* filter up close

The *Reduce Noise* filter has a large preview display. This can be zoomed in and out and moved around to enable you to review the detail. There are three output values controlled by sliders:

Strength: 8

Strength: This controls how the filter will affect the image. Increase this value depending on the amount and intensity of the noise.

Preserve Details: 60

Preserve Details: This setting counteracts the blurring effect of the *Strength* level. Its function is to balance out the loss of sharpness.

Reduce Color Noise: 60 %

Reduce Color Noise: Use this slider to remove blotches of color. These are typically green or pink-red.

Doctor, I want plastic surgery!

They say that photographs never lie, but every now and then it would be nice if they did. Whether the subject wasn't quite ready when the photo was taken, or a blemish appeared on the day of the shoot, it's good to know that Elements is at hand to clear things up.

symptom

Patchy skin tone

Photographs can be very harsh critics. Everyday images, particularly when taken with a flash, can turn a potentially flattering portrait into the picture you quickly flip past in the family album. Even under carefully set up studio lighting, shadows and blemishes can become more pronounced.

With photo manipulation software, your digital pictures can be rescued with relative ease. Photoshop Elements has many tools to help with this task: the *Clone Stamp*, *Healing Brush*, and the aptly named *Spot Healing Brush* are all designed for retouching purposes. The latter tool is one of the most powerful, yet simple to use. Take care when retouching, however, as it's very easy to overdo it, and the results can look artificial. In this example, the subject's uneven skin tone and minor blemishes detract from the portrait.

treatment

Smooth out roughness with the *Spot Healing Brush*

The portrait itself is fine, so no major recomposition is required. The minor blemishes can be removed using the *Spot Healing Brush*, and the larger patches of uneven skin cleaned up with the *Healing Brush*. The overall skin color can then be improved using the *Replace Color* command on a duplicate layer.

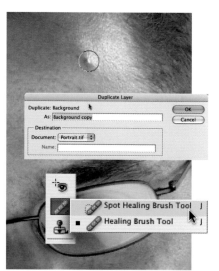

1 First duplicate the background layer by selecting *Layer>Duplicate* from the main menu. It's always a good practice to do this as a guard against irrecoverable mistakes, but in this instance, the duplicate is used to complete the effect.

2 Use the *Spot Healing Brush* tool for the blemishes. Choose a small, hard-edged brush, and zoom in so you can see the areas clearly. Then simply position the cursor over the spots to be fixed and click once on each to repair them.

HEALTHCHECK

Making the most of the *Spot Healing Brush*

The *Spot Healing Brush* works in a similar way to the *Healing Brush*, matching tone, color, and texture, but it only takes samples from the brush area. It has two modes: *Proximity Match* and *Create Texture*. The first examines the immediate area surrounding the brush for blending. The second uses the pixels within the brush area to generate a pattern to repair the selection. Generally, you should use a brush size slightly larger than the section you want to fix.

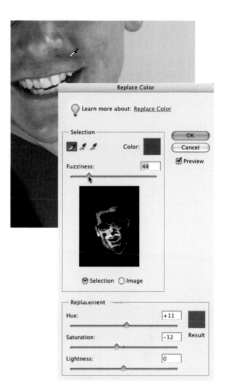

Mastering the *Replace Color* dialog box

The *Fuzziness* setting of the *Replace Color* dialog box is similar to the *Tolerance* settings of tools like the *Magic Wand*. The higher the value, the greater the number of similar colors that will be affected.

3 The *Spot Healing Brush* is great for smaller fixes, but it can behave erratically on larger areas, such as pitted skin on cheeks. The standard *Healing Brush* tool is more useful in these situations.

Select the *Healing Brush* tool from the *Tools* palette, hold down the Alt/Option key, and click on an area of clearer skin—the forehead is a suitable place in this image. Next paint over the area of the photo to be healed. This is similar to the *Clone Stamp* tool, but the cloned parts are automatically blended with the background.

4 There are still some patches of redness to the skin. For these, you can use the *Replace Color* command, accessed from *Enhance>Adjust Color> Replace Color*. Use the eyedropper to take a sample of the red, and all areas of a similar color will show as white in the dialog box's preview window. Then lower the *Saturation* and adjust the *Hue*. Lastly, adjust the *Fuzziness* to give a more balanced tone.

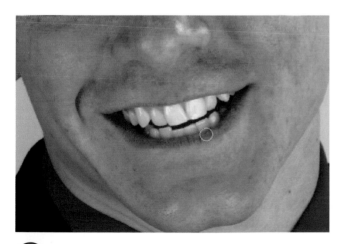

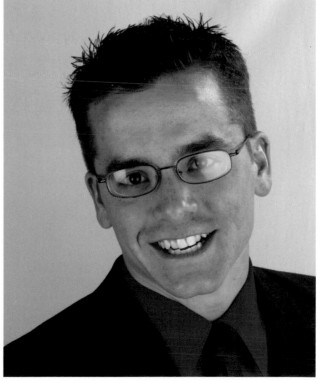

5 Now it's time to use the duplicate layer from step 1. The earlier color change also affected the subject's mouth, but it is simple to erase the discolored areas of the image to allow the original to show through. Use the *Eraser* tool with a soft-edged brush, set it to an opacity of 50 percent, and brush away some of the affected area to reveal the original beneath.

Subject blinked

Blinking is an autonomous function that serves to cleanse or protect your eyes. Although it happens for a fraction of a second, the speed of a camera can easily catch the moment the eyelids are closed. In portrait shots, the eyes are a strong focal point and without them, the photo will seem strange and unappealing. In a studio setup, you can often retake the shot. But if you are capturing a special moment, the second take may not be so good.

All is not lost, however. With a bit of clever manipulation, you can open a person's eyes and restore a seemingly spoiled shot. In this image, the composition is good but the model closed her eyes just at the wrong time. A similar picture was taken but she wasn't as happy with the position. The flash also threw some harsh shadows on the wall behind her.

 treatment

Use Elements to replace closed eyes with open ones

The open eyes from the second image are copied to a layer, then pasted into the first image and distorted slightly to match the angle. Finally, the shots are blended with the *Eraser*. Although you won't always have the luxury of two shots taken under the same conditions, the basic technique can be used with completely different images.

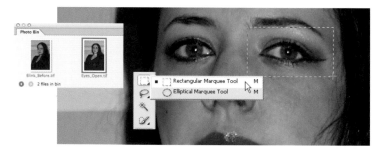

1 First open both images. They will appear in the *Photo Bin* and can be alternated between by clicking on their thumbnails. Select the image with the eyes open and choose the *Rectangular Marquee* selection tool (keyboard shortcut: M). Position the cursor in the top corner, just above the right eye, then click and drag the bounding box to the bottom corner, just below the eye. Press Ctrl/Cmd+C to copy the selection to the clipboard.

2 Switch to the target image and press Ctrl/Cmd+V to create a new layer above the background layer containing the selection. Double click its name in the *Layers* palette and change it to "Right Eye." Lower the layer's opacity to around 50 percent. Select the *Move* tool (keyboard shortcut: V). Click and drag the layer into roughly the correct position. The layer is translucent, so the original background can be used to line it up.

3 Select *Image>Transform>Free Transform* or press Ctrl/Cmd+T. Move the cursor outside of the bounding box and the pointer will become a curved arrow. In this mode, the entire layer can be rotated. Click and drag the mouse up, and the box will rotate counterclockwise. Place the cursor inside the box, then click and drag again to move the layer. Try to match the left corner of the eye. Generally, this point moves very little when blinking.

4 A little more fine-tuning is needed. Hold Ctrl/Cmd again and drag the outer-top handle up and to the right slightly. Then drag the outer-lower handle down and to the right a little. This will match the new perspective more accurately. Finally, press Enter to apply the changes.

5 Now the eye is in position, it needs to be blended in. Bring the opacity back up to 100 percent. Select the *Eraser* (keyboard shortcut: E). Choose a medium, soft-edged brush and erase the larger unwanted areas. Bring the brush in as close a you can to the eye. Using the edge will create a good blend. Repeat the procedure for the left eye. Once you're happy with the image, use *Layer>Flatten Image* and save.

Portrait is unflattering to subject

Poorly or unevenly lit conditions can bring out the worst in even the most flawless skin, and standard cameras will pick out every detail. Whatever the occasion, there will almost certainly be someone anxious to record the day's events and even with all the best intentions, one or two less than flattering photos might find their way into the family album.

This example is a good portrait, but the lines and shadows are a little too harsh. One technique to prevent this is selective soft-focus. In photography, this is achieved using a specific soft focus lens or filter. The subject is shot with a very shallow depth of field and the foreground is blurred very slightly, but not so much as to lose the detail. The rest of the image appears slightly more out of focus, giving a hazy ambience that helps to soften it down.

 treatment

Use filters and layer blends to add a soft-focus effect

You don't need an expensive studio setup to create a beautiful portrait. This effect can be created quickly and easily with Photoshop Elements. By using duplicate layers and the *Gaussian Blur* filter at various settings, the depth of field can be controlled to produce a professional-looking image.

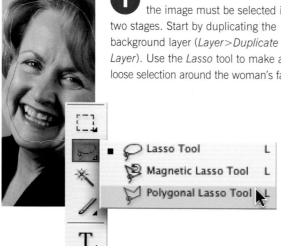

1 To achieve the desired effect, the image must be selected in two stages. Start by duplicating the background layer (*Layer>Duplicate Layer*). Use the *Lasso* tool to make a loose selection around the woman's face.

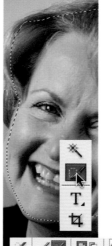

2 Pick the *Selection Brush* tool with a medium-sized, soft-tipped brush. Next paint around the previous selection, bringing in the contours around the face. Try to keep the brush roughly centered on the line of the existing selection, so that about half the width of the brush overlaps the edge.

This softens the edge and is vital for the effect to work correctly. You could use the *Feather* command but this method allows more control.

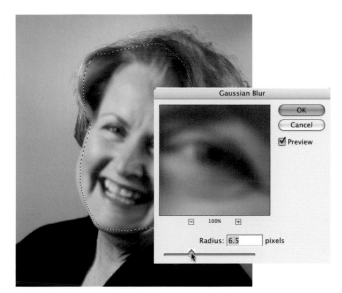

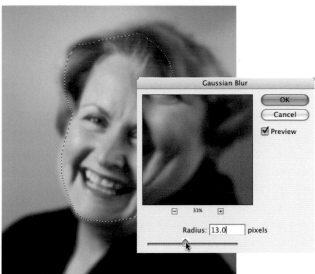

3 With the first selection complete, the next stage is to create a light blur. Select *Filter>Blur>Gaussian Blur*, and set a *Radius* of 6.5 pixels. This varies depending on the size of the image, so you may need to experiment by changing the *Radius* and checking the result in the *Preview* window. Once you're happy with the level of blur, apply the effect by clicking OK.

4 Next invert the selection by going to *Select>Inverse*. Bring up the *Gaussian Blur* filter dialog box once more, and set a higher blur *Radius*. Try about double the previous value, which is 13 in this instance. This creates a shallow depth of field. If the edge of the selection is not softened, there will be a visible border between the two levels of blur.

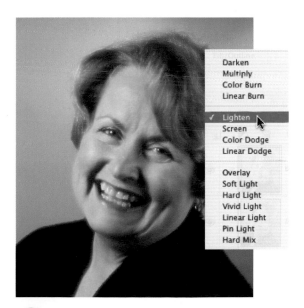

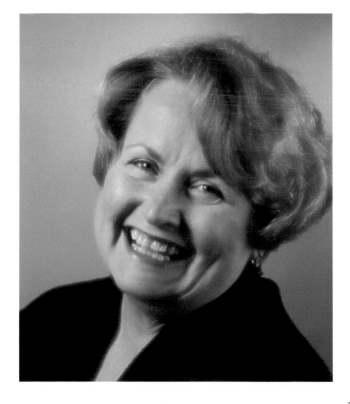

5 To complete the image, first deselect the selection (*Select>Deselect*) then change the layer's blending mode to *Lighten* from the menu in the *Layers* palette. This lessens the blur and softens the harsh shadows. The skin now looks smoother, but the image still retains a natural look.

Subject's figure appears bulky

Photographs capture and preserve a moment—however good or bad the subject looked at the time. Harsh lighting and poor composition can change a person's appearance, often for the worst. Heavy shadows can emphasize areas that are normally not prominent. The camera's lens can also distort the picture, causing the subject's image to curve more.

If a photo isn't quite what you expected, a little digital manipulation can work wonders. Elements has many features that can be used to straighten, tidy, and hide the features you'd rather not repeatedly see.

 treatment

Thin the body shape with layers and *Transform*

The following example uses layers and transformation to alter the overall body shape. Problem areas are flattened, reshaped, and smoothed with the *Clone Stamp* and

Healing Brush tools. Although some parts of the technique are specific to this image, its individual parts can be used to enhance any pose.

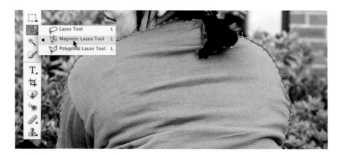

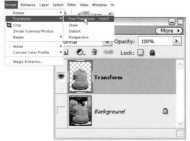

1 Begin by selecting the person's body outline. Pick the *Magnetic Lasso* (keyboard shortcut: L) and carefully work your way around the outline and any overlapping areas, such as the model's hair. Click again when you meet the selection's starting point. Now press Ctrl/Cmd+J to create a new layer. Double click its label and name it "Transform."

2 Click the background layer's *Eye* icon. This hides the layer to provide an uncluttered view. Go to *Image>Transform> Free Transform* or press Ctrl/Cmd+T. Hold Ctrl/Cmd+Alt/ Option+Shift, then click and drag the bottom-right corner point to the left. This will pull the layer in at the bottom but not distort too much at the top. Don't go too far, because it will look unrealistic. Press Enter when you are happy with the correction.

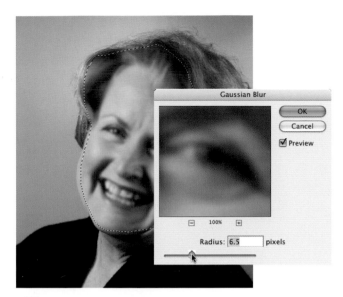

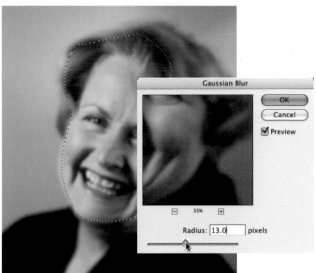

3 With the first selection complete, the next stage is to create a light blur. Select *Filter>Blur>Gaussian Blur*, and set a *Radius* of 6.5 pixels. This varies depending on the size of the image, so you may need to experiment by changing the *Radius* and checking the result in the *Preview* window. Once you're happy with the level of blur, apply the effect by clicking OK.

4 Next invert the selection by going to *Select>Inverse*. Bring up the *Gaussian Blur* filter dialog box once more, and set a higher blur *Radius*. Try about double the previous value, which is 13 in this instance. This creates a shallow depth of field. If the edge of the selection is not softened, there will be a visible border between the two levels of blur.

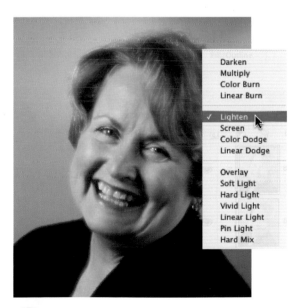

5 To complete the image, first deselect the selection (*Select>Deselect*) then change the layer's blending mode to *Lighten* from the menu in the *Layers* palette. This lessens the blur and softens the harsh shadows. The skin now looks smoother, but the image still retains a natural look.

Subject's figure appears bulky

Photographs capture and preserve a moment—however good or bad the subject looked at the time. Harsh lighting and poor composition can change a person's appearance, often for the worst. Heavy shadows can emphasize areas that are normally not prominent. The camera's lens can also distort the picture, causing the subject's image to curve more.

If a photo isn't quite what you expected, a little digital manipulation can work wonders. Elements has many features that can be used to straighten, tidy, and hide the features you'd rather not repeatedly see.

 treatment

Thin the body shape with layers and *Transform*

The following example uses layers and transformation to alter the overall body shape. Problem areas are flattened, reshaped, and smoothed with the *Clone Stamp* and

Healing Brush tools. Although some parts of the technique are specific to this image, its individual parts can be used to enhance any pose.

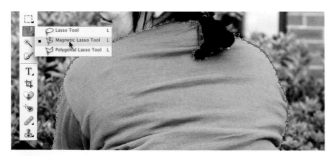

1 Begin by selecting the person's body outline. Pick the *Magnetic Lasso* (keyboard shortcut: L) and carefully work your way around the outline and any overlapping areas, such as the model's hair. Click again when you meet the selection's starting point. Now press Ctrl/Cmd+J to create a new layer. Double click its label and name it "Transform."

2 Click the background layer's *Eye* icon. This hides the layer to provide an uncluttered view. Go to *Image>Transform> Free Transform* or press Ctrl/Cmd+T. Hold Ctrl/Cmd+Alt/ Option+Shift, then click and drag the bottom-right corner point to the left. This will pull the layer in at the bottom but not distort too much at the top. Don't go too far, because it will look unrealistic. Press Enter when you are happy with the correction.

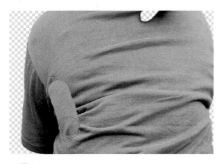
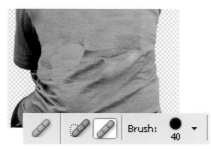

3 The contours of the body need to be altered and blended. Select the *Clone Stamp* and choose a medium-sized brush. Set the *Hardness* to 100 percent. Position the cursor on a smooth area of the shirt, hold Alt/Option, and click the mouse. Now reposition the cursor just above where the body line dips in under the arm. Carefully paint over the area. It will be replaced with the sampled section. Build it up so that there is a smoother contour.

Apply this technique on the other areas to remove the heavier creases. Take fresh samples as you go to avoid repetition.

4 The *Clone Stamp* tool leaves obvious patches that will need to be blended in. Select the *Healing Brush* tool (keyboard shortcut: J) and Alt/Option+click with it to sample a smooth area. Paint over the edges of the cloned areas with the tool to create a consistent texture. Don't flatten out all of the creases because this will look unrealistic.

5 Press Ctrl/Cmd and click the Transform layer's thumbnail in the *Layers* palette. Go to *Select>Modify>Contract* and use a value of 5. Press Ctrl/Cmd+I to invert the selection. Use the *Eye* icon to hide the layer, then click the background layer's thumbnail. Use the same technique as before to build up the background so that it meets the selection.

7 Go to *Layer>New>Layer*. Name it "Shadow" and use the *Brush* tool to lightly shade the bench beneath the model.

6 Make the Transform layer visible again, and zoom in on the face. Clone in the background to cover the excess of the shirt. Press Ctrl+D to deselect. Pick the *Selection Brush* (keyboard shortcut: A), and use a small, hard brush. Draw in the area where the chin should be. Now clone the skin to fill the selected area. Deselect and use the *Healing Brush* to blend the new area.

Next hold Ctrl+Shift+D to bring back the selection. Select the *Brush* tool, and choose a large, soft tip. Lower the opacity to 20 percent. Select black as the foreground color. With the very edge of the brush, add a soft shadow under the chin.

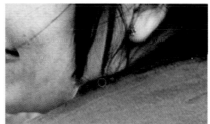

8 Pick the *Burn* tool (keyboard shortcut: O). Select a large, soft brush and set the *Exposure* to 50 percent. Lightly paint in a little shading on the sides of the body. Go to *Layer>Flatten Image* to merge the layers, then use the *Healing Brush* to neaten the area around the hair. Finally, clone in the collar of the shirt.

Photo needs a softer focus

Soft-focus is a technique often used in professional portraiture. A specialty lens softens the image, but retains enough clarity so the photo does not look completely out of focus. A cheaper alternative to these lenses is to use a diffusing filter in front of the normal lens. These differ slightly from true soft-focus lenses because they give a slight glow as well as soften the photo. You will often see this used to give a dreamy or romantic feel, especially in subjects such as wedding portraits or pictures of children.

Even with the right equipment, it can be tricky to produce the desired effect because soft-focus relies on good lighting levels. This is why soft-focus images are often taken in studios where the conditions can be controlled accurately. This photo captured a great moment, but the presentation is a little too harsh.

 treatment

Add an overall soft focus with *Gaussian Blur*

A hazy, diffused look can be quickly reproduced with a great degree of control by using a combination of filters and layer blending modes in Photoshop Elements.

Of course, you don't have to limit this technique to portraiture. You can apply it to many subjects, such as still life or even landscapes.

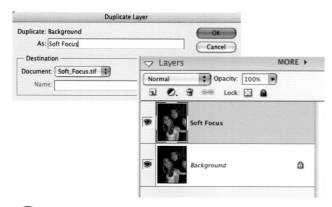

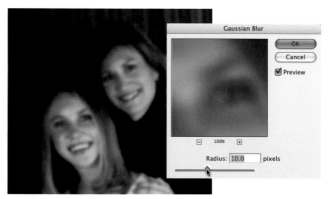

1 Duplicate the background layer with *Layer>Duplicate Layer*. Name the new layer "Soft Focus." In addition to being a part of the final effect, it's always good practice to work on a copy of the image in case something goes wrong.

2 Next blur the copy using the *Gaussian Blur* filter (*Filter> Blur>Gaussian Blur*). The amount of blur required will vary depending on the image size. In this case, a *Radius* of 10 pixels is sufficient. The effect will be toned down soon.

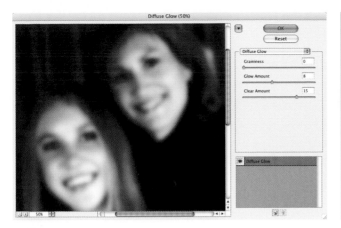

3 To give the image the slightly dreamy, high-key effect, select *Filter>Distort>Diffuse Glow*. Set the *Grain* to 0 to ensure a clean image. Set the *Glow Amount* to 8 to pick out the highlights without overpowering the image. The *Clear Amount* determines the translucency of the overall effect. In this case, we've set it to a high 15.

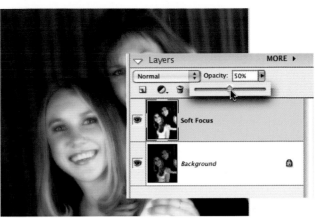

4 The effect is still too strong. Lower the opacity to 50 percent by adjusting the slider in the *Layers* palette. This makes the layer semitranslucent for a subtler blend.

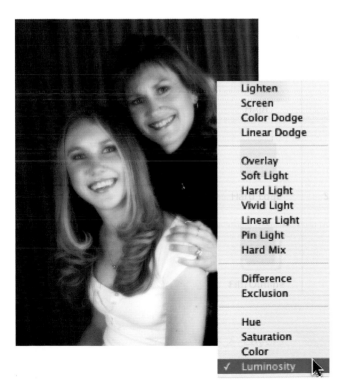

5 As a final touch, change the layer's blending mode to *Luminosity*. This returns some of the warmer midtones that had been slightly washed out by the *Diffuse* effect. The soft focus portrait is now complete.

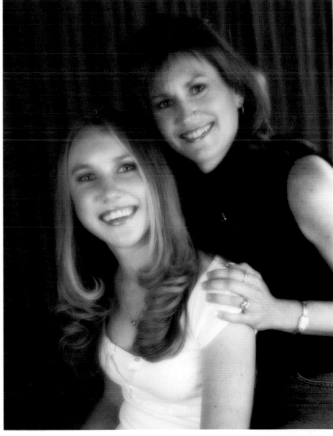

Eyes aren't the desired color

Have you ever wondered what it would be like to change your eye color? Maybe brown would suit you rather than blue, or perhaps you'd like to try something out of the ordinary, such as purple! Or maybe you have an image of a model to use in an advertisement, and it would look more appealing if the model's eyes reflected the color of the product.

You could use contact lenses at the shoot, of course, but there is an easier—albeit virtual—way. With Photoshop Elements, you can quickly and effectively alter the shade or the entire color of the subject's eyes.

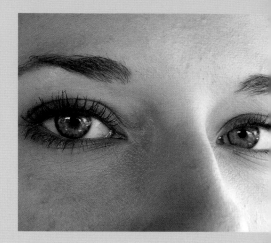

treatment

Change eye color with brushes and adjustment layers

It's easy to change the eye color in this example image from blue to brown by using a combination of the *Selection Brush* tool and an adjustment layer.

Adjustment layers are particularly good for this type of effect, because they do not overwrite the pixels and can be easily altered at a later stage.

1 Start by selecting the *Zoom* tool; position the cursor above and to the left of one eye. Now click and drag a selection box to the opposite corner and release the button. This will provide a better view of the subject, making it easier for you to work.

2 Choose the *Selection Brush* tool and set the *Size* to 60 pixels. The size of brush you choose will depend on your image. Choose *Selection* as the mode, and lower the *Hardness* to 98 percent. Use a slightly softer brush for blending around the eyes.

3 Pick a starting point on one of the eyes, and begin to carefully paint around the inside of the iris. As you paint, you'll see the marching ants selection boundary start to form. Continue until the iris is completely selected and repeat the process for the other eye.

4 Before changing the shade of the eyes, you need to remove the existing blue color. Select *Enhance>Adjust Color>Remove Color*. This gives a purely tonal base—one containing only tones, not colors—on which to apply the new eye color.

5 Go to *Layer>New Adjustment Layer>Hue/Saturation* and click OK to accept the default settings for the naming box. Notice how the layer's mask has taken the existing selection, so any changes will only affect the iris. Apply the following settings in the main dialog window: first check the *Colorize* box, then set the *Hue* and *Saturation* sliders to 27 and the *Lightness* to -10. The eyes are now a sparkling gold color, but the face remains unchanged.

HEALTHCHECK

Using the *Selection Brush*

If you make a mistake, switch the mode to *Mask* in the *Tool Options* bar. The red area represents the unselected part of the image. Now when you paint, you will be erasing the selection. When you're done, switch the mode back to *Selection* to see the changes.

Doctor, everything's wrong!

Although in a lot of photos there are only one or two small areas that need to be fixed to make a better print, in others the whole image seems to need correction. This chapter helps with the big fixes, and those times where a small fix can change the whole image.

Unwanted reflections

Unfortunately, with so many shiny surfaces around, unwanted reflections are unavoidable, and may spoil your picture by drawing the focus away from the intended subject. You may not even notice it at the time you are taking the shot, because some reflections only appear when the photo is seen at full size. With film photography, that's often too late. It can be almost impossible to rectify such problems, so you may have to discard the shot.

With digital photography however, this is not always the case. In this image, the woman's glasses are reflecting other people (including the photographer) and an unappealing parking lot.

 treatment

Remove using layers and blending modes

Many photos can be recovered with careful use of cloning tools. If, however, there is a large amount to remove or not enough of a clean area to use for cloning, it's easier to replace the offending area. By using the selection tools, layers, and blending modes to add a new image for a reflection, you can create a much more pleasing photo.

1 The first step is to isolate the area containing the reflection. The best tool for this is the *Magnetic Lasso*. Select the tool, and set the *Width* to a low value in the *Tool Options* bar—3 pixels in this case. This determines how much of the surrounding area is sampled by the tool when it looks for edges to follow. The *Edge Contrast* needs to be high as well, because this tells the tool how "different" the adjacent pixels have to be to count as an edge. Carefully trace the outline of the area to be replaced.

2 Once the selection is complete, go to *Layer>New> Layer*. Call this new layer "Base" and click *OK*. Next select *Edit>Fill Selection*, and choose *White* from the *Use* drop-down menu. This will become a template on which the new reflection will be created.

3 You'll need another photo at this stage. This will become the replacement reflection. Open it as a new file, use *Select>All* to select the entire image, and then *Edit>Copy* to copy it to the clipboard. Go back to the original picture, and use *Edit>Paste* to paste it as a new layer. Name this layer "Reflection."

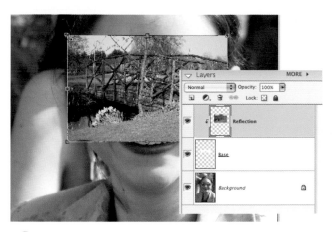

4 This new image is too large and needs scaling down to look realistic. Go to *Image>Transform>Free Transform*. Hold the Shift key, click one of the corners, and drag it toward the center. This ensures that the proportions are maintained when resizing. Shrink the image until it's only slightly larger than the target area. Press Enter to accept the transformation. Use *Layer>Group with Previous* to create a Clipping Group, indicated in the *Layers* palette by a small arrow next to the layer thumbnail. This binds the image to the layer below, and any empty layers on the lower layer will be masked out on the upper layer. Finally, lower the layer's opacity to around 75 percent.

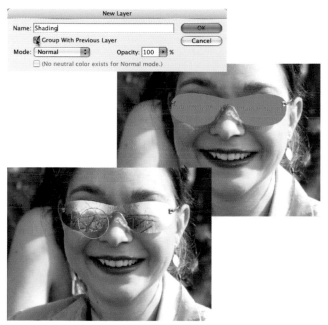

5 Select *Layer>New>Layer*. Name it "Shading" and check the *Group With Previous Layer* box. Next fill the layer with 50 percent gray, and set the layer's blending mode to *Hard Light*. Select the *Burn* tool from the *Tools* palette and use a large, soft brush to paint in some darker areas. Use the lighting on the original photo as a guide. Hold the Alt/Option key to temporarily switch to the *Dodge* tool to paint in some highlights. This gives the impression of a rounded surface and adds realism.

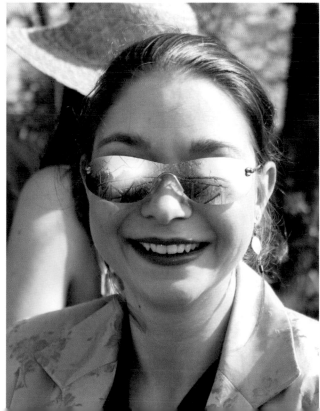

153

Image is distorted

Camera lenses are constructed from several individual elements of convex (outwardly curved) glass. As light enters, it starts to spread as it nears the edges of the lens. When taking photographs of subjects close-up or using the lens at its widest angle, the image can become noticeably curved; this is more commonly known as barreling. This effect is particularly prominent when the image contains strong horizontal or vertical lines. The problem can also occur when taking close-up portraits, where the subject's face may appear slightly bloated—similar to looking at someone through the security peephole in a door.

This image was taken with a wide-angle lens and consequently, there is a large amount of curvature visible toward the edges of the photo.

treatment

Correct wide-angle lens distortion with filters

Distortion can be removed using Elements' *Pinch* filter. The effect works by drawing the edges of the image in toward the center. The larger the value, the more pronounced the curve becomes. Take care with this filter because it uses a circular grid, which can cause a rippling effect as it reaches the edge of the frame.

I The first step is to increase the canvas size. Double click the background layer's thumbnail in the *Layers* palette to convert it to a regular layer. Now select *Image>Resize>Canvas Size*. Use the drop-down menu to set the measurement to *Percent*. Set the *Width* and *Height* to 50. Finally, check the *Relative* box and click OK.

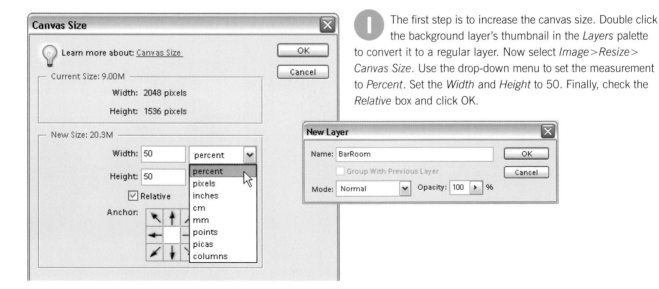

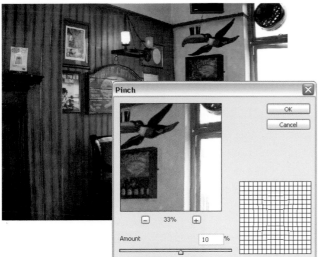

② Go to *Select>Select All* (Ctrl/Cmd+A). This creates a selection that encompasses the entire canvas. Choose *Filter>Distort>Pinch*. Set the *Amount* to 10 percent. This filter does not give a live preview of the full-size image, so it can be difficult to judge. Use the dialog box's preview zoom buttons (+ and -) to alter the amount of the image shown in the window. The image can also be panned to different areas by clicking the mouse and dragging inside the window. Click OK to apply the effect.

③ The image needs to be trimmed to remove the concave edges that the filter has produced. Select the *Crop* tool (keyboard shortcut: C) and position the cursor in the top-left corner of the photo, just inside the edge. Click and drag the bounding box to the bottom-right of the image. Keep within the bowed sides. Release the mouse button to preview the change. Use the boundary's handles to adjust the border, if necessary. Click the check mark in the *Options* bar to perform the crop.

④ The final result is a marked improvement over the original image. All traces of distortion are gone, and the lines now run straight.

Skies are weak

A pale sky can cause an image to lose some of its appeal, especially when it's used to frame a piece of architecture or it is the backdrop to a stunning landscape. This happens because it's difficult for the camera to balance the exposure between the bright background and the darker foreground. If the sky is metered, the foreground may be underexposed or more commonly, the subject will be okay but the sky is overexposed and washed out.

To overcome this problem, photographers will often take two separate shots, setting different exposure levels for each and merging them later in the darkroom or digitally. This generally requires the use of a tripod to minimize the difference between the two photos. This image captured a double rainbow, but the sky is so weak that it is difficult to see the color.

 treatment

Boost pale skies with filters, selections, and levels

A simple increase of the brightness or saturation of the image won't fix the washed-out sky because the correctly exposed foreground will look too heavily processed.

To work around this, you need to isolate the sky. You can do this with the *Magic Wand* tool. Adjustment layers can then be created to alter the sky's brightness and color.

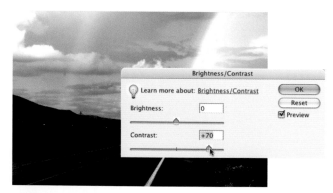

1 First create a *Brightness/Contrast* adjustment layer by selecting *Layer>New Adjustment Layer>Brightness/Contrast*. This will allow you to temporarily increase the contrast to much higher levels without affecting the image itself. You can now select the sky without it bleeding into the landscape.

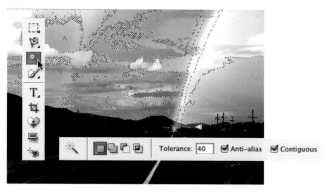

2 Using the *Magic Wand* tool with a *Tolerance* set to 40, start to select the sky area. By holding Shift and clicking the different areas, you can add to the selection each time. If you have a complex sky, you may need to click several times before it is all selected.

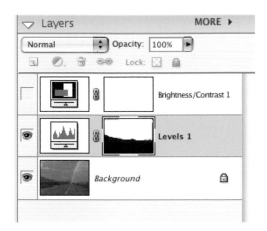

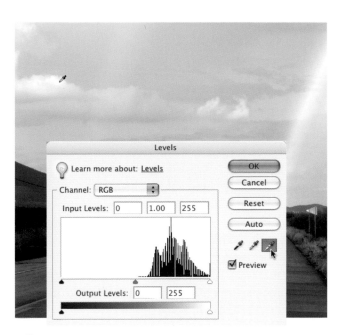

3 Once the entire sky has been selected, hide the adjustment layer and select the background image again by clicking its thumbnail in the *Layers* palette. Create a new *Levels* adjustment layer (*Layer>New Adjustment Layer> Levels*). You will notice that a mask has been created from the selected area. This means that only this part of the image will be affected by the *Levels* changes.

4 Pick the *Set White Point* eyedropper on the right of the *Levels* dialog box. When this tool is clicked on an area of the image it will make the selected tone pure white and adjust the rest of the image accordingly—in this instance, the selection was the brightest area of a cloud.

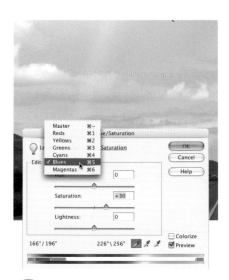

5 As a final touch, you can boost the sky a little more. This is done by selecting the original *Brightness/Contrast* layer, and then going to *Layer>Change Layer Content>Hue/Saturation*. Only the blue tones need to be changed, so choose them from the *Edit* drop-down menu. Using the eyedropper, pick a strong blue from the background and increase the *Saturation* to +30.

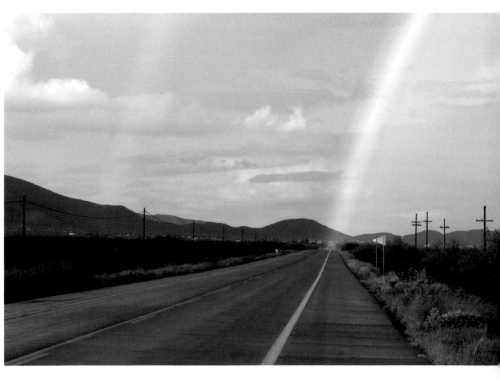

symptom

Vertical shapes converge

Most photographs are taken from a standing position and use the same viewpoint each and every time. Changing your viewpoint creates a very different result and utilizes one of photography's core functions: to see the world in a new way. A low vantage point can easily be set by squatting or kneeling down to a child's eye level and it can make ordinary and everyday items seem surreal. A worm's eye view is created by lying on your front with the camera placed firmly on the ground or on a mini tabletop tripod. This can be an unexpected way to convey the drama of a surrounding landscape—an effect increased by using a wide-angle lens setting. One problem with such shots is that they will often be distorted, and the converging verticals, such as those in this image, may not be the effect you're after.

treatment

Use *Perspective* tools to fix the photo

Most perspective errors can be corrected with Photoshop Elements' simple *Transform* tool. If the outcome of this tool looks fake, or just doesn't work, you can try using the *Perspective* command to pull converged verticals apart again, filling in the new image areas with interpolated pixels.

1 To undergo a perspective change, it's essential to make your image appear slightly smaller than usual in the workspace. Use the *Navigator* palette to zoom out of the image so you can see an area of blank gray space between the image window and the image edge.

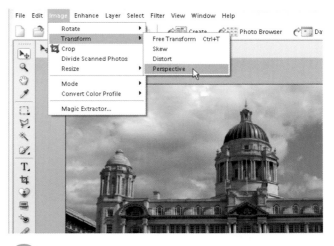

2 From the *Image* menu, choose *Transform>Perspective*.

3 For the *Perspective* command to work, the background layer must be altered from its default locked state and changed into an editable layer. Elements can do this for you—just follow the on-screen instructions.

4 When the transform handles appear around the image, pull either the top-right or top-left handle away from the image edge, as shown above. This will straighten the sides of the distorted building. If your new building shape starts to look squat, move either of the transform handles upward to stretch the height of the building.

5 Without visible distortion, the finished image looks much better. However, keep in mind that while solving the distortion, new pixels were added to the image, which can cause a minor loss of sharpness if viewed up close.

Objects look too far away

Many digital cameras have an additional function called a digital zoom that works differently from a conventional telephoto lens. Rather than pulling your subject closer, like a telescope, a digital zoom works by enlarging a small central section of pixels to make a far-off subject appear larger. The process is called interpolation and works by mixing new pixels—with estimated color values—with the original pixels. The resulting images can appear soft and much lower quality than those shot with a conventional longer lens. In this image there are two focus points vying for the viewer's attention. The task is to remove as much of the lower half of the picture as possible without ruining the upper half. In hindsight, many images look better if fewer subjects are crammed into the frame.

 treatment

Enhance with *Crop* tool and interpolation methods

In the latest versions of Photoshop Elements, the *Crop* tool darkens the areas you propose to crop, so you get a better representation of how the final image will appear.

Digital recomposition inevitably means the loss of some areas of original pixels, thereby reducing the potential to print images at a large size.

1 Apply the *Crop* tool to the entire image, as shown above. This will give you the option of retaining the same image proportions, if you wish.

2 Hold down the Shift key, and click on the bottom-left corner handle. Push the corner handle upward to retain the image proportions while determining the exact edge of the crop. When it is correct, click the check mark in the *Tool Options* bar to confirm your decision.

3 To check the new size of your cropped image, go to the *Image Size* dialog box (*Image>Resize>Image Size*) and check the new *Document Size*. In this case, the image has lost a significant amount of its area to the crop, so new pixels need to be added back to make the image print at a good size.

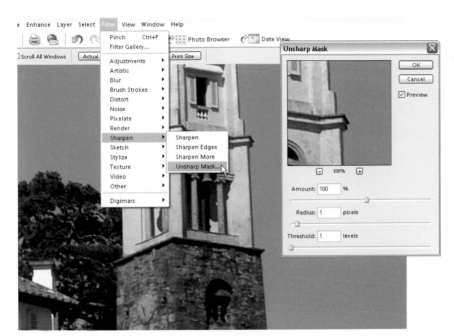

4 Select the *Unsharp Mask* filter (*Filter>Sharpen>Unsharp Mask*) and zoom into your image so that you can clearly see a defined edge, then set your dialog box as shown at left.

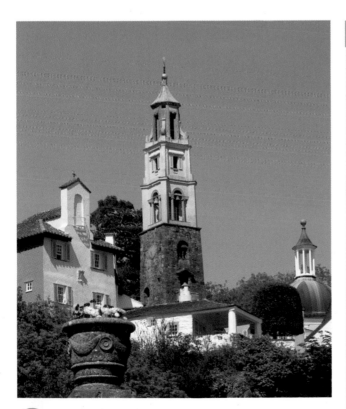

5 With little sign of enlarging or sharpening, the final result is a much better version compared to the unfocused starting point.

How sharpening works

Sharpening works by increasing the level of contrast between edge pixels. In a soft-focused image, colors are muted at the edges of shapes, but in a sharp image, colors are more widespread and inherently have more contrast. Digital camera images are often soft because of the anti-aliasing filter that is fixed in front of the sensor to prevent jagged pixel shapes from appearing.

Photoshop Elements comes with four sharpening filters: *Sharpen*, *Sharpen More*, *Sharpen Edges*, and *Unsharp Mask*. All of these can either be applied to the overall image, or to a smaller selection area. Only the *Unsharp Mask* filter can be modified, the others are all one-click fixes.

The *Unsharp Mask* tool

Under the *Filter>Sharpen>Unsharp Mask* command, the *Unsharp Mask* filter's dialog box has three controls: *Amount*, *Radius*, and *Threshold*. *Amount* describes the extent of the change of pixel color contrast. The *Radius* slider is used to determine the number of pixels surrounding an edge pixel. Low values define a narrow band and high values create a thicker edge. The *Threshold* modifier is used to determine how different a pixel needs to be from its neighbors before sharpening is applied. At a zero *Threshold* value, all pixels in an image are sharpened, resulting in a noisy and unsatisfactory image. When set at a higher value, less visible defects will occur overall.

Water images look dull

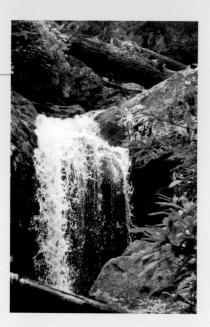

Ususally when you capture a scene you want to keep it as crisp as possible. Modern cameras have incredibly fast shutter speeds that can record the spokes of a bicycle or a speeding train with amazing clarity. However, this can also have the adverse effect of taking a valuable sense of motion away from your picture. The result, as seen in this example, is that images of waterfalls, babbling streams, and other naturally animated scenes lose their impact and look as if they have been frozen in time.

The solution—when using your camera—is to lower the shutter speed. Values ranging from ⅙ of a second up to 3 seconds are not uncommon for this type of shot. The movement is then recorded as a smooth, dreamy blur. This is a tricky technique, however, and requires a good deal of practice to master.

 treatment

Restore motion to the water with the *Smudge* tool

Luckily, the motion effect can be created digitally using Elements' filters, selection tools, and creative brushes. A sense of action can be restored to this otherwise static picture by using the *Threshold* filter to carefully select the water, then blurring the selection using the *Smudge* tool while leaving the surrounding area sharp.

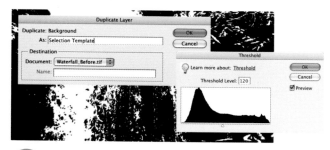

1 This technique uses a destructive filter so you'll need to duplicate the background. Go to *Layer>Duplicate Layer*, and name the new layer "Selection Template." Next select *Filter>Adjustments>Threshold*. This filter separates the light and dark areas of the image. Any pixels darker than the set value become black and those that are lighter become white. In this case, 120 is a good value.

2 Select the *Brush* tool from the *Tools* palette. Choose a fairly large, hard brush, and press D on the keyboard to restore the default color palette. The foreground color should now be set to black. Start to paint out the white areas around the waterfall. To help you determine which parts need removing, you can reduce the layer's opacity slightly (to around 70 to 80 percent). Once all of the unwanted area has been erased, return the opacity to 100 percent.

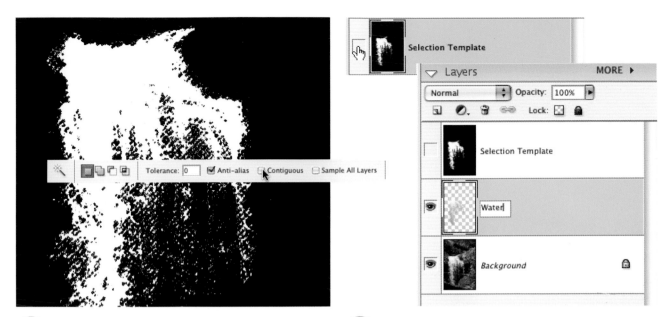

3 Select the *Magic Wand* tool. Go to the *Tool Options* bar, set the *Tolerance* to 0 and uncheck *Contiguous*. This ensures that all pixels of the sampled color will be selected at once. Click the cursor over any part of the white area.

4 Hide the Selection Template layer by clicking the *Eye* icon to the left of the thumbnail in the *Layers* palette. Reselect the background layer by clicking its thumbnail. Now go to *Layer> New>Layer Via Copy* to create a new layer from the selection you have just made. Double click the layer's name and call it "Water."

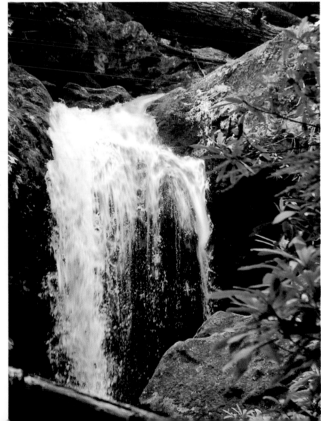

5 Pick the *Smudge* tool from the *Tools* palette, and select a reasonably large, soft brush with the *Strength* set to around 30 percent. Following the direction of the flow, use short to medium strokes to smudge the water. Continue down the image until you've created the desired effect. This mimics the slow exposure technique and brings back the illusion of motion.

Doctor, I need assistance!

Even if your images look perfect on your computer screen, they can still be disappointing when printed at home. In this section, you'll find a visual guide to common printer problems along with solutions for fixing them, as well as a look at some tasks Elements can perform.

Printing problems

It's one thing to tweak your photographs so that they look perfect on your computer screen, but when these shots are printed, the results can be completely different. Sometimes this is caused by using the wrong paper in the printer but, more often than not, it's something harder to pin down.

When printing photographs on ink-jet printers, you may find that shadow gain (extreme dark colors expanding) and highlight spread (extreme light colors expanding) become a problem, but if you're prepared to spend some time calibrating your printer, you'll be able to get rid of these problems.

Printer software paper settings
Selecting the wrong paper type in your printer software can have the greatest impact on your image contrast. This is usually the case when using a different brand of paper from the printer manufacturer, because printer manufacturers often exclude competitor's products from the list of media options. Confusion can grow more intense when recommended media is rebranded with a name that doesn't correspond with any of the options in the media settings dialog box. To avoid this dependence on presets, it's a good idea to stick with one media setting for glossy paper and one for matte paper, and set your printer resolution to 1440 or 2880 dots per inch (dpi) and leave it at that.

Printer software presets
Unexpected results often stem from the use of printer presets, such as *Auto Contrast*, *Auto Color Correction*, or *Auto Sharpening*. You'll never be able to predict exactly how these commands will change your image, so it's better to leave these unselected and use manual settings before getting to the printing stage.

Camera presets
If you know the effect a camera preset has on your final print quality, you may decide to switch most of them off and stick with making any required amendments in Elements. In fact, you'll get more controlled, and often better results if you do just that.

Paper differences
Despite the name on the box, there is a world of difference between ink-jet paper bought in sheets of 500 from a local store, and photo-quality paper made by an established professional brand. Cheap papers will never give you good results—however long you spend tweaking your software settings—because they do not have the necessary coatings to cope with the fine dots of ink. Cheap paper gets soggy, lacks rich contrast, and presents poor color saturation independent of the perfect image on your monitor.

Paper and printer calibration
Each type of paper responds differently to printer software settings, so you may still need additional corrections to achieve a flawless print. Testing your paper beforehand is straightforward and very cost effective in the long run. Testing involves finding the exact points at which the paper can't separate dark gray from full black and pure white from light gray. Once this has been established, you can account for it in Elements so your prints will no longer burn out or fill in.

Common printing pitfalls

Print too dark
The monitor has not been calibrated correctly, or the print paper settings are set too high.

Print too light
The monitor is not calibrated correctly, or the print paper settings are set too low.

Scratches running horizontally across print
The printer head needs realignment. Run your printer maintenance utility to reconfigure.

Blocky or pixelated print
The image's resolution is too low. Photo quality needs at least 200 pixels per inch (ppi) to print well.

Blurry print
The image has been overenlarged. Too many new pixels have been introduced to boost the print size at the expense of sharpness.

Tiny printout
The image was sent to print with too high a resolution, such as 2400 ppi. This often occurs after an image scanned from film has not been properly prepared for print.

Noise appearing on edges
The image is oversharpened. It's better to use only a tiny amount of unsharp filtering on a final image.

Blurred edges
The image needed to be sharpened before sending it to the printer.

Color casts in lines
Blocked ink nozzles cause this problem. Run your printer's cleaning utility to clear the blockage.

Posterization
These tones have been overcorrected with the *Levels* commands, and have broken into separate bands.

Patchy colors
This is an overprocessed image using excessive saturation commands. This occurs when the color values are raised too high and subtle gradients break up into patches of extreme color.

Hair and dust specks
These marks are caused by debris on the surface of the lens or image sensor. If the problem remains after cleaning the lens, take the camera to a professional store and ask them to take a look at it.

Noise

This image was shot in very low light with a high ISO setting. Digital cameras respond badly to creating detail in deep shadow areas, but this generally becomes much worse in extreme conditions. Although you can minimize the grain effect by applying a noise reduction filter, the result will lose a lot of sharpness.

Blocky patterns

This is caused by an overcompressed image using the JPEG file format. Although much more data can be squeezed onto a memory card by using the *JPEG Low* camera preset, the result will be low quality. If this file is subsequently edited and resaved as another low quality JPEG, the quality drops even more.

Banded color cast

In this case, the ink cartridge color ran out midprint. This is annoying when it occurs on a large print, but there isn't much that can be done about it. Some ink-jet printers will warn you if the ink level is low so you can change the cartridge before making an important print.

File corruption

Sometimes data corruption occurs at the saving or storing phase in a camera. This is rarely correctable, and it can be caused by faulty memory cards or excessive exposure to magnetic radiation. The best option in these situations is to reformat the memory card to try and avoid future problems.

Using Photoshop Elements' extra functions

Photoshop Elements is much more than a photo-manipulation package, it can also help you organize your images, compress them to e-mail to friends and family, create slide shows and greeting cards, and much more. The only problem is finding the time to sit down and play with them. Some of those extra features are listed below, but you should take the time to explore the software—you may be surprised at what you find!

Using the *Organizer*

The PC version of Photoshop Elements contains an extra utility called the *Organizer* that lets you view your images and sort them into albums. Images can be directly imported from a disk, memory card, or camera, and arranged to fit your needs. At the top of the *Organizer* window is a timeline, showing you exactly when the image was taken—this is a very useful reference. At this point, you can also tag each individual image—essentially placing a reference word against it to aid later retrieval. For example, you could tag all images of a family member with their name, and then use a search for that tag to find all photographs of that family member.

Selecting for e-mail attachment

Another useful function allows you to select the images you'd like to attach to an outgoing e-mail. The *Add Photos* command offers you the chance to select each individual image and it tells you how long the message is likely to take to transmit, depending on your Internet connection speed. Each image can be retrieved by name, tag, or just by browsing through the entire album and checking a selection box for those you want to send.

Making a desktop slide show

A very good way to review your work or show it off to your family or friends is to make a desktop slide show. Within Elements, this process is very simple and it gives you the flexibility to order and alter the running sequence of the show and display the file name at the base of the screen. You can even set the transitions between images so that some fade out, while others come in with a wipe across the screen, and so on. This example shows a slide show with its desktop control panel at right.

Creation wizards

Digital images are not just destined for printed photographs; they can be used for many other purposes as well. Within the *Create with Your Photos* window on a PC, you can choose to format your photos to create: slide shows, VCD disks (for playing your images on a TV), photo album pages, greeting cards, postcards, wall calendars, or Web photo galleries. You can also download extra wizards—for example, adding the functionality to print your images onto postage stamps. Each wizard takes you through the different processes in a step-by-step, easy-to-follow manner, so you don't need to develop expert skills beforehand.

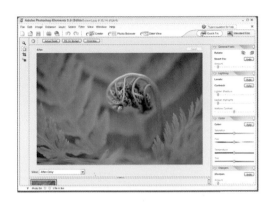

Editing in *Quick Fix* mode

An alternative to editing in the full desktop environment is Element's *Quick Fix* mode. Your images are presented next to a panel on the right-hand side containing all of the editing tools that you are likely to use in one session. Each dialog box can be used in quick succession and the results from each one are shown immediately within the image window. This mode is great for tweaking slight errors before printing out.

Using the *How To* palette

Another source of assistance, in *Standard Edit* mode, is the *How To* palette. Found at the base of the right-hand panel of palettes, each *How To* offers you precise, step-by-step instructions on how to use each tool, and covers everything from simple tonal changes to advanced techniques for making your images look old-fashioned.

Using the searchable Adobe *Help* menu

For more complex help topics, you can use the Adobe *Help* menu. Each topic can be accessed by a straightforward menu of subjects or it can be searched by typing in a keyword. Using fewer words in your search will help you get better results to review.

Glossary

anti-aliasing
The smoothing of jagged edges on diagonal lines created in an imaging program by giving intermediate values to pixels between the steps. This is especially common around text.

artifact
Any flaw in a digital image, such as noise. Most artifacts are undesirable, although adding noise can create a grainy texture, if desired.

CCD (Charged Coupled Device)
The name given to the component of a digital camera that sees and records the images, like film does in a traditional camera. The CCD is made up of a grid of light sensors, one for each pixel. The number of sensors and the size of image output is measured in megapixels.

channel
Images are commonly described in terms of channels, which can be viewed as a sheet of color similar to a layer. Commonly, a color image will have a channel allocated to each primary color (red, green, and blue in a standard RGB image) and sometimes an extra alpha channel for transparency.

clone/cloning
In Photoshop Elements, the clone tools allow you to sample pixels from one part of an image, such as a digital photograph, and use them to paint over another area of the image. This process is often used for the removal of unwanted parts of an image or correcting problems, such as facial blemishes.

color picker
An on-screen palette of colors used to describe and define the colors displayed and used in Photoshop Elements. The color picker can be opened by clicking on one of the color chits in the *Tool Bar*.

compression
The technique of rearranging data so that they either occupy less space on a disk or transfer faster between devices or over communication lines. For example, high-quality digital images, such as photographs, can take up an enormous amount of disk space, transfer slowly, and use a lot of processing power. They need to be compressed (the file size needs to be made smaller) before they can be published on the Internet; otherwise they take too long to appear onscreen. However, compressing them can lead to a loss of quality. Compression methods that do not lose data are "lossless," while "lossy" describes methods in which some data are lost.

contrast
The degree of difference between adjacent tones in an image from the lightest to the darkest. High contrast describes an image with light highlights and dark shadows, but few shades in between, while a low-contrast image is one with even tones and few dark areas or highlights.

dots per inch (dpi)
A unit of measurement used to represent the resolution of output devices such as printers and also, erroneously, monitors and images, whose resolution should be expressed in pixels per inch (ppi).

The closer the dots or pixels (the more present in each inch) the better the quality. Typical resolutions are 72 ppi for a monitor, 600 dpi for a laser printer, and 1,440 dpi for an ink-jet printer.

file format
The way a program arranges data to be stored or displayed on a computer. Common file formats include TIFF (.tif) for full resolution image files, JPEG (.jpg) for compressed image files, and PSD (.psd) for layered Photoshop Elements working documents.

FireWire
A type of port connection that allows for high-speed transfer of data between a computer and peripheral devices. Also known as IEEE-1394 or iLink, this method of transfer—quick enough for digital video—is employed by some high-resolution cameras to move data faster than standard Universal Serial Bus (USB).

histogram
A "map" of the distribution of tones in an image, arranged as a graph. The horizontal axis is arranged in 256 steps from black to white (or dark to light), and the vertical axis is the number of pixels. In a dark image you will find taller bars in the darker shades. The histogram is most commonly seen in the *Levels* palette, but it can also be viewed separately by going to *Window>Histogram*.

hue
A pure color. Choose a hue by clicking the *H* button in the color picker and moving the sliders on the central color bar.

JPEG, JPG
The Joint Photographic Experts Group. An ISO (International Standards Organization) group that defines compression standards for bitmapped color images. The abbreviated form gives its name to a "lossy" (meaning some data may be lost) compressed file format in which the degree of compression, ranging from high compression and low quality, to low compression and high quality, can be defined by the user.

layer
One level of an image file, separate from the rest, allowing different elements to be moved and edited in much the same way as animators draw onto sheets of transparent acetate.

lossless/lossy
Refers to the data-losing qualities of different compression methods. "Lossless" means that no image information is lost; "lossy" means that some (or much) of the image data is lost in the compression process (but the file will be smaller).

mask
A grayscale template that hides part of an image. One of the most important tools in editing an image, it is used to make changes to a limited area. In Photoshop Elements, a mask can only be applied to an adjustment layer, but in Photoshop masks can be applied to all layers.

megapixel
This has become the typical measure of the resolution of a digital camera. It is the number of pixels on the CCD, so

a size of 1280 x 960 pixels is equal to 1228800 pixels, or 1.2 megapixels. The higher the number of megapixels, the higher the resolution of the images the camera will create.

memory card
The media a digital camera uses to save photos. This can be CompactFlash, Memory Stick, SD Memory Card, or SmartMedia—all store images that can then be transferred to the computer.

midtones/middletones
The range of tonal values in an image anywhere between the darkest and lightest, usually referring to those approximately halfway.

noise
Random pattern of small spots on a digital image that are generally unwanted. It is often caused by overtreating a digital image in Photoshop Elements—typically by trying to introduce missing detail into overexposed images. Noise is a type of artifact.

pixel (picture element)
The smallest component of any digitally generated image. In its simplest form, one pixel corresponds to a single bit: 0=off, or black, and 1=on, or white (a bit is the smallest element of digital data). In color or grayscale images or monitors, one pixel may correspond to several bits. An 8-bit pixel, for example, can be displayed in any of 256 colors. A 24-bit pixel (8 bits per channel) can display any one of up to 16.8 million separate colors.

pixels per inch (ppi)
A measure of resolution for an image.

RAM (Random Access Memory)
The working memory of a computer, to which the central processing unit (CPU) has direct, immediate access. The data are only stored while the computer is switched on—permanent data is stored on the hard disk. More RAM can dramatically improve a computer's performance.

resolution
The number of pixels across an image or monitor by the number of pixels down. Common resolutions are 640 x 480, 800 x 600—the size most Web designers use—and 1,024 x 768.

resampling
Changing the resolution of an image either by removing pixels (and lowering the image resolution) or adding them (and increasing the resolution).

RGB (Red, Green, Blue)
The primary colors of the additive color model, used in video technology, computer monitors, and graphics used for the Web and multimedia.

USB (Universal Serial Bus)
An interface standard developed to replace the slow, unreliable serial and parallel ports on computers. USB allows devices to be plugged and unplugged while the computer is switched on. It is now the standard means for connecting printers, scanners, and digital cameras. USB 2.0 is the newer, faster standard.

Index

Acknowledgments

The authors wish to thank:

Philip Andrews
Editor, *Better Photoshop Techniques*

Chris Dickie
Editor, *Ag* Magazine

Anna B. (Sxc.hu)—64–65
Gergely Óhegyi (sxc.hu)—66–67
Steve Luck—68–69, 86–87, 92–93, 106–107
Brendan Gogarty (sxc.hu)—80–81
ImageAfter.com—84 (red eye close-up)
Jonathon (morguefile.com)—88
Dee Kull (morguefile.com)—89 (bottom)
Paul Cowan (iStockphoto.com)—94 (off-camera flash)
Fanelie Rosier (iStockphoto.com)—94 (ring flash)
Don Wilkie (iStockphoto.com)—94 (mounted flash), 115 (zoom tripod)
George Cairns—96–97
Wade Kelly—100–101
Chris Matei (Sxc.hu)—102–103
Daniel Norman (iStockphoto.com)—115 (supported zoom)
Christoph Ermel (iStockphoto.com)—115 (zoom lens)
Luis C. Tejo (MorgueFile.com)—118–119
Corey Ward (Sxc.hu)—138–139, 146–147
Angela Michelle (Sxc.hu)—142–143
Elizabeth Shoemaker (elizabethshoemaker.com)—144–145
Helmut Gevert (Sxc.hu)—148–149
Steve Caplin—154–155
Dawn M. Turner (morguefile.com)—156–157
Kenn Kiser (morguefile.com)—162–163